SOTHEBY'S GUIDE TO AMERICAN FOLK ART

JACQUELYN OAK

ILLUSTRATIONS BY JAMES ALLEN HIGGINS

A FIRESIDE BOOK

Published by Simon & Schuster

New York London Toronto Sydney Tokyo Singapore

FIRESIDE
Rockefeller Center
1230 Avenue of the Americas
New York, New York 10020

Copyright © 1994 by Sotheby's Inc.

Cover art: "St. Tammany" weathervane, copper, late 19th century. Photograph courtesy of Sotheby's.

FIRESIDE and colophon are registered trademarks
of Simon & Schuster Inc.

Sotheby's Books
New York • London

Director: Ronald Varney

Executive Editor: Signe Warner Watson

Associate: Allegra Costa

Specialist: Nancy Bruckman,
Senior Vice President, American Folk Art

Manufactured in the United States of America

10 9 8 7 6 5 4 3 2 1

Library of Congress Cataloging-in-Publication Data

Oak, Jacquelyn.
 Sotheby's guide to American folk art / by Jacquelyn Oak; illustrations by
James Allen Higgins.
 p. cm.
 Includes bibliographical references and index.
 1. Folk art—United States. I. Higgins, James Allen. II. Title.
NK805.018 1994
745'.0973'075—dc20 94-22813

ISBN: 0-671-89950-3

Contents

CONTENTS

\mathscr{A}CKNOWLEDGMENTS

Many folk art historians and museum staff members provided valuable research and reference information and assistance for this publication. I am grateful to Jane S. Becker, Society for the Preservation of New England Antiquities; Barbara Franco, Minnesota Historical Society; Lauren B. Hewes, Shelburne Museum; Richard Miller, Abby Aldrich Rockefeller Folk Art Center; Pauline Mitchell, Shelburne Museum; Celia Oliver, Shelburne Museum; Laura B. Roberts, New England Museum Association; Nola Skousen, Museum of Our National Heritage; Kathleen Stocking, New York State Historical Association; and Kenneth J. Zogry, The Bennington Museum.

Three museum colleagues deserve special mention: curator Paul S. D'Ambrosio, New York State Historical Association, offered suggestions and insights on many aspects of this publication; chief conservator Richard Kerschner, Shelburne Museum, served as technical adviser for the chapter on conservation; and Shel-

7

ACKNOWLEDGMENTS

burne Museum curator Robert Shaw provided expert commentary and advice throughout this project. Their contributions added a significant dimension to these pages.

Many people shared encouragement and support as this folk art study progressed. I extend my sincere thanks to Susan and Steven Balthaser; Diane and John Childs; Gisele B. Folsom; Philip N. Grime; Mary Johnsen; Harriet D. Liddell; Patricia and Gerard Marchese; Andrea and John Miller; Millie Rahn and William Stokinger.

As always, my parents, Elizabeth and David Oak, greatly assisted my efforts.

At Sotheby's, I am indebted to Wendell D. Garrett and Nancy Druckman for their guidance and enthusiasm.

I am most grateful to executive editor Signe Warner Watson; her remarkable editorial skills, energy, and optimism made her an ideal collaborator.

JACQUELYN OAK

PHOTOGRAPHIC CREDITS

SOTHEBY'S
GUIDE TO
AMERICAN
FOLK ART

WHAT IS AMERICAN FOLK ART?

A gilded copper eagle weathervane. Grandma's patchwork quilt. A giant carved wooden tooth. A likeness of a winsome child holding a puppy. What do these have in common? All are objects called "American folk art" and are eagerly sought by collectors.

The types of objects generally collected by folk art enthusiasts are exceptionally diverse, yet most were created with some type of useful function in mind. Weathervanes guided farmers and others whose livelihoods were dependent on the weather. Trade signs and shop figures graphically advertised wares and services to a public that was still partially illiterate. Carved and painted wildfowl decoys aided hunters in capturing their prey. Stoneware and ceramics were used for food preparation and storage. Girls learned the alphabet and embroidery stitches by making samplers that also served as family records. Quilts and coverlets were used as bedding and sometimes commemorated local and national events. Hooked rugs added warmth by covering a floor. Even portraits, not usually considered utilitarian, often served as the

only pictorial record of middle-class families. Frequently called "primitive," "naïve," and the "art of the common man," all of the objects were products of ordinary people made to fulfill everyday needs and to satisfy expression.

Folk art fascinates many collectors because of its eye-catching sculptural forms, inventive use of materials, hand-craftsmanship, and unpretentious style. Much of folk art's aesthetic appeal lies in its straightforward designs, originality, and pictorial simplicity. Unlike austere, formal furniture, mysterious Oriental carpets, or monumental bronze and marble sculptures, folk art is less intimidating and, perhaps, more easily understood than many other art forms.

Because most folk art was produced during the nineteenth century, the majority was found in New England and the Northeast, areas settled generations before where a growing middle class prospered. Farmers, merchants, professional people, and tradesmen thrived in an economy that offered unlimited opportunity for advancement. As families moved westward, they brought their artistic traditions with them, but never again was folk art produced in such large quantities or with as much ingenuity.

Because of their humble origins—most of folk art objects were made by untrained artisans—they were not viewed as works of art or valuable remnants of history until the early twentieth century. As a result, the field is relatively new and the scholarship that has appeared in the last sixty years or so is still constantly being reviewed and challenged. Because the objects were made by ordinary people, not academically trained artists or members of a formal salon, records of manufacture are scanty, making research difficult and limiting the amount of literature available. These limitations, however, demanded that researchers delve into primary sources—newspapers, diaries, city directories, first-person accounts—to record the diverse histories of makers and objects. What has emerged is a clearer picture of the so-called common man. While artifacts owned by notable Americans—Presidents, statesmen, wealthy aristocrats—have been collected and studied since the 1800s, only since the 1930s have art and cultural histories investigated the meaning of objects owned

by ordinary "folks." Because of its "democratic" nature, we twentieth-century citizens can relate directly to our nineteenth-century counterparts and share a commonality of experiences.

It is almost impossible to imagine a group of objects made of more diverse materials and levels of skill than those found in American folk art. Painters used mattress ticking as supports for portraits; bits of worn-out clothing were made into quilts; wooden logs were transformed into carved human figures and tree roots became faces; even used cardboard and bottlecaps were recycled and made into works of art. Because of these extensive variations, folk art presents a challenge for those attempting to understand and evaluate it. Some general guidelines, however, can be applied to almost every type of object.

CONDITION

As is the case with most collectible objects, condition is one of the most important factors in determining value and authenticity. The most desirable objects will be as original as possible, in a fine state of preservation, with all of their elements, both structural and decorative, intact. If wear is evident, it should be that incurred through normal use rather than abuse or neglect. Objects that have suffered damage but have been properly restored by qualified, professional conservators usually do not have their value reduced.

RARITY

Because they were made by hand, many folk art objects are "one of a kind." Knowledgeable collectors will judge objects by comparing them to others. A few questions can be considered: Is the object well crafted? How does it relate to other objects of the same type? Does the ornamentation add to the overall impact? Does it exhibit some of the maker's personality? Experienced collectors and museum curators often use such queries to form

a set of hierarchical guidelines to determine value. Because folk art is astonishing in its variety of styles and materials, such "good, better, best" evaluation may be difficult, but the criteria can usually be applied to groups of similar objects.

ARTIST/MAKER

Many examples of folk art were made anonymously with no indication of origin or date. Coming from a craft rather than fine art tradition, the makers generally did not identify their work. When objects are signed and dated, the maker researched, and the information published, the object is significantly more interesting to the collector. The object should always be judged by aesthetics, too, because a poorly executed piece, even if it is signed and dated, is of lesser value.

CRAFTSMANSHIP

Although many folk artists were "untrained" in the formal sense, many were skilled craftsmen. Collectors look for objects that exhibit inventive alternatives to traditional modes of expression. Perspective in a landscape painting may be unrealistic, for example, but the artist compensates by adding engaging details; a simply constructed chest of drawers is transformed into a masterpiece when covered by a layer of colorful, eye-dazzling paint. Many objects display a variety of decorative motifs such as florals, geometric patterns, or traditional symbols—painted, carved, stitched, or a combination of several; experienced collectors look for typical types of decoration that have been manipulated by the maker in an unusual or imaginative way, setting the object apart from other examples. Perhaps a good "rule of thumb" to use when evaluating folk art is the old axiom "The whole is greater than the sum of its parts"; if the object is, the artist has been successful and the collector should take notice.

PROVENANCE

In art terms, "provenance" means "an object's history"—who owned the object, when, and where over successive years. Provenance is very important when considering an object for purchase because it can often verify or suggest further research with regard to the maker or origin. Documentation is a significant aspect of an object's value. In the minds of some collectors, who owned the object is as important as the object itself.

APPEAL

Some of the finest collections have been formed by those who have focused on a particular type of folk art (portraits or decoys, for example) that appeals to their own personal taste. Others have acquired a variety of objects from several categories, including many examples of different folk art forms. Some objects "speak" in an intangible way, arousing interest or passion for inexplicable reasons; individual preferences should not be ignored when building a collection, even if the objects do not fall into any traditional category. The so-called finest, rarest, or most-researched object may not necessarily be the one that evokes the most enjoyment.

The most successful collectors were not born with a knowledge of American folk art. They acquired it through study and observation. Fortunately for the would-be collector, the number of books, magazines, and catalogues on the subject has reached an all-time high. Museums and galleries regularly mount exhibitions on every variety of folk art; many offer symposiums and workshops for beginners and experts alike. Take advantage of the many painless opportunities to learn. The most informed consumer usually makes the best purchases!

COLLECTING
AMERICAN
FOLK ART

Traditional histories of folk art collecting cite a group of academically trained artists as the first American folk art collectors. In the summer of 1913, Hamilton Easter Field (1873–1922), an artist, critic, and collector, established an art school in Ogunquit, Maine. Having traveled extensively in Europe, Field had been exposed to many varieties of modern art and was particularly interested in the art of Asia and Africa. To furnish the fishing shacks that served as the school's studios, Field collected homely objects that were available locally: decoys, weathervanes, hooked rugs, wood carvings, and primitive paintings. Their simple forms and abstract qualities appealed to Field, who saw pleasing similarities between them and the art he had come to appreciate in Europe. Joined by several of the artists who had come to work at Ogunquit—notably sculptors Robert Laurent (1890–1970) and William Zorach (1887–1967) and painters Yasuo Kuniyoshi (1893–1953) and Bernard Karfiol (1886–1952), who saw parallels of their own work in many of the "furnishings"—Field continued to acquire more objects. Interest in the naïve paintings and sculpture expanded among other modern artists who were eager to learn more about objects created by untrained nineteenth-century craftsmen.

During the early 1920s, a New York City art dealer, Edith Gregor Halpert (1900–1970) accompanied her husband, Samuel, a painter, to the Ogunquit school. Recognizing the commercial potential of the paintings, sculpture, and needlework she saw used as decoration, Mrs. Halpert soon built a collection herself and began to sell it at her gallery in New York City in 1929.

On a subsequent visit to Ogunquit, Mrs. Halpert was joined by Newark Museum curator Holger Cahill (1887–1960), who had become intrigued with folk arts and crafts during a study trip to Europe. Cahill, too, was immediately drawn to the artwork that the group had collected. Through a series of exhibitions in the early 1930s (most importantly "American Folk Art—The Art

of the Common Man in America, 1750–1900") held at the Museum of Modern Art and the Newark Museum, Cahill helped to legitimize folk art by placing it in a museum setting. (Earlier exhibitions, such as the "Homelands Exhibit" at the Newark Museum in 1916, featured European immigrant folk arts and crafts but did not include American examples.) In later years, Cahill further promoted folk art when he directed The Index of American Design, a federal arts project that supported hundreds of artists during the Depression. Through watercolor paintings and black-and-white photographs, the artists recorded folk objects and other examples of American crafts made prior to 1890. In the late 1930s, sets of the beautifully rendered plates were exhibited in museums, galleries, and department stores across the country. (Some of the plates are currently owned by the National Gallery of Art in Washington, D.C.)

Throughout the 1930s and 1940s, folk art came to the attention of a handful of wealthy collectors who had previously been involved in other art worlds. Among the first was Abby Aldrich Rockefeller (1874–1948). Mrs. Rockefeller had been a longtime collector of modern art and became acquainted with folk art during a visit to Mrs. Halpert's gallery in the late 1920s. For the next several years, Mrs. Rockefeller actively collected American folk art, including paintings, quilts, sculpture, ceramics, and a variety of other forms. Having been the major lender to early folk art exhibitions—most notably "American Primitives: An Exhibit of the Paintings of Nineteenth-Century Folk Artists," at the Newark Museum in 1931, and "American Folk Art—The Art of the Common Man in America 1750–1900," at the Museum of Modern Art in 1932—she deposited her collection of over four hundred objects permanently at Colonial Williamsburg, another Rockefeller project, in 1939. After display in one of the restored houses, the collection was opened to the public as the Abby Aldrich Rockefeller Folk Art Collection (later renamed Center) in 1957.

Another pioneer collector, Electra Havemeyer Webb (1888–1960), the daughter of New York City industrialists and art patrons the Henry O. Havemeyers, inherited the passion for collecting from her parents. The Havemeyers, early collectors of

Impressionist paintings, European furniture, and high-style decorative arts, were astonished when Electra, at age eighteen in 1906, purchased a cigar-store Indian. As her acquisitions of other types of folk art increased, her exasperated mother queried, "How can you, Electra, you who have been brought up with Rembrandts and Manets, live with such American trash?" Despite her mother's skepticism, during the 1930s and 1940s, Mrs. Webb continued to develop her collections of wood carvings, quilts, hatboxes, tools, pottery, and decorative accessories that were generally overlooked by others. Her folk art collection formed the basis of what would become the Shelburne Museum, established in 1947. Mrs. Webb expanded the holdings considerably with the addition of hundreds of decoys, textiles, and primitive paintings during the 1950s. Today, the Shelburne Museum is popularly known as a "collection of collections" and focuses on every variety of American vernacular art. Explaining her passion for collecting, and perhaps also explaining how the museum grew to include some forty-odd buildings and a nine-hundred-ton sidewheeler steamboat, the S.S. *Ticonderoga,* Mrs. Webb commented, "Some collectors have the place and look for the piece . . . I buy the piece and then I find the place."

Influenced by his friend Electra Havemeyer Webb, Henry F. du Pont (1880–1969) came to appreciate American decorative arts and folk art. Writing about his experience in 1951, du Pont stated, "The house at Winterthur, Delaware, my family's home where I was brought up, was furnished with miscellaneous foreign and American Empire pieces. . . . A visit to Mrs. Watson Webb's house in 1923 was therefore a revelation. This was the first early all-American interior I had ever seen and it captivated me." In addition to a significant American decorative arts collection that du Pont acquired and installed at his family's estate, he actively sought folk art made by the Pennsylvania Germans. Although they are not the main research interest of the museum, the Pennsylvania German materials are rich and varied and illustrate this specific aspect of folk art. The museum opened to the public in 1951.

Three private folk art collections, formed in the 1920s and 1930s when folk art was still a nascent field, make up the nucleus

of the New York State Historical Association in Cooperstown. In the mid-1940s, the Association acquired a group of weather-vanes, sculpture, and paintings from the estate of sculptor Elie Nadelman (1885–1946), who had opened his own folk art museum in 1926. With his wife, Nadelman had collected superlative examples of American and European folk art, housing them at their Riverdale, New York, estate. Known first as the Museum of Folk and Peasant Art, then renamed the Museum of Folk Arts, the Nadelmans' museum contained over 70,000 examples of cigar-store Indians, chalkware, costumes, fraktur, furniture, needlework, paintings, ship figureheads, rugs, textiles, toys, trade signs, wagons, and weathervanes, among others. Because of financial setbacks, the collection was sold throughout the 1930s and 1940s. Many of the paintings, sculptures, and weathervanes sold by collectors Jean (b. 1909) and Howard (1905–1993) Lipman to the association in 1949 had been featured in many of Mrs. Lipman's publications about American folk art. Writing in 1990 about the early days of collecting, Mrs. Lipman commented, ". . . I [couldn't] believe some of the mini-prices which were asked in the early years when folk art was considered a rather dubious, unclassified variety of American antiques. . . . Our collection of 334 pieces, sold to [the association] for $75,000 (including three paintings that today would each be worth well over a million)." An addition of almost two hundred primitive pictures in the late 1950s, purchased from the estate of Mr. and Mrs. William Gunn, greatly augmented the museum's holdings. A couple from Massachusetts, Marion (1881–1957) and William Gunn (1879–1952) acquired a large collection (about six hundred pieces) of folk paintings, mostly portraits, during the early twentieth century. The Nadelman, Lipman, and Gunn collections form the basis of the interpretive exhibitions mounted at the association's headquarters, Fenimore House.

Many museums, such as the National Gallery of Art in Washington, D.C., and the Metropolitan Museum of Art in New York City, as well as twenty-one other regional museums, benefited from the folk art collection put together by Edgar William (1899–1980) and Bernice Chrysler (1907–1980) Garbisch. In 1944 the Garbisches began to acquire primitive paintings of every variety

and, by the 1960s, the collection numbered over 2,600 pieces. Traveling exhibitions of the Garbisches' collection toured the country before parts of it were dispersed to museums throughout the United States.

Other museums and galleries integrated folk art into their exhibition and lecture schedules as public interest increased. First opened for public view in 1963, the Museum of American Folk Art in New York City has organized and circulated hundreds of exhibitions of every variety of nineteenth- and twentieth-century folk art. A seminal exhibition, "The Flowering of American Folk Art, 1776–1876," organized by the Whitney Museum of American Art in 1974, synthesized much of the research that had been done during the previous fifty-odd years. Since that time, through the 1970s and 1980s, numerous previously unknown folk artists have been identified, and catalogues have been produced by a variety of art and historical associations. Several museums, such as the Connecticut Historical Society, Hartford; the Fruitlands Museum, Harvard, Massachusetts; the Genesee Country Museum, Mumford, New York; Heritage Plantation of Sandwich, Massachusetts; and Old Sturbridge Village, Sturbridge, Massachusetts, among others, have concentrated on the studies of regional folk art, and several states, such as Connecticut, Michigan, New York, Ohio, and Vermont, have undertaken folk art surveys.

The most recent private folk art collection to come into the public venue was formed by two New Englanders who possessed unfailing instincts for acquiring the best examples of man-made items known as "material culture." Although Nina Fletcher Little (1903–1993) had no professional art or museum training, she, with her husband, Bertram Kimball Little (1899–1993), created one of the twentieth century's most comprehensive and distinguished folk art and Americana collections. Beginning in the 1920s, the Littles acquired vast quantities of ceramics, textiles, paintings, carvings, furniture, decoys, and related arts for their homes in Massachusetts. The significance of the collection was greatly enhanced by the scholarly research undertaken by Mrs. Little and subsequent books and articles she authored. The Littles donated one of their homes, Cogswell's Grant, and its contents,

located in Essex County, Massachusetts, to the Society for the Preservation of New England Antiquities, which maintains it as a museum.

Folk artists are being documented today in record numbers, and awareness and appreciation are at an all-time high. Galleries specialize in folk art materials and auction prices have skyrocketed. Currently, folk art is valued for its aesthetic qualities by some and for its social and historical significance by others. Whatever the viewpoint, work by the "folks" is firmly established as an integral part of the panorama of American art.

FURTHER READING

Becker, Jane S., and Barbara Franco, eds. *Folk Roots, New Roots: Folklore in American Life*. Lexington, Mass.: Museum of Our National Heritage, 1988.

Cahill, Holger. *American Folk Art—The Art of the Common Man in America, 1750–1900*. New York: Museum of Modern Art, 1932.

Christensen, Erwin O. *The Index of American Design*. New York: Macmillan and Company, 1950.

D'Ambrosio, Paul S., and Charlotte M. Emans. *Folk Art's Many Faces*. Cooperstown: New York State Historical Association, 1987.

Hoffman, Alice J. "The History of the Museum of American Folk Art." *The Clarion*, Winter 1989.

Jones, Agnes Halsey, and Louis C. Jones. *New-Found Folk Art of the Young Republic*. Cooperstown: New York State Historical Association, 1960.

Kert, Bernice. *Abby Aldrich Rockefeller: The Woman in the Family*. New York: Random House, 1993.

Lipman, Jean. "Recollections, Mostly About Old-Time Prices." *The Clarion*, Fall 1990.

Little, Nina Fletcher. *The Abby Aldrich Rockefeller Folk Art Collection*. Williamsburg, Va.: Colonial Williamsburg, 1957.

———. *Little by Little: Six Decades of Collecting American Decorative Arts*. New York: E.P. Dutton, Inc., 1984.

National Gallery of Art. *An American Sampler: Folk Art from the Shelburne Museum*. Washington, D.C.: National Gallery of Art, 1987.

Oaklander, Christine I. "Elie and Viola Nadelman, Pioneers in Folk Art Collecting." *Folk Art*, Fall 1992.

Quimby, Ian M. G., and Scott T. Swank, eds. *Perspectives on American Folk Art*. New York: W.W. Norton for the H.F. du Pont Winterthur Museum, 1980.

Rumford, Beatrix T., and Carolyn J. Weekley. *Treasures of Folk Art from the Abby Aldrich Rockefeller Folk Art Collection*. Boston: Little, Brown, in association with the Colonial Williamsburg Foundation, 1988.

Saarinen, Aline B. *The Proud Possessors*. New York: Random House, 1958.

Schaefer, Clifford W. *Forty-eight Masterpieces from the Collection of Edgar W. and Bernice Chrysler Garbisch*. Norfolk, Va.: The Chrysler Museum, 1975.

Stillinger, Elizabeth. *The Antiquers*. New York: Alfred A. Knopf, 1980.

WHAT IS SCULPTURE?

WEATHERVANES AND WHIRLIGIGS

WEATHERVANES

For decades, American tradespeople looked to the weathervane placed high atop the roof to determine the weather and plan the day's activities. As utilitarian wind-indicating devices, the vanes played an important part in the life of American settlers; to twentieth-century eyes, they can be appreciated as sculptural works of art.

The earliest vanes date from ancient times, when a bronze figure of Triton, a Greek sea god, half-man, half-fish figure, topped the Tower of the Winds in Athens, built about 48 B.C.

Archaeological studies have proven that the Vikings had quadrant-shaped metal vanes attached to their ships during explorations in the ninth century. Also during the ninth century, a papal decree ordered that a rooster symbol be placed on the rooftop of every church to recall Peter's betrayal of Christ ("... the cock shall not crow this day, before that thou shalt thrice deny that thou knowest me") and to remind the congregation to attend services. References to weathercocks appear in medieval English literature and were regularly in use on domestic architecture in England by the seventeenth century.

The earliest vanes used in America were imported from Europe and used as architectural devices, appearing on churches and civic buildings alike, and some are still extant today. The first truly American-made efforts date from the early eighteenth century and include some well-documented examples. Metalsmith and woodworker Shem Drowne (1683–1774) made several of the most famous American vanes in Boston in the eighteenth century. In 1722 Drowne created a five-foot-high metal rooster, patterned after European models, for the New Brick Church; in 1740 he made a metal "banneret"—literally, meaning shaped like a banner—vane for the Old North Church, and in the 1740s he made what is possibly his most famous vane, the copper grasshopper with green glass eyes for Faneuil Hall. An Indian archer made by Drowne in 1716 was described by author Nathaniel Hawthorne (1804–1864) in a story entitled "Drowne's Wooden Image" (1844): "One of his productions, an Indian chief, gilded all over, stood during the better part of a century on the cupola of Province House, bedazzling the eyes of those who looked upward, like an angel in the sun."

The earliest American weathervanes were made by amateur woodworkers and blacksmiths of wood or sheet iron and were usually flat silhouettes, often with exaggerated features that would appear in correct proportion when viewed from the ground. The first rooster vanes were made in a stylized, European style, showing no legs, and mounted on the upright. Gradually, the silhouettes were replaced with full-bodied styles, legs were included, and the makers attempted a more realistic depiction. Both types were sometimes decorated with paint. In addition to the

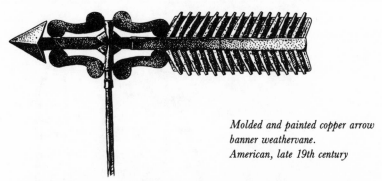

*Molded and painted copper arrow
banner weathervane.
American, late 19th century*

ubiquitous rooster, banners and pennants were popular motifs
seen on the early vanes. Derived from medieval heraldry, metal
banners were reminiscent of flags and cloth pennants that nobility
displayed on castles and in parades. The Americans added arrows
to the banners and further elaborated the designs with the ad-
dition of geometric shapes. Other early motifs included fish, such
as the "sacred cod," a Christian emblem and symbol of New
England's reliance on the sea; dolphin; Indians, some shown with
bows and arrows; the angel Gabriel with a trumpet; peacocks;
and every variety of barnyard animal: cows, horses, pigs, and
sheep.

The vanes that were cut out of wood or metal, hammered or
nailed together by anonymous farmers and other amateurs, dis-
play unique, individualistic expression. About 1850, however,
weathervanes changed dramatically as American manufacturers
began to mass-produce and commercially market them as a com-
modity. Alvin A. Jewell of Waltham, Massachusetts, just outside
Boston, was the first manufacturer of weathervanes, beginning
in 1852. Skilled as a designer and patternmaker, Jewell fabricated
the vanes from copper, molded in iron forms based on carved
wooden templates. The copper vane was molded in two identical
halves, then joined at the center with solder. Gold leaf was added
to create a brilliant surface. Jewell successfully marketed the
vanes through a published catalogue, and the designs were copied
by later commercial makers. Included in Jewell's early catalogues
were figures of a variety of eagles, roosters, and horses, among
others. After Jewell's death in 1867, the business was sold to L.
W. Cushing, also of Massachusetts, who added some designs and

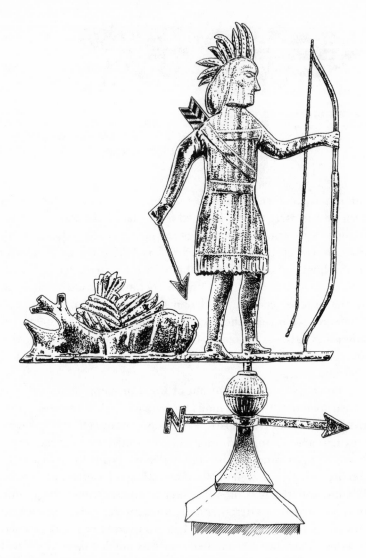

Molded copper "St. Tammany" Indian weathervane.
American, third quarter 19th century

continued to expand the business. Other companies, too, such as J.W. Fiske & Company and E.G. Washburne in New York, and J. Harris & Son in Massachusetts, produced a variety of vanes of similar subjects. Most of the companies issued illustrated

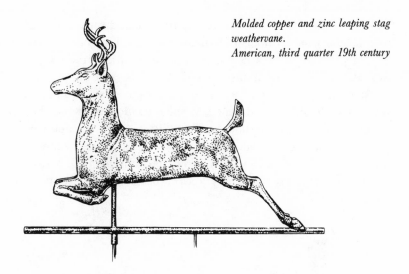

Molded copper and zinc leaping stag weathervane.
American, third quarter 19th century

catalogues to pique public interest and promote business. Today the catalogues are invaluable research tools for scholars who document the work of individual companies.

Public response was enthusiastic, and by the last quarter of the nineteenth century, many companies mass-produced the product. The variety of subjects manufactured by such companies was staggering. In addition to the roosters, one of the favorite animals was the horse, depicted in several positions such as trotting, cantering, jumping, and standing still. As patriotic emblems, eagles have been part of American iconography from the beginning but were seldom used by early weathervane makers. Commercial manufactories, however, embraced the symbol and used it extensively. One of the most familiar images, made by virtually every company, shows the eagle perched on a ball, with wings spread, ready for flight. Like the eagles, the figure of the Goddess of Liberty, usually shown holding a flag, was produced by Fiske, Boston Metal Workers, and Cushing and White, of Waltham, Massachusetts, and was one of the most popular motifs. Following the earlier tradition, figures of barnyard animals were in great demand by cattlemen and argiculturalists. By the mid-nineteenth century, farms had changed from simple, one-family sustaining

enterprises into factories that produced milk and meat for commercial markets. Symbols of bulls, cows, pigs, and sheep served a dual purpose as weathervanes and rudimentary trade signs. Symbols of increasing industrialization, too, became subjects for the commercial makers. Steam locomotives and fire equipment were favorite subjects; detailed to show particular styles, they were often found on firehouses. The 1893 J.W. Fiske catalogue gives an idea of how diverse the subjects had become by late in the century. Of the different offerings, including simple arrows and bannerets, there were eight types of roosters; thirty-two types

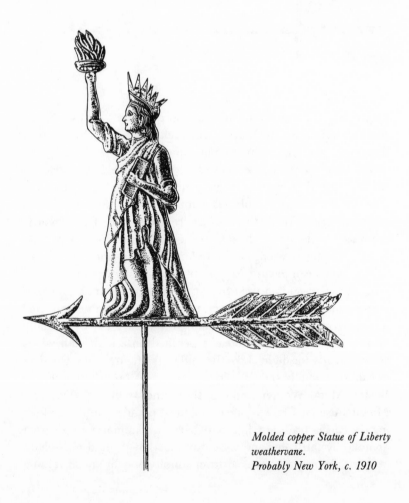

Molded copper Statue of Liberty weathervane.
Probably New York, c. 1910

Molded and gilded copper ram weathervane. Attributed to L. W. Cushing & Sons Company, Waltham, Massachusetts, third quarter 19th century

of horses; five eagles; four firemen and engines; three cows, deer, sheep, and ships; two bulls, dogs, dragons, fish, hogs, "Miss Liberty," and pigeons; and one each of bear, buffalo, fox, "Gabriel," Indian, lion, owl, swan, and an exotic elephant and ostrich! Depending on size and style, the vanes ranged from twenty-five dollars to fifty-five dollars. The catalogue assured the customer that the vanes were "made of copper, gilded with the finest gold leaf, will not corrode and will keep bright a long time."

WHIRLIGIGS

A wind-powered device that was related to the weathervanes was the whirligig, a small, carved figure that usually had oversized arms or paddles to catch the breeze and rotate accordingly. Often brightly painted, the figures were probably used as wind toys, for amusement. A variety of figures—patriotic characters, military men, Indians—were carved in the round with their arms suspended on rods or dowels. Frequently, the military figures were carved with great attention to detail in uniforms: soldiers

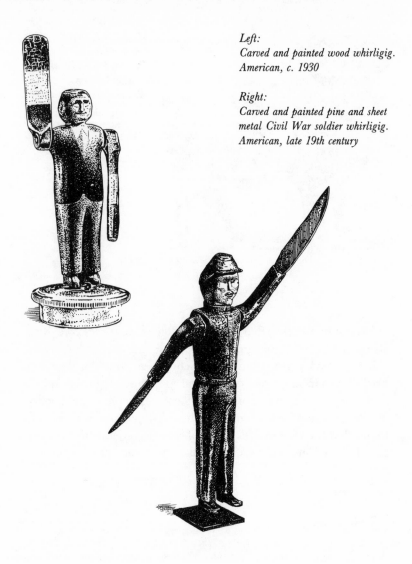

Left:
Carved and painted wood whirligig.
American, c. 1930

Right:
Carved and painted pine and sheet
metal Civil War soldier whirligig.
American, late 19th century

are seen with elegant sashes, headgear, and epaulets, and the jaunty sailors are shown in middy blouses and bell-bottomed trousers. An interesting, if rare, whirligig that actually was a trade sign used in Salem, Massachusetts, about 1875 shows a seated woman at work at a spinning wheel; others depict bicycle riders or men sawing wood. All engage in kinetic activity, de-

pending on the wind, and are fine examples of folk carvings that afford amusing diversion.

WHAT TO LOOK FOR

CONDITION

Since weathervanes were constantly exposed to the elements, the finishes vary widely; it is fairly unrealistic to expect to obtain a real one in perfect condition. On wooden vanes, the wood will show cracks and splits, the paint layer (if any) will show crackling, and the metal supports may be corroded. Copper vanes, through oxidation, acquired a light greenish-blue patina when exposed to the weather; sometimes areas of gold leaf can still be seen. Authentic vanes will usually have varying areas of wear, not even, over the entire surface, and one side will usually show more wear than the other. Evidence of water damage, such as ruts, can also sometimes be observed on the body. Sophisticated forgers have developed methods of chemically aging metals to produce a surface that is virtually identical to the naturally weathered examples. The collector should take care to purchase vanes that have been authenticated by the dealer or auction house. Vanes were frequently used as shooting targets and many retain bullet holes. While the holes may be unsightly and decrease the vane's value somewhat, they are part of the object's history. Check for entrance and exit holes.

Like weathervanes, whirligigs suffered similar damage from exposure to the elements and often show similar characteristics. Check the upright center-post components, such as blades, surface, and attachments (pins, screws) for water or sun damage.

GUIDELINES

Because the early handmade examples, such as a sheet-iron rooster or a carved wooden codfish, are difficult, if not impossible,

to document, they are seldom collected for investment purposes. Unless the complete provenance is known, including the time the vane was removed from its original site, careful consideration should be used prior to purchase. The factory-made, mass-produced vanes can be easily documented and are those most valued by collectors today. Full-bodied barnyard animals, traditional designs such as the leaping stag, and the intricate automobile and fire engine models are among the finest examples. Vanes showing patriotic symbols, such as "the Goddess Liberty," are always popular with collectors.

Many catalogues published by the weathervane factories are in museum and library collections, and some have been reproduced and are commercially available. A comparison of forms with the originals advertised in the catalogues can help identify the makers. Remember that some makers copied each other's designs, so careful study is required.

Undoubtedly, many of the earliest whirligigs did not survive. Many on the market today are contemporary, but they are sought by collectors as examples of folk sculpture. The whirligigs that show figures engaged in activities—such as the washerwoman or the bicycling man—are among the most valuable.

FURTHER READING

Fitzgerald, Ken. *Weathervanes and Whirligigs*. New York: Clarkson N. Potter, 1967.

Klamkin, Charles. *Weather Vanes: The History, Design, and Manufacture of an American Folk Art*. New York: Hawthorn Books, Inc., 1973.

Lipman, Jean. *American Folk Art in Wood, Metal, and Stone*. New York: Pantheon, 1948; Dover, 1972.

National Gallery of Art. *An American Sampler: Folk Art from the Shelburne Museum*. Washington, D.C.: National Gallery of Art, 1987.

ADVERTISING FIGURES, TRADE SHOP AND TAVERN SIGNS

The cigar-store Indian is undoubtedly the most easily identifiable nineteenth-century advertising symbol in American culture. For decades these familiar figures stood in front of tobacco shops beckoning customers to purchase cigars and snuff. Both Indians and tobacco were indigenous to the United States and held great fascination for Americans and Europeans alike. Although small carved figures advertised tobacco in English smoke shops in the seventeenth century, it was in America, about 1840, that the Indian became the preeminent symbol for tobacco.

The culture of the American Indian was of great interest and was romanticized in advertising, popular magazines, and manufactures. Americans' fascination with Indian life drew the attention of hundreds to the commercial shops. The earliest cigar-store Indians were made by ship figurehead and sternboard carvers who had seen the need for their services decline when wooden sailing vessels were gradually replaced by those made of iron or steel. The Indians were carved in a manner similar to that of the figureheads: local woods, usually pine, were used; the carvers formed the body with axes, hammers, and chisels, and sometimes, hands, legs, and arms were carved separately. The figures were enameled in bright colors to attract as much attention as possible. Generally, the carvers used their imaginations to create the figures; some Indians are depicted wearing skirts of tobacco leaves, stylized "noble savage" costumes, and fancy headdresses. Frequently, the figures held a bundle of tobacco leaves or ready-made cigars. Among the most charming figures is an Indian squaw shown carrying a papoose. In the more inventive figures, real props, such as hatchets or quivers and arrows, were added. Often the figures were mounted on wheels so they could be moved indoors at night. In fact, some enterprising ornamental painters found employment repainting the Indians that had been exposed to the elements. (Apparently not all attempts were successful: according to a contemporary commentator, ". . . it is the fate

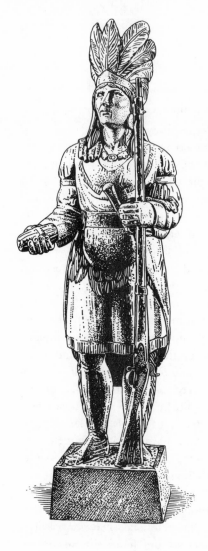

Carved and painted pine cigar store Indian chief.
Samuel A. Robb, New York, 1902–22

of sculptures of this nature to be given over to house painters for refurbishing, and when they get old, they hardly ever look . . . as the carver intended.")

Indians were by far the most popular cigar-store advertisements, but from the 1850s to the 1880s many other figures also promoted tobacco. The Scotsman, or Highlander, shown wearing kilts, sash, and sporran, appeared in America based on English prototypes that advertised snuff. Patriotic figures such as "Brother Jonathan," the predecessor of Uncle Sam; exotic Turkish princesses and soldiers; "Ladies of Fashion," stylish mannequins copied from women's magazines; the English puppet "Punch"; literary characters; sailor boys; and the Negro minstrel caricature "Dancing Sam" were used by the merchants to hawk their wares.

Through written advertisements, catalogues, broadsides, and signed figures, many carvers have been identified and researched. William Rush (1756–1833) of Philadelphia, famous as America's most successful ship carver, also created advertising and architectural ornamental figures. Known as one of America's first

sculptors, Rush worked mainly at carving commercial figures. His work is characterized by realistic depictions that capture individual likenesses with great precision. Having been taught to model in clay to perfect idiosyncratic features, Rush's figures are less stylized than those of carvers whose figures follow a prescribed pattern.

Julius Theodore Melchers (1829–1909) received wide recognition as a carver. Born in Prussia where he had some training as a woodcarver, Melchers eventually settled in Detroit. He found work there carving cigar-store figures, for which he charged five dollars to one hundred fifty dollars. Melchers's figures tend to be rigid, with verticality emphasized by elongated torsos and features and realistic detail in costume.

John Philip Yaeger (1823–1899) came to Baltimore from Germany in the 1840s. Active in the German business community,

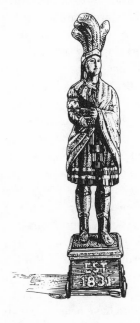

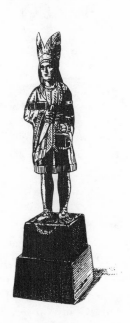

Carved and painted cigar store princess. Attributed to Samuel Robb, New York, c. 1870

Carved and painted pine cigar store Indian chief. American, third quarter 19th century

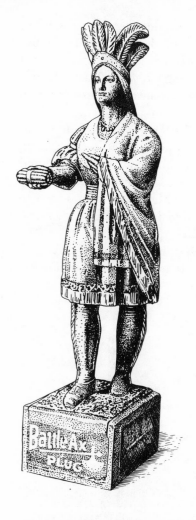

Carved and painted pine cigar store Indian princess.
Samuel Robb, New York, late 19th century

Yaeger carved signs and figures for local merchants and tobacconists. He preferred to work in pine and hickory and produced oversized, rather corpulent carvings that lacked detail in costuming and props. One of his most successful figures shows an Indian princess, for which, it is said, he used his daughter as a model.

One of the most prolific carvers was Samuel Anderson Robb (1851–1928) of New York. Having served as an apprentice ship carver in the 1860s, Robb had some training in drawing technique at the National Academy of Design. In 1876 he opened his own carving shop where he employed several men. In his advertisements Robb offered "Figure carving . . . Show Figures and Carved Lettered Signs. A Specialty Tobacconist Signs . . . Ship and Steamboat Carving, Eagles, Scroll Heads, Block Letters, Shoe, Dentist, and Druggist Signs." Robb frequently signed his work, and among the wide variety of inventive carvings were figures of firemen; "Captain Jinks," a character known in a Civil War–era song and said to have been a caricature of Robb himself; Highlanders; grenadiers in military dress; an elephant; and Santa Claus, made for a toy dealer.

William Demuth (1835–1911), a German native, became the largest U.S. supplier of Indian and show figures. Demuth came to America at sixteen, worked in a novelty and tobacco supply business in New York City, and in 1865 set up his own shop, supplying the trade with wooden figures. Demuth's idea to cast the wooden figures in metal provided even more business opportunities. In 1869 Demuth had eight wooden models cast in zinc, which he considered a great improvement. The metal figures lasted longer and they could be left outdoors. Demuth's catalogue offered a small, wooden cigar-store Indian (six feet two inches tall) for thirty-three dollars; a wooden Turk figure of about the same size for sixty-eight dollars; a metal squaw with papoose (seven feet) for seventy dollars; and an elaborate metal Indian warrior for one hundred fifty dollars. Demuth's business was so successful that he established branch offices in Chicago and San Francisco, and exhibited at the World's Columbian Exposition in Chicago in 1893.

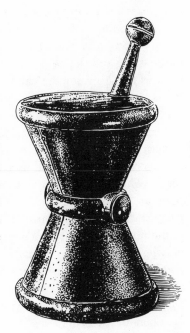

In a world where many people could not read, carved and painted trade signs graphically communicated what goods and services were readily available. A two-foot-high figure called "The Little Navigator," dressed jauntily in a waistcoat and top hat and holding a quadrant, was a trade sign for a nautical instrument maker; a ship's chandlery was represented by a man holding a telescope, surrounded by other nautical gear; the

Molded copper apothecary trade sign. American, late 19th century

figure of the classical messenger Mercury, with winged hat and feet, was used as the emblem of the postal service; and importers of tea from the Far East featured Asian figures. Animals, too, were used as motifs on the signs; a sheep represented a woolen mill or textile manufactory, and saddlers' signs were full-sized, carved horses. Taverns and inns were also publicized by carvings: a man holding a bunch of grapes promoted a bar, as did the classical Greek character Bacchus, the god of wine and spirits. Trades also employed symbols to advertise their services: a giant pocket watch symbolized a clock- and watch-repair shop; a shoemaker used a huge boot or shoe; a three-foot-high mortar and pestle denoted the apothecary; a pig was the butcher's emblem; a yard-high tooth indicated that the dentist was in his office; and wall-sized eyeglasses assured people that the optician was on duty. Metal, too, was used in trade signs: a sheet-metal shop might have a "tin man" created from parts similar to those on sale, and locksmiths often displayed huge metal locks to promote their products.

As part of ornamental painters' daily work, signs were frequently seen in both urban and rural areas. Hung at right angles to the building, painted signs were decorated on both sides to attract maximum attention. Frequently, one side featured tools of the trade and the other showed examples of finished products, such as furniture for the cabinetmaker, hats for the furrier, and boots for the cobbler. In many instances, the proprietor's name was included as part of the design.

Ornamental painters also decorated tavern signs. Many of the earliest tavern signs displayed English emblems or symbols, such as the crown, the crowned lion, and other heraldic devices. After the Revolution, American patriotic motifs, such as eagles, became popular, and heroes, such as George Washington and General John Stark, were also featured. It was not unusual to see images of the tavern itself, or convivial figures engaged in drinking and playing "gambols" or games on the signs. Animals, such as horses and lions, were frequently seen, reminiscent of English examples, and fraternal symbols, such as the Masonic square and compasses, indicated that the owner was particularly hospitable to members of the order.

Because they were constantly exposed to the elements, painted signs did not survive in large numbers. As examples of the ornamental painters' art, however, they were produced in vast quantities throughout the eighteenth and nineteenth centuries. According to newspaper and city directory listings, many painters known for their portrait work also painted signs. Among many others, these included John S. Blunt, Horace Bundy, Winthrop

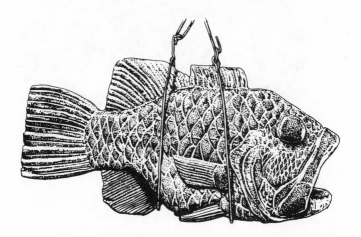

Carved and painted pine fish trade sign.
American, late 19th/early 20th century

Carved and painted pine whale trade sign.
American, late 19th/early 20th century

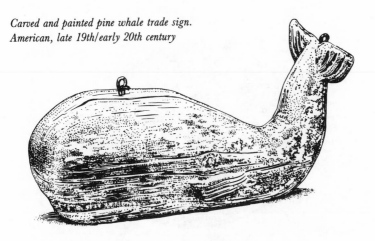

*Painted and gilded
trade sign,
"Wm. S. Bickford & Co.
Boot and Shoe
Manufactory."
Probably New England,
early nineteenth century*

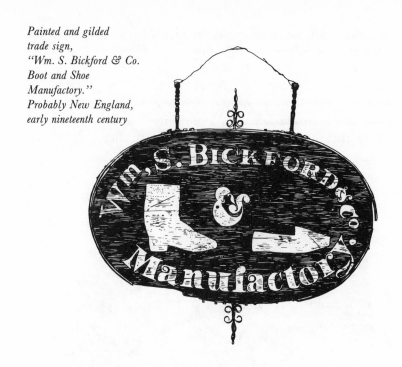

*Pine and wrought-iron
Eastkoy House tavern sign.
1854*

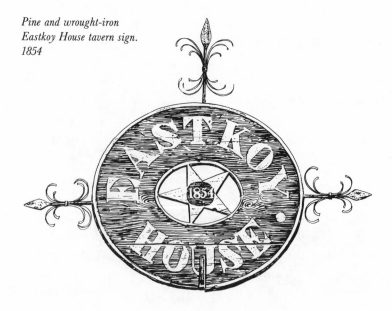

Chandler, M. W. Hopkins, Frederick Kemmelmeyer, Noah North, Ammi Phillips, and Joseph Whiting Stock.

WHAT TO LOOK FOR

CONDITION

Cigar-store Indians and other tobacconist figures are excellent examples of sculptural folk art and can add an interesting dimension to any collection. The most sought-after pieces are in sturdy condition with no appendages missing or major cracks in the body. Ideally, much of the original paint will be intact and the bright colors will still be evident. Because they were often displayed outside, however, most figures available today, if they have not been restored, show evidence of the weather, such as cracks or splits in wood and crackling and darkening of paint. Repainting or repair by amateurs will decrease the value. Paint that appears inside cracks or splits may indicate repainting.

The oversized wooden tooth, the giant boot, and other out-of-scale carvings capture the imagination of many. The best examples should be structurally sound with much of the original paint intact. Like the cigar-store Indians, however, they were used outside and often show similar signs of weathering. If no wear is present, the sign may not be original, and the buyer should use caution. Amateur repairs and repainting diminish the value.

GUIDELINES

The preferential subject varies from collector to collector, but the placid, smiling Indian princesses seem to have a universal appeal. Because of the superb carving and attention to facial features, the figures from the shop of Samuel Robb, which were sometimes signed, have the most personality and are among the finest examples.

Though not easily found, painted tavern and trade signs are

a collecting specialty. The finest pieces are painted on both sides with engaging pictorial motifs and/or decorative lettering. If a specific business and location have been lettered on the sign, research can be done to corroborate its origin. If the sign also displays imaginative painting, its value will be greater than that of other types.

The major folk art museums have collections of carved figures and trade and tavern signs. Old Sturbridge Village, Sturbridge, Massachusetts, and the Connecticut Historical Society own fine examples of signs. The Henry Ford Museum and Greenfield Village, Dearborn, Michigan, and The Newark Museum, Newark, New Jersey, among others, house collections of trade figures.

FURTHER READING

Fried, Frederick. *Artists in Wood.* New York: Clarkson N. Potter, 1970.

Lipman, Jean. *American Folk Art in Wood, Metal, and Stone.* New York: Pantheon, 1948: Dover, 1972.

National Gallery of Art. *An American Sampler: Folk Art from the Shelburne Museum.* Washington, D.C.: National Gallery of Art, 1987.

FIGUREHEADS

Shipping and shipbuilding were a vital American industry throughout colonial days and into the nineteenth century. Wooden sailing ships were constructed in many towns in the Northeast and all along the Atlantic seaboard. One of the most symbolic and decorative components of the ship was the figurehead, located near the bowsprit, at the front of the ship where the sides come together. The earliest American figureheads resembled English examples—usually images of animals or elegant, classical female figures. By the mid-eighteenth century, the va-

riety of American figureheads increased markedly and a national style began to emerge.

The most common motif showed a female figure, larger than life-size (often six or seven feet high), costumed in the garb of the day. Carved of native woods, usually pine, by masters and apprentices, the figures were composed of several parts: the body was made of one piece of wood, with decorative bases, arms, legs, and other projectiles attached by dowels or pegs. Some parts were detachable and could be removed when the ship encountered stormy weather. Most figureheads were painted in bright colors with much attention paid to details in faces and dress. Occasionally, some figureheads were enameled in white paint with decorative elements embellished with gold leaf to reflect the brilliant sunlight. Often, the figure's head looked upward and her dress was shown flowing backward as if blown by the wind, thus exaggerating the silhouette.

Although the lovely female figures were the most popular, a vast variety of subjects were depicted by skilled craftsmen: sea serpents, dolphins, and other aquatic creatures; patriotic and political personages and national heroes such as George Washington and Benjamin Franklin; portraits of the shipowner or his family; literary characters; "Columbia" and "Liberty"; Indians; and eagles. Sternboards, broad boards attached to the backs of ships, were also decoratively carved. Many featured eagles and elaborate curvilinear scrolls and curlicues. Some carvings were bust-length; others varied in size depending on the type and dimensions of the ship. Another type of carved marine decoration showed a cat or lion's

Carved and painted ship figurehead. American, c. 1850

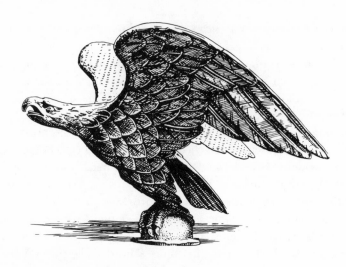

Carved and gilded pine pilot house eagle.
American, probably New England, 19th century

head in a visual "play on words" describing the "cathead," a projection on the bow to which the anchor line was attached.

While the makers of most ship carvings remain anonymous, the work of some craftsmen has been documented through primary sources such as bills of sale, advertisements, or customs house records. In the late eighteenth century, Simon Skillin, Sr. (1716–1778), and his sons were among the nation's leading carvers, working in Boston. The quality of the Skillins' carvings, usually lifelike figures in full-round, earned them a reputation in many mercantile circles. They worked both in small scale—such as bust carvings for tall chests of drawers—and large scale for figureheads. In Salem, Massachusetts, Samuel McIntire (1757–1811), a notable architect and cabinetmaker, also turned his hand to ship carving about 1800. McIntire's figures, however, were not as lifelike as those carved by the Skillins and more closely resembled the stiff caricatures found on some of his monumental pieces of furniture. William Rush (1756–1833) of Philadelphia was one of the best-known carvers and teachers of the trade. His figurehead of George Washington, carved for the ship of the same name, received enormous acclaim in the United States and Lon-

Carved and painted pine lady ship's figurehead.
Probably New England, c. 1860

don. John Haley Bellamy (1836–1914), best known for his eagles and Masonic carvings, decorated naval vessels at the shipyard in Portsmouth, New Hampshire, in the late nineteenth century. Many of Bellamy's earlier carvings, especially of eagles, are more lifelike than his later, more stylized efforts.

When wooden ships were replaced by those made of metal near the end of the nineteenth century, demand for wooden decorations decreased; in 1907 the United States Navy ordered that figureheads be removed from all of its ships, and consequently many were destroyed. Many ship carvers found employment making trade signs, such as cigar-store Indians, or circus and carousel animals.

WHAT TO LOOK FOR

CONDITION

For obvious reasons, figureheads did not survive in great quantities in good condition. Continuously subjected to salt water and wind, many deteriorated. Ideally, figures with minimal damage to the body and most of the original paint would be fine examples. Most, however, exhibit cracks, splits, and crackling of the paint layer. Generally, cracks are acceptable if they do not

disfigure the head or face. Although the figures were painted many times over while in use, amateur repaint will decrease the value. No evidence of wear should be a caution signal, unless the piece has been restored and is complete with accompanying documentation.

Carved and painted portrait bust plaque of ship builder Donald McKay. New England, 19th century

GUIDELINES

Figureheads and marine carvings represent the romance of the sea, and some enthusiasts even find fragments suitable for a collection. Many collectors find the figures of beautiful women, classically posed and wearing flowing gowns, to be among the most valuable examples. History buffs might seek figures of famous people or carvings such as eagles with patriotic associations, which are also choice. Busts of shipbuilders are also collectible, particularly if the image has been identified and can be documented to a specific ship.

To be viewed properly, the figureheads should be hung as high as possible off the floor; keep in mind the space where the figurehead will be displayed prior to making a purchase.

As well as many folk art museums, the leading maritime museums have fine collections of figureheads and related marine objects. These include: the Kendall Whaling Museum, Sharon, Massachusetts; Mystic Seaport, Mystic, Connecticut; and the Peabody Essex Museum, Salem, Massachusetts.

FURTHER READING

Bishop, Robert. *American Folk Sculpture*. New York: E.P. Dutton, 1974.

Brewington, M. V. *Shipcarvers of North America*. New York: Dover, 1972.

Christensen, Erwin O. *The Index of American Design*. New York: Macmillan, in association with the National Gallery of Art, 1950.

Stackpole, Edouard A. *Figureheads and Ship Carvings at Mystic Seaport*. Mystic, Ct.: Marine Historical Association, Inc., 1964.

CAROUSEL FIGURES

For many people, mention of the circus brings back memories of the thrill of the parade, the magic of carnival acts, exotic animals, and peanuts and cotton candy. A closer look reveals an imaginative and unique art form.

The circus originated in ancient Rome, where the populace participated in parades, foot and chariot races, and games to celebrate the consecration of the gods. When the Roman Empire declined, so did the circus. The tradition was revived in spirit in twelfth-century England by traveling fairs, where troupes of acrobats, musicians, magicians, mimes, and animals performed throughout the country. The circus in America began about 1800 when the first exotic animal, an Indian elephant, was brought

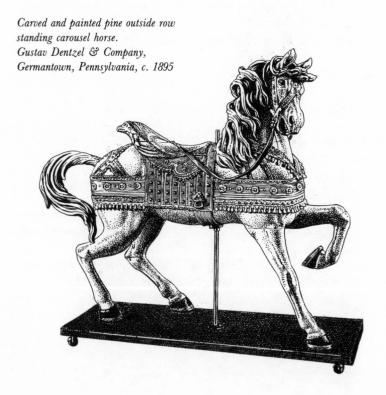

Carved and painted pine outside row standing carousel horse.
Gustav Dentzel & Company,
Germantown, Pennsylvania, c. 1895

to the United States and exhibited as a curiosity. By the 1850s, with the addition of other specialty acts, the circus had developed into a full-scale extravanganza, composed of people, animals, and paraphernalia.

Just as the circus provided live entertainment in the 1850s, the amusement park, long extant in Europe, appeared in the United States. Many were rudimentary resorts and picnic areas used for outings by social and church groups or meetings, such as fraternal lodge encampments. Frequently, games and sports were played and bands provided music. At this time, three amusement parks in New York City were known to have had a carousel, or merry-go-round, in operation daily to the amazement of the public. The carousel had been in use in Europe since the seventeenth century, and the term "merry-go-round" had been in common parlance since the 1720s. The rides were a great attraction at the parks, and interest in them grew quickly. The first American carousel patent was issued in 1850, but it was not until 1860 that production began in earnest.

American carousel figures are distinguishable from their English and European counterparts by their carving. American-made animals are carved with more extensive detail on their right side, the side that faced the viewer. On English and European examples, the left side is more elaborate. The difference was a result of the alternate movements of the carousels: American carousels move counterclockwise, and English and European examples rotate clockwise.

One of the most notable carvers of American carousel figures was Gustav A. Dentzel (1840–1909), who arrived in Philadelphia from Germany in 1860 and opened a cabinetmaking shop. Members of Dentzel's family had carved horses and made carousels in Germany and, to test the public market, Dentzel himself built a small carousel and exhibited it in Philadelphia. Finding great public support, Dentzel changed occupations, calling himself a "steam and horsepower carousel builder" in the mid-1860s. His early carousels consisted of a centerpole from which small benches were suspended; Dentzel pulled the riders around himself. Encouraged, he continued to produce more machines, adding carved horses, giraffes, lions, and tigers, and converted the carousels to

Carved and painted pine carousel goat.
Herschell-Spillman Company,
North Tonawanda, New York, c. 1914

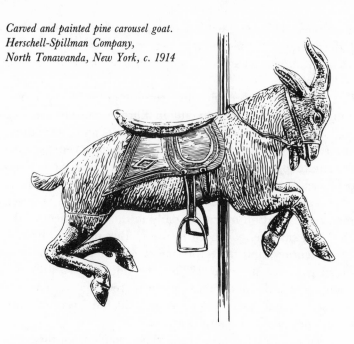

steam power. As the company prospered, Dentzel enlarged the factory and hired more employees.

Of the many carvers employed at the Dentzel shop, some left carvings that were of outstanding quality. John Henry Muller (d. 1890) and, later, his sons (especially Daniel) displayed special talents as carvers, creating regal, spirited horses decorated with intricate motifs. Salvatore Cernigliaro (1879–1974) came to Philadelphia from his native Italy in 1903 and joined Dentzel's company soon after. Cernigliaro had extensive experience as a woodcarver, having made ornaments for villas and palaces in Italy. He created some of the most imaginative and elegantly carved animals in the shop and introduced the figures of cats, bears, and rabbits.

At the turn of the century, production in the Dentzel shop was specialized: carpenters roughed out the figures on the first floor; the carvers were located on the second; and the painters were on the third. Dentzel's menagerie animals included bears, cats, deer, donkeys, giraffes, goats, hippocampuses (a figure that had the

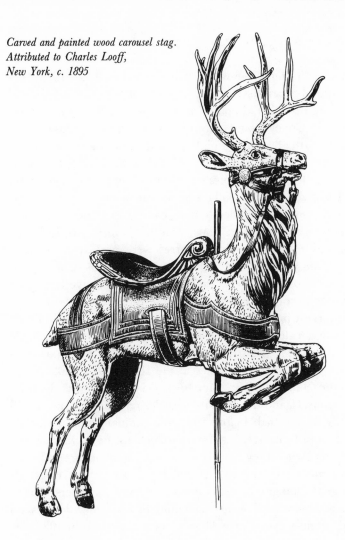

Carved and painted wood carousel stag.
Attributed to Charles Looff,
New York, c. 1895

head of a horse and the tail of a fish), lions, ostriches, pigs, rabbits, roosters, tigers, and zebras. The deer always had real antlers. One of the most charming beasts in the Dentzel zoo was the cat, shown holding its prey—birds, fish, frogs, crabs, or squid—in its mouth. The horses, however, were always the most popular subjects. Painted in both realistic and fanciful colors, some of the horses have real horsehair tails and glass eyes. These classically

carved Dentzel figures are the finest examples of carousel art in America.

Another German immigrant, Charles Looff (1852–1919), became a notable carousel maker. Arriving in America in 1870 and settling in Brooklyn, Looff, who had been a furniture carver, convinced a Coney Island entrepreneur to install a carousel. Looff constructed the frame and platform and carved and painted all of the animals. The enterprise succeeded, and Looff expanded his operation to include other rides and funhouses. Looff often visited the zoo and actually kept exotic animals as pets. His menagerie animals included buffalo, camels, deer, dogs, dragons, elephants, giraffes, goats, lions, panthers, storks, teddy bears, tigers, and zebras. The Looff horses were portrayed in many postures and were covered with carved decorations such as plaid blankets or rosettes. Looff's animals were decorative but stiffer and not as deeply carved as those from the Dentzel shop.

The largest producer of carousels was the Herschell-Spillman Company, located in North Tonawanda, New York, just outside Buffalo. Founder Allan Herschell (1851–1927) had started in business making steam engines in the 1870s and completed his first carousel in 1884. The company specialized in portable, traveling carousels, and the animals were designed so that they could be easily dismantled. Before 1914, the company produced only a few types of menagerie animals—chickens, dogs, zebras, and pigs. Later, when they began to make permanent carousels, the animals included camels, cats, chickens, deer, dogs, frogs, giraffes, goats, kangaroos, lions, mules, ostriches, roosters, storks, tigers, and zebras. The figures could be custom-ordered with carved or glass eyes. After Allan Herschell's death in 1927, the company continued production; it introduced aluminum animals about 1930 and remained in business until 1955.

Solomon Stein (1882–1937) and Harry Goldstein (d. 1945), both born in Russia, began carving carousel horses at a Coney Island company about 1905. Two years later, they went into business for themselves, calling the company "Stein and Goldstein, the Artistic Carousel Manufacturers." Their first carousel, made for a resort in Virginia Beach, caught fire and was completely destroyed. With the construction of their second carousel

in Brockton, Massachusetts, their business boomed. Stein and Goldstein did not make carousel mechanisms themselves, but they carved all of the animals and relied on professional painters to add the coloration. They carved no menagerie animals, and concentrated on horses. Their horses are generally oversized, with aggressive expressions and prominent teeth; they are sometimes decorated with delicately carved flowers and tassels. In the 1920s, the partners diversified and also carved circus, carnival, and barbershop figures before going out of business in the mid-1930s.

Although styles and decoration varied widely from shop to shop, most manufacturers followed a fairly prescribed, deliberate method to create the carousel animals. The carpenters worked from large patterns drawn on paper or cardboard to cut wood planks (usually poplar or basswood), which were then laminated together to form a rough outline of the figure. Before machinery, the carpenters also roughed out the head, legs, and tail; the carver

Carved carousel frog.
Herschell-Spillman Company,
North Tonawanda, New York, c. 1914

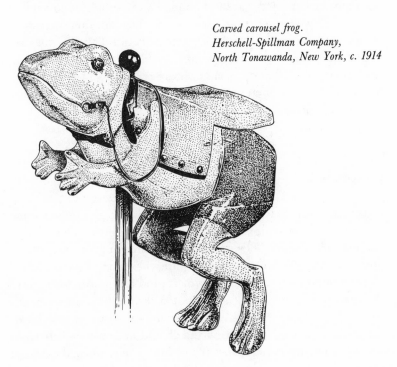

finished the figure, adding details when the parts were joined. To reduce weight, the torso of the animal was hollow.

Although menagerie animals are often whimsical and charming, they were never as popular as the horses. The horses were categorized by their poses: the "standers," usually the largest and most elaborately carved, have three or four feet on the platform and were placed on the outside of the carousel; the "prancers," with two feet on the platform, were found on the inner rows; the "jumpers," placed throughout, have four bent legs, move up and down, and never touch the platform.

WHAT TO LOOK FOR

CONDITION

As might be expected, carousel animals were subjected to heavy use and received much wear, especially in the saddle and stirrups. If not extensive, retouching of paint does not significantly diminish the figure's value. If the varnish is discolored or darkened, professional conservators can generally restore paint to its original brilliance. In fine examples, the figures will be structurally sound with few cracks or splits.

GUIDELINES

Carousel figures have become a collecting specialty. While the traditional horse figures are popular as typical examples of the carvers' art, many collectors prefer the imaginative menagerie animals, whose features can be quite charming. The graceful Dentzel figures are arguably the finest produced in America, and the quality of the carving and painted details surpasses any of those of the competitors. As with figureheads, where and how the large animal is to be displayed should be considered before purchase. Many carousel figures reside in museums; the Shel-

burne Museum and the Heritage Plantation of Sandwich have extensive collections, but many are still available. Unfortunately for history, but fortunately for collectors, even today remaining carousels are being dismantled and the animals are being sold individually, forever separating these masterfully carved beasts.

FURTHER READING

Fried, Frederick. *A Pictorial History of the Carousel*. New York: A.S. Barnes, 1964.

National Gallery of Art. *An American Sampler: Folk Art from the Shelburne Museum*. Washington, D.C.: National Gallery of Art, 1987.

SMALL WOODCARVINGS

Small, whimsical sculptures that were carved by whittlers were used as decorations to adorn the household. Usually produced in rural areas, they often featured barnyard animals and birds— subject matter that could be observed close at hand. The eagle was one of the most popular subjects, as were political heroes— George Washington, Andrew Jackson, and Abraham Lincoln.

Most of the makers were anonymous, but some makers have been identified, including two who worked in Pennsylvania. One of the most skillful carvers was Wilhelm Schimmel (1817–1890), who led a somewhat unorthodox life. Schimmel was born in Germany and came to the United States after the Civil War. Following a traditional method of woodcarving, he chip-carved hundreds of animal figures: lions; dogs; squirrels; birds, such as parrots and roosters; an occasional biblical scene, such as Adam and Eve; and, most notably, eagles. Schimmel wandered around Pennsylvania carving his figures, which he sold for a few pennies or traded to farmers for room and board or to barkeepers for spirits. Using only a jackknife and cheap paints, Schimmel carved

Carved and painted pine rooster.
Wilhelm Schimmel, Carlisle,
Pennsylvania, c. 1875

Left:
Carved and painted pine dog.
Wilhelm Schimmel, Cumberland
Valley, Pennsylvania, c. 1880

Right:
Carved and painted pine parrot.
Wilhelm Schimmel, Cumberland
Valley, Pennsylvania, c. 1880

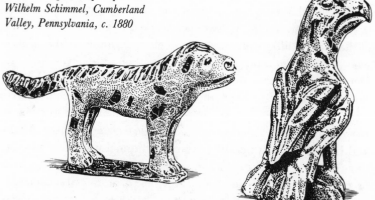

and decorated hundreds of small creatures. Schimmel's eagles, usually made of pine, are chip-carved and vary in size from about eight inches wide to over thirty inches. The eagles are usually shown with their wings spread, strutting boldly, and were painted in brilliant colors—red, pink, green. (Today, however, many appear brown as pigments and varnishes have darkened over the years.) It appears that Schimmel led an unsettled life during the latter part of the nineteenth century. He died, some say of intemperance, in the Carlisle, Pennsylvania, almshouse in 1890.

A student of Schimmel, Aaron Mountz (1873–1949) of Carlisle, Pennsylvania, produced small carvings in a style similar to that of his mentor. Mountz's talents were noticed and encouraged by Schimmel when Mountz was a boy. Their choice of subjects—eagles, domestic animals—was identical, and the figures were carved in the same chip-carved manner. Mountz's figures, however, are stiffer and show more verticality and, unlike Schimmel's, were not painted. Mountz turned to farming when demand for his carvings waned in the early twentieth century. Ironically, because of mental problems and failing health, he, like Schimmel, died in the Carlisle almshouse in 1949.

Some craftsmen, such as Schimmel and Mountz, attempted to sell carvings commercially, but undoubtedly hundreds of others whittled them as a hobby to give as gifts to family and friends.

WHAT TO LOOK FOR

CONDITION

Like other wooden objects, small carvings are susceptible to heat and humidity. Most survive today with cracks and chips. Normal wear is expected and acceptable as long as the cracks are not major and do not appear in critical areas, such as the head. Overall nicks and scratches in the original paint are commonly seen and diminish the value slightly. Major paint loss and amateur repainting decrease the carving's value. Paint seen inside a crack or split usually indicates that the piece has been repainted.

A perfect example will be structurally sound, with no cracks, only minor nicks or dents, and with most of the original paint intact. Qualified conservators can usually remove discolored varnish and return the object to its original, colorful state.

GUIDELINES

Collectors of sculpture prize Schimmel's carvings of eagles because of their beautiful, deep carving and impressive stance. (Some have wing spans of about three feet.) Those that show evidence of original paint are particularly valuable, and the larger versions are generally more expensive. In addition to eagles, Schimmel carved and painted hundreds of roosters, on a smaller scale; examples range from tiny two-inch-high birds to larger versions ten to twelve inches high. They, too, were brightly painted and are sought by collectors, but do not achieve the prices of the eagles. Because Schimmel has been well documented, his carvings are among the most costly examples on the market today.

Carvings done by unidentified artists, composed of groups of figures—such as a farmer and his animals, several men gathering logs, or a maple-sugaring scene—are in demand by collectors because of their complexity and imaginative arrangements. If the maker can be identified, the value increases greatly. Carvings of barnyard animals are always popular with those who seek to build a collection around a single theme; cat and dog fanciers can indulge their passion at a reasonable price by purchasing these relatively inexpensive items.

The Abby Aldrich Rockefeller Folk Art Center, Williamsburg, Virginia, and the Shelburne Museum, Shelburne, Vermont, own numerous Schimmel carvings; most folk art museums have carved objects in their collections.

Group of folk art woodcarvings, "A Farmer, His Family and Animals."
Probably Jones Island, Wisconsin, c. 1890

FURTHER READING

Bishop, Robert. *American Folk Sculpture*. New York: E.P. Dutton, 1974.

Flower, Milton E. *Wilhelm Schimmel and Aaron Mountz, Woodcarvers*. Williamsburg, Virginia: Abby Aldrich Rockefeller Folk Art Collection, 1965.

Sisum, Deborah, and Leslie Hasker. "American Folk Sculpture at the Shelburne Museum." *The Magazine Antiques*, September 1983.

DECOYS

Over the past twenty years, beautifully carved and painted wildfowl decoys have been considered superb examples of American folk sculpture. The elegant, long-necked geese and swans, graceful shore birds, and compact ruddy ducks have captured the interest of many collectors.

Historians and archeologists have determined that the first bird decoys date from at least a thousand years ago and were made from bunches of bound reeds and feathers to resemble reddish-brown, white, and gray canvasback ducks. Early European settlers in the Northeast used similar devices to lure fowl for food, but the reed decoys were fragile and impractical for use. By the late 1700s, settlers began to carve decoys from woods such as cedar and white pine to make a lure that could withstand heavy use. By the early nineteenth century, carvers made two types of wooden decoys: floating lures, made from a single piece of wood, or from pieces joined with nails or dowels, to represent the swimming birds—ducks, geese, gulls, and swans; and "stickups," full-bodied birds that were mounted on poles and placed in beach sand to imitate wading shore birds such as curlews, peeps, plovers, and yellowlegs. Simpler "stickups" called "flatties" were silhouettes used to attract many varieties of birds. By the 1840s, hand-carvers, working at home or in small shops using primitive hand tools, made elaborately decorated birds to sim-

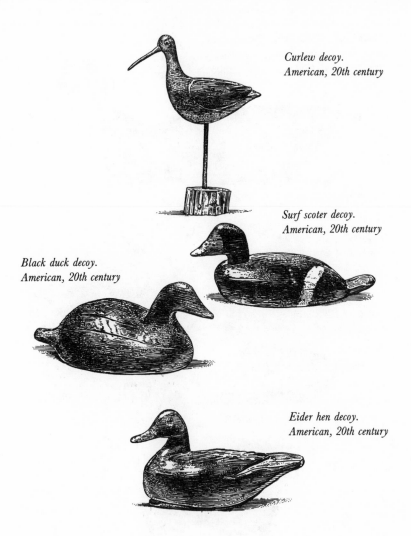

Curlew decoy.
American, 20th century

Surf scoter decoy.
American, 20th century

Black duck decoy.
American, 20th century

Eider hen decoy.
American, 20th century

ulate the individual species that migrated along the major American flyways: the Atlantic and Pacific flyways, along both coasts; the central flyway across the Midwest from Canada to Mexico; and the Mississippi flyway that runs from Ontario to the Gulf of Mexico. Throughout the mid-to-late nineteenth century, the number of amateur hunters, as well as the professional or market

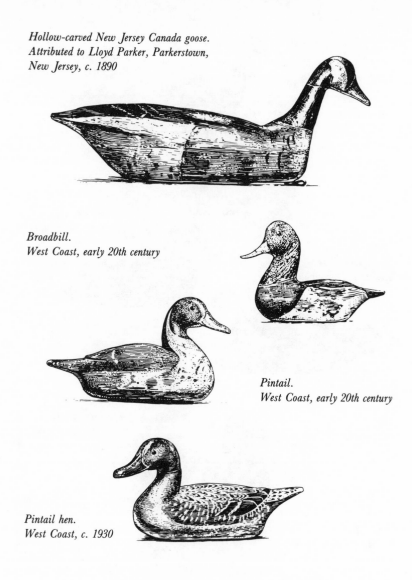

Hollow-carved New Jersey Canada goose.
Attributed to Lloyd Parker, Parkerstown,
New Jersey, c. 1890

Broadbill.
West Coast, early 20th century

Pintail.
West Coast, early 20th century

Pintail hen.
West Coast, c. 1930

hunters who supplied birds commercially for meat and plumage, increased dramatically. So great was the demand for decoys that several factories, such as the Mason Factory in Detroit and the H. A. Stevens Factory in Weedsport, New York, began to produce

and market decoys through mail order catalogues. Also during this period, wealthy sportsmen discovered duck hunting and added it to their list of "socially correct" pastimes, thus increasing the need for decoys.

By the beginning of the twentieth century, because of the enormous hunts, the wildfowl population had decreased dramatically, and several species, such as the Labrador duck, had become extinct. (Contemporary records reveal that it was not uncommon for some hunters to shoot hundreds of birds in one day.) The situation came to the notice of preservationists and, amid their outcry, Congress passed the Federal Migratory Bird Act in 1913, which prohibited spring shooting and shipment of waterfowl for sale; later legislation reinforced earlier protective measures. As a result, during the 1920s the market gunners had no business and factories closed as the demand for decoys diminished. The majority of decoys made after the 1920s was produced by individual craftsmen who created them for sportsmen or as decorative sculptures. Working decoys were mass-produced from plastics in the late 1940s and, by the 1960s, wooden decoys were outmoded.

The work of several well-documented makers can illustrate variations among many types of decoys. Anthony Elmer Crowell (1862–1952) of East Harwich, Massachusetts, was one of the most notable. Having hunted as a boy, Crowell became a market gunner and managed a hunting camp during the early years of the twentieth century. Specialists generally acknowledge that Crowell's best decoys were his earliest: he used white pine for the one-piece bodies, carved primary and tail feathers with crossed wing tips, finished the head and breast with a rasp, and painted the birds in an extremely realistic manner. Crowell carved shore birds, ducks, brant, and geese, and about 1915 began to brand almost all of the examples with an oval; later, he used a rectangular brand to mark the birds. Throughout the years, Crowell's son worked with him to produce the decoys; it has been suggested that the rectangular brand may identify the son's work, too. Eventually, Crowell began to make fewer working decoys and produced more purely decorative examples. Many of these were miniatures that he made by the thousands—ducks and geese, shore birds and songbirds.

Pair of pintails.
Attributed to "Fresh Air" Dick Janson,
West Coast, c. 1930

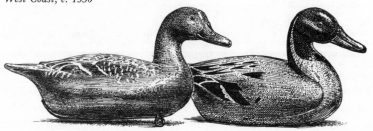

Among the early carvers, Albert Laing (1811–1886) stands out as an innovative leader. Coming to Stratford, Connecticut, from his native New Jersey in 1865, Laing developed two significant decoy improvements: he was the first to use copper nails that would not rust to fasten the body together, and he made changes in the design of the decoy's breast so the bird would not be submerged under flowing ice. Laing was best known for his black ducks and greater scaup, but also carved scoters, goldeneyes, and, more rarely, old squaw. Some displayed his LAING brand on the bottom.

Harry V. Shourds (1861–1920) was one of the most accomplished and prolific of the New Jersey carvers. For forty years, Shourds carved and painted scaup, black ducks, brant, Canada geese, goldeneyes, mergansers, redheads, and buffleheads, as well as shore birds of several varieties. Famous for their excellent, realistic carving and painting, Shourds's decoys were purchased by hunters from many different areas of the country.

In Chincoteague, Virginia, Ira Hudson (1876–1949) carved hundreds of decoys yearly from about 1900 until his death. Unlike most other carvers, Hudson made decoys in several grades, varying from a plain, simply painted model to those with realistically detailed paint.

In Illinois, along the Mississippi flyway, Robert A. Elliston (1849–1915) is known as the Midwest's first professional decoy maker. Elliston carved mallards, teal, scaup, pintails, canvasbacks, redheads, ring-necked ducks, and Canada geese; recent

research has revealed that Elliston's wife, Catherine, painted all of the birds. Elliston's hollow decoys display delicately combed paint patterns and glass eyes that were placed high on the bird's head.

Only recently have decoys become a folk art collecting interest. The earliest documented collector, New York City architect Joel D. Barber (1877–1952), became fascinated with decoys he found near his Long Island home about 1918. During the 1920s, Barber traveled along the eastern seacoast gathering more examples and recording the "old-timers'" stories of the birds' origins. For thirty years, his *Wild Fowl Decoys,* published in 1934, was the only book on the subject. Although the Shelburne Museum had acquired Barber's collection privately in 1952, the first significant public sale of decoys did not take place until 1973. Over the past twenty years, interest in the birds has grown continuously, prices have skyrocketed, and today decoys are recognized as one of America's finest indigenous folk arts. Between 1850 and 1950, literally hundreds of thousands of decoys were made in America, so virtually every collecting preference can be satisfied.

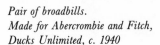

Pair of broadbills.
Made for Abercrombie and Fitch,
Ducks Unlimited, c. 1940

WHAT TO LOOK FOR

CONDITION

For protection and versimilitude, most decoys were always painted. The collector should examine the bird to determine how much original paint remains; many decoys were repainted after years of use, and this generally decreases their value. However, original paint with discernible areas of wear, such as areas of abrasion and overall nicks or small chips, is acceptable and helps to document the bird's authenticity. The smell of paint or raw wood usually indicates that the surface has been altered. The body of the bird was far sturdier than the head, neck, and tail; minor restorations in these areas do not necessarily diminish the value. Some radiologists will X-ray decoys for a nominal fee; the X-ray will reveal any interior cracks or mended repairs.

GUIDELINES

Style considerations are of importance when evaluating decoys. Does the form capture the essence of the species? Because they were made to be viewed from a distance, the overall silhouette is the foremost first impression. (The would-be collector might do well to study ornithology before making a serious purchase; many regional variations in the decoys of the various flyways have more to do with the species of birds than the ingenuity of the carvers.) Birds that are shown in varying positions, such as preening, with their heads back and bills touching their feathers, or sleeping, with heads down or under a wing, are among the choicest examples of the carvers' art. The elegant swan and Canada geese decoys are among the finest examples of American sculptural art and are coveted by collectors. The decoys made at factories such as Mason or Stevens are not the usual, undistinguished, mass-produced varieties; although the bodies were turned on a lathe, the heads and painting were done by hand.

As semi-hand-made products, they are collectible and sometimes display finer paint than those that were individually crafted.

Researching decoys and tracing their provenance is much easier today than it was twenty years ago. Numerous regional studies as well as dozens of pictorial books are widely available and are extremely helpful when beginning to learn about decoys. The Shelburne Museum in Vermont has the most comprehensive decoy collection in the world, including some 850 working examples and 200 miniature and decorative carvings. The Museums at Stony Brook, on Long Island, own a fine collection of decoys made by the island's well-known makers. The Peabody Essex Museum in Salem, Massachusetts, houses an outstanding collection of Massachusetts decoys, and the Ward Foundation Wildfowl Art Museum in Salisbury, Maryland, features carvings from Maryland and the eastern shore of Virginia.

FURTHER READING

Engers, Joe, ed. *The Great Book of Wildfowl Decoys*. San Diego: Thunder Bay/Abbeville, 1990.

Mackey, William F., Jr. *American Bird Decoys*. New York: E. P. Dutton, 1965.

WHAT ARE FURNITURE AND DECORATIVE OBJECTS?

DECORATED FURNITURE

When the house, sign, and fancy painter advertised his skills, one of the most frequently offered was that of furniture ornamentation. In addition to painting portraits, the painter decorated furniture for an upwardly mobile middle class who sought to furnish their homes in as fashionable a manner as possible. By the mid-eighteenth century, furniture-making was an important industry in cities such as Philadelphia, New York, Boston, and Baltimore, with craftsmen producing goods that were available to the wealthy. Rural ornamental painters created furniture that was painted and grained in imitation of the expensive furnishings seen in the urban style centers. Using a variety of techniques, crafts-men turned simple, utilitarian chests, storage boxes, chairs, cupboards, desks, and tables made of humble woods such as pine or basswood into visual masterpieces.

Painted furniture originating in Europe was first seen in America in the seventeenth century. Much of the turned and joined oak furniture made in the 1680s and 1690s was painted or stained for protection and often featured stylized floral or geometric motifs in conjunction with carving. During the eighteenth century, particularly in Guilford and Saybrook, Connecticut, furniture was decorated with floral designs as well as borders and crowns, reminiscent of English decoration. In New York State, the Dutch influence was seen in the decoration of large storage cupboards called *kas* that featured baroque-type designs of painted fruit, such as pears, apples, and pomegranates on the front and sides. Furniture painted by the Pennsylvania Germans often displayed hearts, birds, unicorns, and angels common to their northern European heritage. (See Chapter 7.) Furniture painted in polychrome by students attending private academies and seminaries shares with needlework and theorem painting such design motifs as classical figure scenes and landscapes copied from prints, vases of flowers, garlands, and ribbons. (See Chapter 4.)

By the early nineteenth century, decoration had reached its zenith, and dramatic, expansive painted designs became the most interesting aspect of vernacular furniture. The major types of decoration are seen on furniture: graining, a type of painting that simulates the look of highly figured woods such as mahogany or rosewood through the use of combs or brushes; freehand painting, where paint is applied in any number of decorative patterns using brushes, fingers, feathers, crinkled paper, or putty; and stenciling, where the artist has used stencils and gold or bronze powders to imitate high-style metal appliqués or to create his own designs. Frequently, the techniques are combined on a single piece. In graining, a light-color paint was usually applied to cover the entire surface and allowed to dry; then a darker pigment was brushed over the piece and, using brushes, combs, or rollers, removed in specific areas to create a pattern. Black-over-red was the most commonly seen combination used to simulate rosewood, but browns-over-ochres or beige was also used extensively. Freehand painting, because it usually followed no set pattern, was far more imaginative and often included elaborate swirls, borders, swags, geometrics, and, on more exuberant examples, figures or

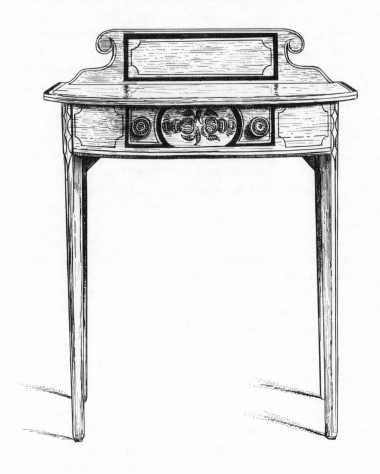

Paint-decorated pine bow-front dressing table.
New England, c. 1825

trees. The colors varied at the discretion of the decorator, but red, yellow, brown, orange, and less frequently blue and green were popular choices. Stenciled designs in gilt usually were placed on the chair splat, or rung, and often featured a bowl or basket of fruit, similar to the designs seen in theorem painting. Depending on the skill of the artist, the stenciled patterns could be simple, such as a single rosette, or complicated, showing the use

of several different stencils. Over a base coat of paint, a binder such as varnish was applied to the piece; when nearly dry, the artist placed a stencil on the surface and brushed on gold or bronze powders with a pad or "pounce." A final coat of protective varnish ensured that the design would be lasting. Other decoration, such as striping or banding, usually done freehand, highlighted the contours of the piece and enhanced the total design.

The artist decorated almost every form of "country" furniture. With their broad surfaces, storage boxes and chests of drawers were suitable for the fanciful swirls, wavy lines, and dots favored by many decorators; tables, stands, clock cases, beds, and chairs were also embellished with eye-catching paints.

One of America's most famous chairmakers, Lambert Hitchcock (1795–1852), made and marketed decorated chairs beginning in the 1820s. Settling in what is now Riverton (formerly called Hitchcocksville), Connecticut, in 1818, Hitchcock produced a distinctive type of chair, made in several shapes, characterized by bronze- and gold-stenciled designs on a dark, usually black, ground. Having met with great success earlier, Hitchcock opened a factory and between 1826 and 1829 produced chairs that were marked "L. Hitchcock. Hitchcocks-ville. Conn. Warranted." The stylish yet inexpensive chairs met with great approval and were copied widely by other makers.

Rufus Holmes and Samuel Roberts (in partnership from about 1835 until 1839) made chairs strikingly similar to Hitchcock's, although marked with their own names, in nearby Colebrook, Connecticut; and Walter Corey copied the designs at his furniture manufactory in Portland, Maine, from about 1836 until 1866. Many other anonymous decorators experimented with the style, and chairs of this type were among the most frequently pictured props in folk portraits of the 1830s and 1840s.

An interesting group of at least eight chests painted during the 1820s in distinctive, swirled designs with simulations of string inlay and banding has long been associated with Thomas Matteson (or Mattison) of Shaftsbury, Vermont. The Matteson name, a common one in the area, appears on four individual pieces of furniture, but extensive investigation by researchers using pri-

Paint-decorated miniature pine footstool.
Landis Valley, Pennsylvania,
early 19th century

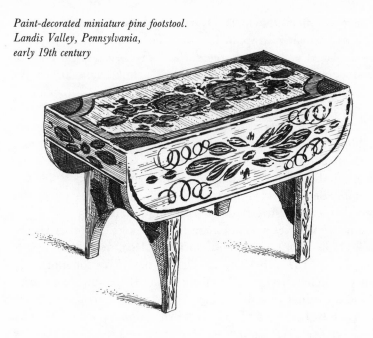

mary sources has failed to identify a Matteson who worked as a furniture-maker or decorator. Current research of Vermont cabinetmaking has revealed, however, that this group of painted chests is conclusively linked to Shaftsbury based on construction methods and high-style, although rural, prototypes that may have been used as models for the painted decoration. As examples of a regional style of furniture, the so-called Matteson group may prove to be helpful for further research into paint-decorated furnishings.

Attempts by scholars to identify particular styles of decorated furniture made in specific areas have been rather unsuccessful. Painted furniture in relatively large numbers, however, has been documented to northern New England, especially Maine, and, through advertisements and other primary sources, compilers have amassed a "paper trail" of numerous decorators. Some artists better known for their portrait work—Erastus Salisbury Field, M. W. Hopkins, Noah North, and Rufus Porter, among others—also decorated furniture and picture frames.

Sponge-painted and freehand-decorated pine box.
New England, 19th century

Grain-painted document box.
Probably New England, mid-19th century

WHAT TO LOOK FOR

CONDITION

Because the painted surface is the most fragile component of decorated furniture, little has survived without some wear on the surface. Minor overall nicks and scratches are expected and are usually a good sign of authenticity. Evidence of wear on handles or on lids and drawers is also a good indication that the piece retains its original paint. While wood and construction details are secondary to the ornamented surface, ideally the furniture should be structurally sound with no loose joints or missing hardware. The better pieces will show evidence of a skilled cabinetmaker: dovetailed joints, planed surfaces, and components that fit together securely.

GUIDELINES

Generally, the more valuable pieces display the eye-dazzling swirls, graining, stenciling, sponge or comb work, striping, or banding as decoration "for its own sake." Choice examples show many techniques combined, thus illustrating the versatility of the maker. Large case pieces, chests of drawers, lift-top chests, and sets of chairs are among the best examples. Many pieces of furniture were grained in deep browns, or brown and ochre, but objects painted in bright colors—reds, oranges, yellows—are more prized by collectors. Some furniture was decorated with floral or other pictorial decoration; it is generally not as popular as the imaginative grained, patterned examples.

It is extremely difficult to find painted furniture that was marked or signed by the maker; any signed piece is a rarity and would be an important addition to a collection.

Because the compositions of paints and varnishes varied widely, some painted surfaces may have darkened or may appear dingy or coated with dirt. A furniture conservator can frequently remove the soil, bringing the surface back to its original condition.

Most folk art museums contain representative examples of dec-
orated furniture. The Hitchcock Museum, Riverton, Connecticut,
houses a particularly fine collection.

FURTHER READING

Churchill, Edwin A. *Simple Forms and Vivid Colors: An Exhibition
of Maine Painted Furniture, 1800–1850*. Augusta: Maine State Mu-
seum, 1983.
Cullity, Brian. *Plain and Fancy New England Painted Furniture*. Hyan-
nis, Mass.: Heritage Plantation of Sandwich, 1987.
Fales, Dean A., Jr. *American Painted Furniture 1660–1880*. New York:
E.P. Dutton, 1972.
Kenney, John Tarrant. *The Hitchcock Chair*. New York: Clarkson
N. Potter, 1971.
Lea, Zilla Rider, ed. *The Ornamented Chair: Its Development in Amer-
ica (1700–1890)*. Rutland, Vt.: Charles E. Tuttle, 1960.
Little, Nina Fletcher. *Neat and Tidy*. New York: E.P. Dutton, 1980.

OVERMANTEL
PAINTINGS
AND FIREBOARDS

A significant part of the work of the fancy painter included the
decoration of houses. Walls were stenciled in imitation of expen-
sive, imported wallcoverings and plain paneling was grained to
simulate high-style woods. The overmantel, a panel located just
above the fireplace, was often decorated with landscape scenes.
The fireboard, a wooden panel that closed off the fireplace during
the warmer months, was painted in a variety of appealing ways.

Even in rural areas, the parlor was considered the most formal
room in the house and often contained wood paneling that could
be painted or grained. The overmantel was frequently embel-

lished with a landscape or house scene, a custom that originated in England. Landscapes were the most commonly seen subjects and generally included views of buildings, human and animal figures, farms, trees, and fields, some recognizable, some not. (The overmantel view of the Van Bergen farm in Leeds, New York, done about 1732, may be the first American landscape painting. Attributed to artist John Heaton [active 1730–45], it includes buildings, figures, carriages, animals, and mountains in the background.) Some overmantels done between the late eighteenth century and the mid-nineteenth show scenes based on contemporary prints.

Fireboards were constructed of wide wooden boards attached together on the reverse by battens, and propped up in the fireplace opening by feet or other supports. Many were painted by room decorators in a manner similar to overmantels. One of the most popular designs included a central vase of flowers that was sometimes surrounded by decoration simulating Dutch tiles. Some interesting *trompe l'oeil* ("fool the eye") examples actually depicted the fireplace interior, including painted brickwork, andirons, and other accessories. Some boards showed local scenes and others, like overmantels, depicted fanciful landscapes, probably copied from print sources. Fireboards continued in use until wood-burning stoves replaced the fireplace as a heat source in the mid-nineteenth century.

Like much decorative painting, most overmantel and fireboard painting was done anonymously. Some identified pieces, however, have been documented to artists better known for their portraiture or other decorative work. Michele Felice Cornè (1752–1845) was brought to America by the Derbys, a wealthy shipping family of Salem, Massachusetts, in 1799. Cornè came to this country from Italy where he had been successful as an ornamental painter in Naples. While in Salem, Boston, and Newport, he painted overmantels, ship portraits, wall scenes, and fireboards. Rufus Porter (1792–1884), a well-known artist, decorated walls from Maine to Virginia from about 1816 until the mid-1840s. Working with him were several members of his family, including his nephew, Jonathan D. Poor (d. 1845), who also

worked on his own as a decorator. Porter is particularly remembered for his wall murals incorporating real and imaginary scenes and fantastic landscape details. Connecticut portraitist Winthrop Chandler (1747–1790) also painted overmantels. Chandler's overmantels often show landscape scenes. One example, done in a house in South Woodstock, Connecticut, features a shelf of books, a *trompe l'oeil* motif he used in some of his portraits.

WHAT TO LOOK FOR

CONDITION

Many overmantels and fireboards did not survive in good condition because of extensive use and the fact that paint on wood is generally unstable. The finer examples will have no major cracks or splits in the wood and will be structurally sound; ideally, the paint layer should be intact, but many show overall nicks and scratches that do not necessarily reduce the value.

GUIDELINES

Overmantels and fireboards appeal to collectors who treasure them both as folk painting and as architectural ornaments. Those that display houses, farms, and landscapes with figures or are site-specific are particularly important as cultural documents. Pictorials, such as vases of flowers or *trompe l'oeil* examples are particularly favored for their decorative effect. The pictorials are more commonly seen than the landscapes, but both are valuable; the selection relies entirely on personal taste. Signed examples are exceedingly rare; fireboards and wall decoration by (or attributable to) Rufus Porter or his associate, Jonathan D. Poor, two of the very few who signed some of their work, rank in the highest category.

Most folk art museums exhibit some type of architectural decoration. Many restorations such as the Genesee Country Museum, Mumford, New York; Old Sturbridge Village, Sturbridge, Massachusetts; and the Farmers' Museum, Cooperstown, New York, among many others, display original decorative painting in many of their buildings.

FURTHER READING

Hewes, Lauren B. *A Permanently Beautiful Appearance: The Nineteenth-Century Fashion for Painted Landscape Murals.* Shelburne, Vt.: Shelburne Museum, 1992.

Lipman, Jean. *Rufus Porter: Yankee Pioneer.* New York: Clarkson N. Potter, 1968.

Little, Nina Fletcher. *American Decorative Wall Painting, 1700–1851.* New York: E.P. Dutton, 1972.

———. *Country Arts in Early American Homes.* New York: E.P. Dutton, 1975.

REDWARE AND STONEWARE

Evidence has been found that earthenwares were produced in America almost from the beginning of the settlement of the New World. Many communities are known to have had kilns in operation as early as the late 1620s. Natural, glacial clay is abundant throughout the Northeast, and the demand for simple ceramics, such as bricks, was great as towns developed. Settlers from England, where brickmaking had been a trade since medieval times, continued the tradition in America. Vessels for food preparation and storage were vital parts of any household, and utilitarian wares were produced by local potters to fill the needs of a pop-

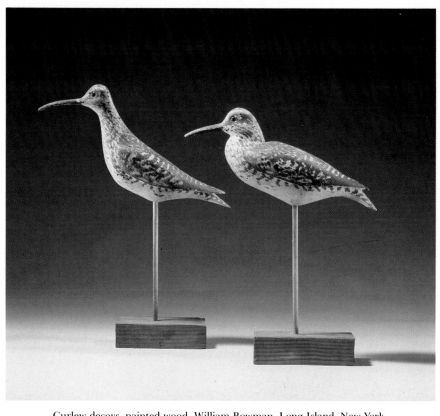

Curlew decoys, painted wood. William Bowman, Long Island, New York, c. 1870–80. Courtesy of Sotheby's

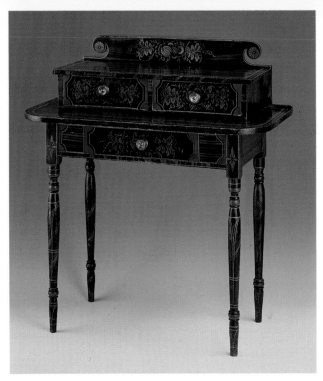

Paint-decorated dressing table. Possibly Maine, c. 1830. Abby Aldrich Rockefeller Folk Art Center, Williamsburg, Virginia

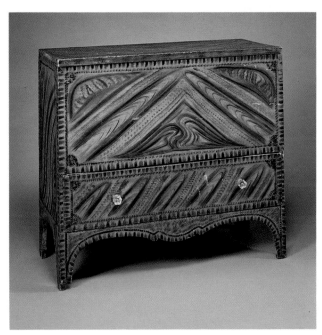

Paint-decorated, single-drawer chest. South Shaftsbury, Vermont, area, c. 1824. Courtesy of Sotheby's

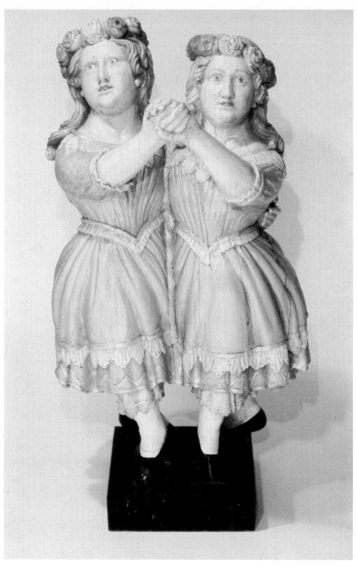

Figurehead, "Twin Sisters," painted wood. C. 1840. Mystic Seaport, Mystic, Connecticut

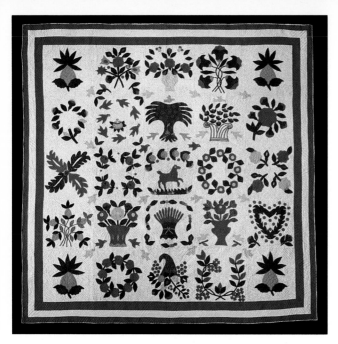

Album quilt, cotton. Baltimore, Maryland, area, c. 1840–50.
Shelburne Museum, Shelburne, Vermont
(Photograph by Ken Burris)

"Feathered Star with Oak Leaf" quilt, cotton. Mary A. Purdy,
Springfield Center, New York, 1869. Shelburne Museum, Shelburne,
Vermont (Photograph by Ken Burris)

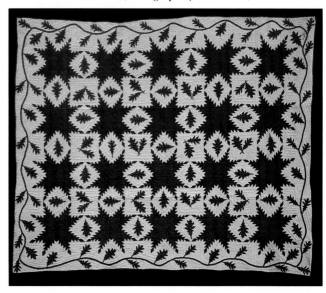

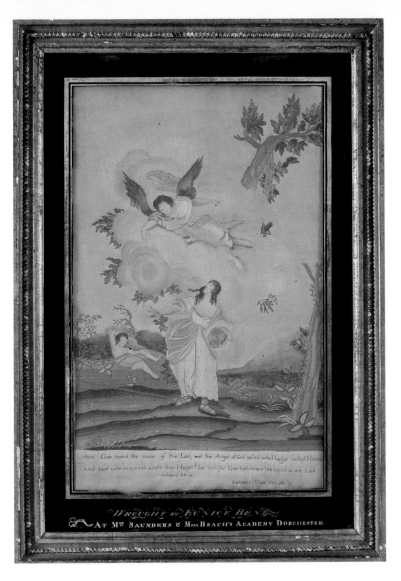

Embroidered picture, "Hagar and the Angel of God," painted and embroidered silk. Eunice Bent, Mrs. Saunders' & Miss Beach's Academy, Dorchester, Massachusetts, c. 1806. Courtesy of Sotheby's

Overmantel painting, oil on pine panel. Winthrop Chandler, Scotland,
Connecticut, c. 1772. Courtesy of Sotheby's

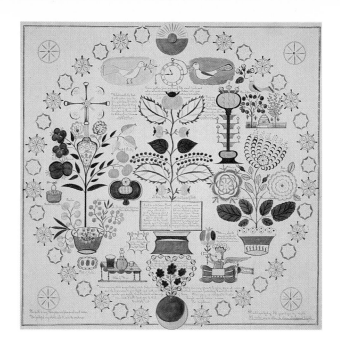

Shaker spirit drawing, "A Present from Mother Ann to Mary H.,"
watercolor and ink on paper. Attributed to Polly Ann (Jane) Reed, New
Lebanon, New York, 1848. Abby Aldrich Rockefeller Folk Art Center,
Williamsburg, Virginia

Pennsylvania German paint-decorated two-drawer blanket chest. Probably Berks
County, Pennsylvania, 1773. Courtesy of Sotheby's

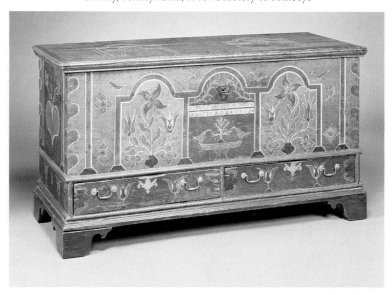

View of Poestenkill, New York; oil on wood panel. Joseph H. Hidley, 1862.
New York State Historical Association, Cooperstown

View of Freeport, Maine; oil on canvas. G. J. Griffin, 1886. Courtesy of Sotheby's

ulation unwilling to pay steep prices for ceramics imported from England and Europe.

REDWARE

The word "redware" is used to describe ceramics made from a type of clay that turns red when it is fired. The clay is dug from the ground; processed, sometimes by adding water; and stored until needed. Almost all utilitarian pieces were thrown on the potter's wheel and shaped by hand into the desired form. Archeological evidence has shown that open pots were the most common form, followed by pans, bowls, cups, mugs, pitchers, chamberpots, and a selection of jugs, teapots, flowerpots, churns, coolers, tiles, strainers, and bedpans. After the clay was formed the objects were allowed to dry. The vessels were then placed in a kiln where they were fired for anywhere from thirty to seventy-two hours. After removal from the kiln, to make them more durable, the objects were glazed, usually with a transparent, lead-based compound. The glazes could be colored by the addition of manganese that created a black or brown color, or powdered metal, such as oxides from brass, that created green.

While the glazes sometimes added color to plain wares, the most commonly used decoration was made by applying slip, or liquid clay, prior to firing. The slip was trailed onto the vessel by using an earthenware cup also called a "slip cup" with an opening for filling on the top and a quill projecting from the front, and could be manipulated with implements to create special designs. Wavy lines, curlicues, and banding are frequently seen; sometimes the slip was "combed" to achieve a striped effect. Often done in a yellow or whitish color, the slip decoration added visual interest to the simple forms. More imaginative potters added dates, initials, or verses to the ceramics; examples reading "Apple Pie," "For a Good Boy," "To Your Health," and "Industry and Temperance" were popular, and some were decorated specifically as presentation pieces.

Top: Slip-decorated redware loaf dish. Pennsylvania, 19th century

Bottom: Glazed redware and slip-decorated bread tray. Pennsylvania, early 19th century

Although the majority of redware is not marked, scholars have identified several potteries that produced redware:

Isaac Parker	Charlestown, Mass.	1713
John Runey	Charlestown, Mass.	1742
Jonathan Kettle	Peabody, Mass.	1730s
John Pierce	Litchfield, Conn.	c. 1753
Jesse Wadhams	Litchfield, Conn.	c. 1753
Abraham Hews	Weston, Mass.	1769
Hervey Brooks	Goshen, Conn.	1802–73

Stoneware

Of the many varieties of ceramics made in this country, stoneware was among the most practical because it was hard and dense and did not require a lead glaze to make it watertight. Unlike redware, which was made from universally found clays, stoneware was

Left: Slip-decorated redware charger, "Temperance/Health/Wealth." 19th century

Right: Slip-decorated redware plate, "Lafayette." Pennsylvania, 19th century

created from clays found mainly in New Jersey and Long Island. It is no surprise that the most successful stoneware potteries were located near rivers or waterways, such as the Erie Canal, where the clay could be shipped easily.

The method of throwing the pot was the same as in redware production. Once the clay had been prepared, the potter threw it on the wheel and formed it into a vessel, usually a crock, jar, or pitcher; a finisher then smoothed the surface with a wet cloth to remove imperfections. At this point, handles, much resembling a clay rope, were applied, and the piece was ready to be stamped with the pottery name and dried. The entire operation—from lump clay to vessel—lasted about five minutes. Placed in a kiln with anywhere from a few hundred to a thousand other pieces, depending on the pottery's production, the vessel was fired at the high temperature of 2,200–2,300 degrees F. When the heat was constant, workers opened the kiln and poured rock salt on the fire; the salt vaporized and combined with the silica in the clay to form a hard surface. The entire process took six to eight days. Perhaps the most interesting aspect of stoneware is its decoration, incised or applied just before the piece was fired. Three basic techniques were used: the wet clay could be impressed with a stamp for identification or decoration; the slightly dry clay could be incised with a stylus or other instrument; or decoration could be brushed or slip-cupped onto the clay prior to placing the vessel in the kiln. Stamping was essentially a mechanical process by which the potters impressed the name of the pottery or—in the case of a commissioned piece—the name of the owner into the wet clay. The process of creating a design by incising was not profitable because it was too time-consuming; great care was required in making the lines and cuts into the clay, and, depending on the talents of the worker, the results varied dramatically. Sometimes incising was used in combination with stamping, and the designs were detailed with a thin blue glaze made of cobalt oxide, a stable compound that could easily withstand the intense heat of the kiln. While incised decoration was aesthetically pleasing, the technique disappeared in the 1830s and 1840s as pottery production increased markedly. By 1850 the demand for stoneware was enormous, and individual potteries

adopted decorating techniques that could be done quickly to enhance production. Using a brush or a slip cup such as those used in redware production, the worker added the glaze to the cup and traced a design on the vessel. The decoration varied, of course, with the skill and imagination of the maker.

Designs varied from pottery to pottery but some motifs were commonly used by many workers. Because they could be drawn quickly, flowers, leaves, and vines were staple decoration. The stylized motifs appealed to many customers and made the wares extremely salable. Birds were a common design, but because they were not easy to draw they, like the florals, were generally stylized or completely imaginary. Some birds were depicted perched on branches; domestic birds, such as chickens, were often shown pecking for corn. Animals were favorites of a populace that was

Cobalt-blue-decorated salt-glazed stoneware covered jar.
J.Norton & Company, Bennington, Vermont, c. 1860

Cobalt-blue-decorated salt-glazed stoneware jug.
Satterlee & Mory, Fort Edward, New York, c. 1865

still largely rural; the potters featured deer, horses, cows, pigs, and, occasionally, a rarity, such as a lion, that would have been seen in the circus. Like many other craftsmen of the day, the potters used patriotic symbols in their designs. Eagles, flags, and laurel wreaths were all emblems of the maker's sense of nationalism. Human figures and scenes are rare in stoneware designs but they are some of the most engaging. Fraternal symbols, such as the Masonic square and compasses, or the entwined rings of the International Order of Odd Fellows, appeared occasionally and were sometimes used on presentation pieces.

Unfortunately, the majority of stoneware pieces was not marked by their decorators, but many potteries have been documented. Stoneware was made in America at least as early as the 1720s, but production did not increase significantly until after the Revolution, when higher duties on stoneware from England and Germany made local potteries more competitive. Some of the identified potteries include:

Thomas Commeraw	New York City	1797–c. 1819
Paul Cushman	Albany, N.Y.	c. 1810
Israel Seymour	Troy, N.Y.	1809–52
Justin Campbell	Utica, N.Y.	1820s
Thomas Morgan	Baltimore, Md.	c. 1810–37
Sylvester Blair	Cortland, N.Y.	1829–35
John Bell Pottery	Waynesboro, Pa.	1833–81
W.H. Farrer & Co.	Geddes, N.Y.	1841
W. Roberts	Binghamton, N.Y.	1850s
Lyons Pottery	Lyons, N.Y.	1850s
J. &. E. Norton	Bennington, Vt.	1850s
Fort Edward Pottery	Fort Edward, N.Y.	1850s
White's Utica Pottery	Utica, N.Y.	1860s
A.K. Ballard	Burlington, Vt.	1860s

As it did with many other crafts, machinery replaced the stoneware makers in the late nineteenth century. By that time, the clay itself was shaped in a two- or four-piece mold, and pottery ceased to be an expensive, hand-made object.

WHAT TO LOOK FOR

CONDITION

Ceramic objects are fragile and often suffer damage through normal use. The best pieces will have no major cracks or chips and the glaze will be intact. Minor chipping and rubbed areas of wear on bases or bottoms usually indicates normal use and authenticity.

Salt-glazed cobalt-blue-decorated stoneware pitcher.
Henry Remmey, Philadelphia, 1864

Like redware, the best pieces of stoneware will have no major cracks, chips, or losses at tops, spouts, or handles. Minor nicks, abrasion, or other evidence of normal wear overall or on bases does not decrease value and may indicate authenticity; few pieces have survived without some damage. Some discoloration in glazes is acceptable and quite common.

GUIDELINES

Redware that is decorated with interesting words or amusing verses such as "Money Wanted" or "A Good Pie" is sought by many collectors and has increased in value. Interesting combed or slip-trailed decoration makes the piece more desirable. Large serving dishes and platters that display unusual colorations are good examples of the potter's craft. Plain forms will undoubtedly be of more interest to those who specialize in ceramics rather than folk art.

Presentation pieces of stoneware—objects commissioned by purchasers to commemorate a special occasion or event—are important ceramic forms and have sold for extremely high prices over the years. They represent the epitome of stoneware production but may be beyond the means of some collectors. Stoneware objects with inventive decoration—human and animal figures, florals, birds, and other pictorials—are valuable to collectors because of their visual interest. Objects with elaborate, incised designs are rarer (because they were more difficult and time-consuming to make) and are prized for sophistication. Because so many pieces were marked with the potter's name and location, a regional collection can be easily documented and acquired. Works by the Bennington, Vermont, potters have been well-documented and are popular as are the many examples produced in the Albany, New York, area.

References for ceramics are numerous and many include listings of regional potters. Interpreters at many restored villages and historical sites demonstrate the potter's art to visitors.

FURTHER READING

Ketchum, William C. *Potters and Potteries of New York State, 1650–1900.* Syracuse, New York: Syracuse University Press, 1987.

Moore, J. Roderick. "Earthenware Potters Along the Great Road in Virginia and Tennessee." *The Magazine Antiques,* September 1983.

Museum of Our National Heritage. *Unearthing New England's Past: The Ceramic Evidence.* Lexington, Mass.: Museum of Our National Heritage, 1984.

Watkins, Lura Woodside. *Early New England Potters and Their Wares.* Cambridge, Mass.: Harvard University Press, 1950.

Webster, David Blake. *Decorated Stoneware Pottery of North America.* Rutland, Vt.: Charles E. Tuttle, 1971.

CHALKWARE

Small ornamental figures called "chalkware" were popular household accessories during the last half of the nineteenth century. Made of gypsum and water, a compound similar to plaster of Paris, the name derives from the chalky appearance of the surface. Related to ceramics, the small figures, usually about eight inches high, were made by pouring the liquid mixture into a two-part mold, removing any excess, and allowing the figure to harden. Removed from the mold, the hollow figure was smoothed and painted, usually in bright, primary colors in oil or watercolors. Although many examples could be produced from one mold, each was hand-painted and varied with the imagination of the maker. Favorite subjects included cats, farm animals such as goats and pigs, and, occasionally, humans. Chalkware figures were quickly produced and sold cheaply, generally from about fifteen cents to fifty cents for the larger examples. Many figures, particularly birds, compotes containing fruit, and small animals, such as dogs, resemble English Staffordshire pottery then popular with the moneyed classes.

WHAT TO LOOK FOR

CONDITION

Minor nicks in base areas are to be expected on chalkware and do not affect value significantly. To check for previous damage, repairs, if any, will be visible on the hollow interior of the figure where glue might be observed. Wear, such as abrasion on the base, generally indicates that the piece is genuine. Chalkware is easily repaired and minor restoration does not affect value.

GUIDELINES

The larger pieces of chalkware are usually the most valuable, although collecting preferences vary. The best examples show detailing of features in imaginative, precise ways by the painter. Many folk art museums have examples of chalkware on display.

FURTHER READING

Bishop, Robert. *American Folk Art: Expressions of a New Spirit.* New York: Museum of American Folk Art, 1983.
Pounds, Rowenna. "The Chalk Menagerie." *The Clarion*, Spring 1982.

SCRIMSHAW

In his novel *Moby-Dick,* published in 1851, author Herman Melville noted: "Throughout the Pacific, and also in Nantucket, and New Bedford, and Sag Harbor, you will come across lively sketches of whales and whaling scenes, graven by the fishermen themselves on Sperm Whale-teeth, or ladies busks wrought out

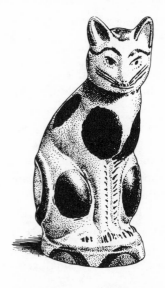

Painted and molded chalkware cat. Probably Pennsylvania, mid-19th century

of the Right-Whale-bone, and other like skrim-shander articles, as the whalemen call the numerous little ingenious contrivances they elaborately carve out of the rough material, in their hours of ocean leisure. Some of them have little boxes of dentistical-looking implements, specially intended for the skrimshandering business. But, in general, they toil with their jack-knives alone; and, with that almost omnipotent tool of the sailor, they will turn you out anything you please, in the way of a mariner's fancy." What Melville described—various decorative and utilitarian objects made from the teeth, bone, and tissue of marine mammals—has come to be known as scrimshaw, a folk art directly related to the American whaling industry.

Before the arrival of the white man, North American Indians salvaged beached whales along the Atlantic coastline, harvesting and processing the valuable blubber. Offshore whaling first appeared in the early eighteenth century, when inhabitants of Nantucket Island used sloops to spot large schools of sperm whales that allegedly had been sighted. By the 1760s, larger boats had been developed, suitable for the long voyages necessary for deep-sea whaling. By the last quarter of the century, voyages to waters as far distant as the Indian Ocean, the Arctic, and around Cape Horn were completed by the American whalers. Specially constructed machinery on the ship allowed the sailors to collect the oil from the recently killed whale and store it until their return to port. The ship usually stayed at sea until the holds were full, often taking voyages that lasted three to five years. While work surrounding the whale kill and the processing of the blubber was extremely exciting, dangerous, and difficult, much of the lengthy

voyage was tedious and boring. For amusement, sailors fashioned small decorative objects from the teeth and bones of the whale to serve as mementos of their adventures.

In terms of American commerce, the most valuable specimen was the sperm whale, which afforded first-quality oil and spermaceti, used to make candles. The bowhead and right whales were also sought by whalers, hunted for their oil and meat, and also for baleen, a substance formed of keratin, the material found in human nails and hair. Baleen was found in the whale's mouth and acted as a strainer to separate small fish and crustaceans from expelled water. After the most valuable parts of the whale were processed, the remaining teeth, baleen, and parts of the bone were salvaged by the sailors and transformed into a variety of objects, including decorative whale teeth, kitchen and sewing implements, corset stays and hoops for skirts, and small tools and parts for the ship.

The most commonly seen scrimshaw item is the tooth taken from the sperm whale's lower jaw. (In an adult whale, the jaw could contain as few as twenty and as many as fifty teeth.) In its raw state, the tooth is white but stained; its surface is rough, and shows normal wear on the tip. To prepare the tooth, the scrimshander buffed the surface with a file or sandpaper and, if the base of the tooth was jagged, it was sawed off evenly. Several methods were used to create the design: the maker could freehandedly sketch the design onto the tooth with pen or pencil; an illustration could be attached to the tooth and the design transferred by using a pin or needle to prick the surface; or the design could be traced with a sharp pencil. After incising with a jackknife, needles, files, or a combination of implements, the sailor then "inked" the piece by using charcoal, lampblack, India ink, commercially prepared pigments, or whatever suitable material was available. The dark design stood out boldly on the ivory. To create a smooth, shiny surface, the maker buffed the piece with a cloth, sometimes using oil or wax for gloss.

Design motifs varied greatly and were both copied from illustrations and products of the whaleman's own imagination. The most popular subject seen on the teeth was the whale itself. Many examples show images of sperm whales and other species and

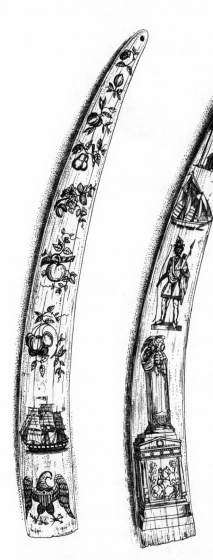

Pair of engraved walrus tusks: "The Federal Union Must Be Preserved." C. L. v. Giller, American, c. 1865

are sometimes identified. Of particular interest are scenes of the whale kill, showing the fearsome beasts struggling to get away from the whaleboats. Scrimshanders also featured the sailing vessel, usually shown with complete rigging and flags, its name, and the dates of the voyage. More elaborate nautical scenes illustrated the ships, whaleboats, seabirds, figures, and occasionally a map showing home port. Naval battles, too, such as the *Constitution* vs. *Java,* or the Battle of Lake Erie, were depicted, often copied from book illustrations or contemporary prints. Classical figures, such as "Columbia" and "Liberty"; images of "fashionable" women, copied from publications such as *Godey's Lady's Book* or *Harper's Weekly;* notable statesmen; historical personages; fictional characters, such as "Alwilda, the Female Pirate," based on a book published in the 1830s; and nautical characters such

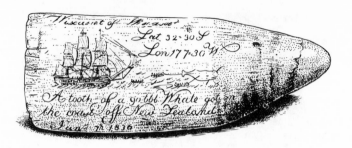

Engraved scrimshaw whale's tooth, "The Ship Wiscasset of Wiscasset."
American, 1836

as "Jack Tar" and the sailors themselves were pictured on the teeth. Patriotic symbols, such as the American eagle and flag, or fraternal, such as the Masonic square and compasses and stonemasons' tools, embellished some examples. While some designs can be documented to printed sources, many motifs shown on the teeth were nonderivative and came from the maker's own memory and imagination.

The lower jaw of the whale, called the panbone, was flat and thin and was also used by the scrimshanders. In part nearly rectangular, the bone was ideally suited to display incised nautical scenes. The teeth and bones of other aquatic mammals, such as walruses and porpoises, were also used for scrimshaw.

Kitchen implements and sewing tools made from teeth and panbone were a large category of the scrimshander's production. Decorative pie crimpers, or jagging wheels, used to press and seal pie crust, were carved in vast quantities. Carved in the round, the crimpers often were fancifully designed, showing human figures, stylized geometric motifs, hearts, initials, or messages such as "Good Pie Well Made." Scoops, dippers, rolling pins, serving items, mortars and pestles, toothpicks, molds, clothespins, and other objects used in food preparation have been found in scrimshaw. One of the most elaborate scrimshaw products was the yarn swift, a collapsible device constructed of over one hundred individual pieces of tooth or bone that looks similar to the skeleton of an umbrella. Attached to a table, the swift held a skein of yarn

as it was wound into a ball. Sewing tools, including needles, needleholders, and knitting needles, as well as storage boxes and jewelry were also made to be presented as gifts to loved ones when the ship returned home.

One of the most interesting scrimshaw forms was the busk, occasionally made of baleen, and used as a corset stay. In the mid-eighteenth century, the busk, a long, narrow piece varying from eight to twelve inches in height, was worn in a slit in the front of a corset to define the stiff bodice then in fashion. When the style changed in the nineteenth century, sailors continued to make the busks as tokens of affection for wives or sweethearts. Decoration of the most intimate nature, hearts, flowers, initials, views of home, love messages, and other personal associations and portraits were typically employed by the maker to illustrate his feelings.

Whalebone was particularly well suited to be made into tools for the ship because of its strength. Items for everyday use on the ship, such as locks, fids, rigging needles, and thimbles, as well as carpenter and coopering tools were frequently carved by the sailors. Particularly charming are the whale stamps made of whalebone. The small stamps, carved in the shape of the many species, were used by the first mate to record in the vessel's logbook the number and types of whales killed. Some stamps were carved of ivory, wood, and bone in combination, and often

Carved whale ivory jagging wheel.
19th century

had a blank area in the middle where the yield of barrels of oil could be noted.

Although some pieces of scrimshaw have the sailor's name, ship, and dates included, most were anonymous. Some initials or messages have meanings lost to history. Sometimes, however, documentation can be found in primary source records such as logbooks or journals to identify the maker and his vessel.

Having dominated the world market for almost a century, the American whaling industry fell into decline after the Civil War. Many of the New England–based ships had been captured and sunk by Confederate forces, and other sources of fuel, such as kerosene, diminished the demand for whale oil and candles. By 1900 whaling ceased to be a viable industry. Ivory cannot now be sold in the U.S. unless it is over one hundred years old.

WHAT TO LOOK FOR

CONDITION

Because of the wide variety of scrimshaw items, their condition will vary from piece to piece. Minor discoloration is to be expected and does not significantly affect value. Baleen items often become brittle, and it is common to find splits in the material. Some of the pigments used in scrimshaw designs will dissolve in water, so any cleaning and/or restoration should be done only by a professional conservator.

GUIDELINES

Over the past few years, many varieties of scrimshaw have been made of synthetic polymers and sold as antiques by forgers. A number of maritime museums, however, have had scrimshaw items from their collections reproduced from polymer, marked,

and sold legitimately as reproductions. Two easy tests differentiate real bone and ivory from polymers: under an ultraviolet light, real bone and ivory appear bright white, and polymer objects do not; the polymer pieces will accept an electrostatic charge (after vigorous rubbing with a soft cloth), white real bone and ivory will not.

Tastes will vary in terms of collecting scrimshaw, but generally signed and/or dated examples, although rare, are choice. Pictorial examples are coveted by collectors. Attention should be paid to the detail in the scenes: if it is a whaling item, check for accuracy in the depiction of the ship, such as the rigging; in a whaleboat chase, are the figures depicted realistically in the act of harpooning the whale? In other graphic work, and in scenes that appear to have been copied from illustrations, check to see if the maker has copied the design exactly or included his own imaginary touches; some inventive, well-executed changes can increase value. The large panbones with elaborate whaling scenes are among the finest sought by collectors. In jagging wheels or other kitchen implements, make certain that the parts fit together well even though they might only be displayed, not used. As with other forms of folk art, patriotic themes are popular with collectors and vessel portraits are of interest. Numerous publications about scrimshaw, including catalogues of museum collections, are available for research. Some rare-book libraries contain logbooks and shipping records that can be used to trace specific ships and sailors. The Kendall Whaling Museum, Sharon, Massachusetts; Mystic Seaport Museum, Mystic, Connecticut; the New Bedford Whaling Museum, New Bedford, Massachusetts; and the Peabody Essex Museum, Salem, Massachusetts, have outstanding collections of scrimshaw of every type. Most folk art museums have representative examples.

FURTHER READING

Earle, Walter K. *Scrimshaw, Folk Art of the Whalers*. Cold Spring Harbor, N.Y.: Whaling Museum Society, Inc., 1957.

Flayderman, E. Norman. *Scrimshaw and Scrimshanders*. New Milford, Ct.: N. Flayderman, 1972.

Malley, Richard C. *Graven by the Fishermen Themselves: Scrimshaw in Mystic Seaport Museum*. Mystic, Ct.: Mystic Seaport Museum, 1983.

Melville, Herman. *Moby-Dick*. New York: Harper and Brothers, 1851.

Stackpole, Edouard A. *Scrimshaw at Mystic Seaport*. Mystic, Ct.: Marine Historical Association, 1958.

HATBOXES AND BANDBOXES

Hatboxes and bandboxes first came into common use during the first quarter of the nineteenth century as storage repositories for hats, bonnets, collars, ribbons, artificial flowers, jewelry, and other accoutrements of the day. They also served as portable luggage for a country that was increasingly mobile. About 1825, when women first entered the labor force as workers in the textile mills scattered throughout the Northeast, boxes were needed to protect and transport bits of wardrobe worn by the "mill girls" who came to the textile centers from rural areas. Affordable for even the lowest-paid employees, the largest boxes cost fifty cents and the tiny examples, suitable for jewelry, cost only twelve cents. Used both for storage and as luggage, the boxes were economical and utilitarian. Most were made by individuals who met the demand for portable luggage, but some were produced commercially and often included a trade card mounted inside. Hat and band (meaning collar) boxes were made of bent wood or pasteboard, lined with newspaper, and covered with contemporary wallpapers.

Many of the myriad of wallpapers depicted current events of the day. Innovations in transportation, such as the Erie Canal, completed in 1825, the railroads, and improvements in carriages and coaches, were featured in the wallpaper motifs. Steamships

and paddlewheelers were also depicted in the designs. Many other wallpaper patterns illustrated a variety of scenes and subjects: exotic animals such as giraffes and rhinoceros, eagles, parrots, swans, cockatoos, and peacocks; other botanical designs such as flowers and fruit and leaves; geometrics and classical motifs such as festoons, swags, columns, and rosettes; pictorial and historical scenes and events such as balloon ascensions; the Battle of Chapultepec; and neoclassical designs such as scenes of Pompeii; classical architecture; and portraits of Greek gods and goddesses.

Most hat- and bandbox makers remain anonymous, but one of the more well-documented artisans is Hannah Davis (1784–1863) of Jaffrey, New Hampshire. To support herself as a spinster after her parents' deaths, Davis made hat- and bandboxes that she sold to young women who worked in the textile mills in the Merrimack River towns of Manchester and Nashua, New Hampshire, and nearby Lowell, Massachusetts. Using locally available woods and papers, Davis crafted boxes in many sizes, some tiny trinket boxes and some suitable for large bonnets and calaches. As a local entrepreneur, Davis frequently labeled her boxes, making them identifiable today. Although the boxes were merely utilitarian objects, their visual expressions of issues current in the first part of the nineteenth century make them valuable artifacts for the social historian today.

WHAT TO LOOK FOR

CONDITION

In the finest examples, the box will be sturdy, the lid intact, and the paper lining and exterior should be free of major tears. Minor losses and small rips are to be expected and do not significantly affect value.

*Printed paper
bandboxes.
American, first half
19th century*

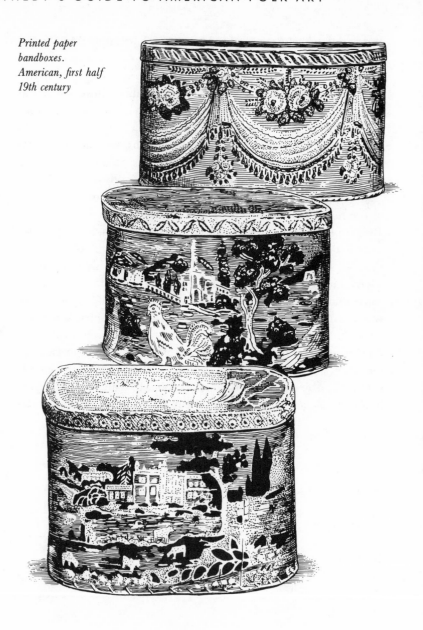

Bandbox.
Probably
New England,
mid-19th century

GUIDELINES

Hat- and bandboxes survived in rather large quantities and are available at auction and in antiques shops. The boxes labeled with the maker's name are the most desirable, as are those that display unusual wallpapers, such as scenes or events. The larger boxes show more of the decorative wallcoverings, but the smaller, trinket-sized boxes also appeal to collectors. Newspaper linings that include the name of the town and the date can be used as research tools to aid in identifying a maker and establishing provenance. The Shelburne Museum, Shelburne, Vermont, owns an extensive collection of hat- and bandboxes, and many folk art museums have representative examples.

FURTHER READING

Carlisle, Lilian Baker. *Hatboxes and Bandboxes at the Shelburne Museum*. Shelburne, Vt.: Shelburne Museum, 1960.

\mathscr{W}HAT ARE TEXTILES?

QUILTS AND COVERLETS

Among the most colorful, inventive, and visually exciting folk art forms are quilts. These textiles were valued by their makers, cherished by families, and are coveted by collectors today. The making of quilts and other textiles for the home by women of the eighteenth and nineteenth centuries was one of the few opportunities they had to display aesthetic creativity; although it was time-consuming, warm bedcovers were a necessary comfort for the home. Their creations, many of which look surprisingly modern, are a true "patchwork history" of the domestic arts of young America. Many bedcovers were unadorned and merely utilitarian, but others were made with aesthetics in mind. Early records indicate that quilts were judged for their beauty and workman-

ship at agricultural fairs and shows throughout the nineteenth century. Prizes were offered for the best quilts and "fancy" needlework pieces in categories with such titles as "Domestic Industry" or "Household Manufactures."

WHOLE CLOTH

One of the earliest types of quilts found in America was of a simple nature: two pieces of woven cloth, such as cotton or linen or wool worsted, were stitched together over a middle layer, usually made of wool. Sometimes called "whole cloth" quilts, the layers were fastened together by stitching or "quilting" with thread. The most interesting examples show geometric motifs, but some were done in more elaborate designs such as medallions, florals, feathers, or rosettes. The designs created a sculptural effect on the quilt's surface. Some woolen tops were glazed by rubbing or applying a mixture of egg white and water that could be polished. Indigo blue was a common color because of its stability, but other whole cloth quilts in the solid colors of bright red, pink, yellow, and a variety of greens, among others, were also seen.

PIECED

The type of quilt that is the most spectacular visually is the "pieced" or "patchwork" variety that flourished from about 1775 until about 1875. Early pieced quilts came about as a way for the housewife to be frugal: small pieces of worn fabric, sometimes from clothing, could be sewn together to create a useful bedcover. Using textiles usually made of cotton, the maker cut pieces of fabric and pieced them together, forming a designated pattern. Sometimes the designs were set into individual blocks but, on most examples, a repetitive design covers the entire surface. After the quilt top was constructed, it was mounted on a frame and attached to other layers of fabric by running stitches that formed

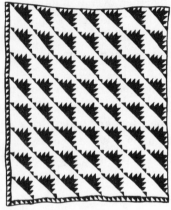
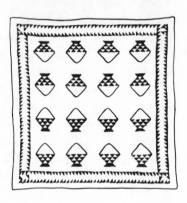

Clockwise from top left:

Pieced "Star of Bethlehem" quilt. Adeline Roberts, Virginia, c. 1860

Pieced cotton schoolhouse quilt. American, c. 1920

"Basket Quilt." Probably Ohio, 1860–80

Pieced "Sawtooth" or "Bear Paw" quilt. Probably Pennsylvania, 19th century

yet another decorative design. The finest examples show elaborate quilting designs, often geometric, from tiny stitches.

The sheer number and types of decorative patterns found in pieced quilts is staggering and visually dazzling. Every variety of flower, vines, geometrics, stars, sunbursts, blocks and bands,

trees, baskets, and houses, among innumerable other imaginative designs, were popular motifs. While some patterns are commonly called "Baby's Blocks" or "Double Wedding Ring," after their obvious characteristics, it is virtually impossible to determine when patterns were named. Researchers have found no references to the names in eighteenth- and nineteenth-century primary source references. It is interesting to note that the same pattern may be named differently in different regions of the country.

APPLIQUÉ

Another technique used in quilting is called "appliqué," after the French word "appliquer" meaning to "put on" or "lay on." In this method, patterns are cut out of one material and sewn onto another piece of fabric. Appliquéd quilts are more pictorial than patchwork ones because the maker could arrange the pieces in many different configurations. Some appliquéd quilts feature intricate designs, such as the Tree of Life, or mirror high-style, intricate English chintz fabrics fashionable at the time. The appliquéd quilts displayed many different motifs such as patriotic or fraternal symbols, in addition to the frequently seen florals and geometrics. Pieced-work and appliqué techniques were not mutually exclusive; sometimes they were combined and embroidery was also included. Other methods were also used to decorate the quilts: they could have an all-over pattern created by embroidery; stenciled quilts, while somewhat unusual, are also known.

ALBUM QUILTS

Quilts made by several women, such as members of a church group, were called "album" quilts. Each maker created an individual block and completed it by signing her name and the date; the blocks were then sewn together to create a complete quilt. Album quilts can be used by social historians to document local history and genealogy.

105

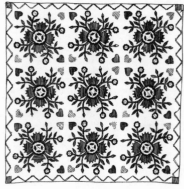

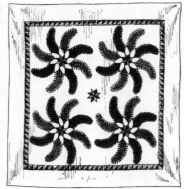

Pieced cotton quilt.
Mandy Williams Brown,
Alamance, North Carolina, c. 1850

Pieced and appliquéd cotton
"Princess Feather" quilt.
Pennsylvania, 1875–1900

CRAZY QUILTS

Introduced about 1870, "crazy" quilts combined different types of fabric—silk, velvet, cotton—in a stylized manner. The fabrics of random shapes and sizes were joined together with a variety of decorative embroidery stitches, and other surface embellishments, such as oil painting, were sometimes added. "Crazy" quilts were so popular that they were marketed through kits during the late nineteenth century.

COVERLETS

Another type of bedding that was produced in large quantities by home weavers was the coverlet, a woven textile made on a loom rather than by quilting. Overshot coverlets, made of wool and cotton or linen, were so named because the colored wool felt yarns (horizontal) overshoot or float over groups of warp (vertical) yarns in a geometric pattern. Most were woven in dark

blue and white, but some makers added other colors, such as red, to enhance the designs.

JACQUARD COVERLETS

About 1820 a type of loom attachment, named for its inventor, Frenchman Joseph Jacquard, was introduced to America. The invention, made to attach to the loom, consisted of a series of cards with punched holes that activated the loom's harness, making a pattern that was more intricate and representational than overshot. The Jacquard loom enabled professional weavers to create complex designs of many varieties; elaborate borders, animals, birds, patriotic symbols, florals, fraternal emblems, trees, buildings—all were possible with the new invention.

As evidenced by hundreds of quilting and weaving clubs and organizations, interest in the textile arts has continued throughout the twentieth century. Members carry on a tradition of conviviality found in the sewing bee that was once one of the few outlets for women's artistic expression.

WHAT TO LOOK FOR

CONDITION

Minor areas of wear do not affect a quilt's value greatly, but major tears, missing pieces, or shredded fabric make it less desirable. The edge bindings should be stable and original. Frequently, colors have faded because of extensive use or exposure to light; quilts that have been treasured (or merely stored away) often retain their original colors and are more valuable than the faded examples. Like quilts, choice coverlets will be in good condition. Minor areas of wear are acceptable, but major fabric losses, especially within the central design, or areas of unraveled yarns decrease the textile's value.

GUIDELINES

In any evaluation of quilts, workmanship is very important. The pieces should fit together precisely with no frayed or protruding edges; the decorative stitching ideally should be as regular, close together, and small as possible—ten to twelve stitches per inch on fine examples—and form different patterns, such as geometrics, plumes, or swirls on the background. (In some cases, the decorative stitches may be seen more clearly by looking at the back of the quilt as well as the front.)

Some patterns, such as the "Mariner's Compass" or "Star of Bethlehem," for instance, were extremely complex to cut and piece together because of the narrow, sharply pointed pieces and the center-outward construction. Quilts made in these patterns are rarer and show more skill on the part of the maker than do those made of the simple block or log cabin patterns. Other quilts with specific designs, such as patriotic symbols or pictorials, or those that include the maker's name, are also valuable. While their colors can be somewhat subdued, Amish and Mennonite quilts are popular with collectors, and lovers of Victoriana eagerly search for crazy quilts. The choicest quilts were made entirely by hand; some examples, however, show both hand and machine stitchery and are not as desirable. (Machine stitches are always of regular, even length, with no variations, and are closer together than those done by hand. The lock-stitch sewing machine was patented about 1850 and was in use shortly thereafter.) Since quilts are still made in virtually every part of the country today, only the collector can determine if an antique quilt or a modern one is preferred.

Coverlets have never been as costly as quilts, and many fine examples are available at reasonable prices. The Jacquard coverlets are most sought after by collectors, especially those with a central design and intricate borders that display the maker's name, location, and date. Those that include inventive designs such as eagles, wild animals, buildings, and figures are very popular and of greater value than the plain examples. Blue-and-white coverlets still remain the favorites of many collectors; how-

ever, some "white" cotton yarns may appear to be cream-colored because they were not dyed, though this does not affect value. Overshot coverlets of many varieties are widely available at surprisingly modest prices. To distinguish these coverlets, look for the long weft thread that can be seen lying on the warp and can be lifted up with the fingers. Many were woven with fringed edges; on the finer examples this will be intact, but many suffered losses. The best examples show combinations of geometrics, such as diamonds, squares, and stripes woven in a manner that is reminiscent of quilt patterns.

Several secondary sources and monographs have listings of identified coverlet weavers. If the coverlet is signed, the location noted, and a previous owner known, the census index and genealogies might be of help to complete the coverlet's history. The Abby Aldrich Rockefeller Folk Art Center, Williamsburg, Virginia; The Art Institute of Chicago; the Museum of American Textile History, Lowell, Massachusetts; and the Shelburne Museum, Shelburne, Vermont, are excellent sources for textile research.

FURTHER READING

Bishop, Robert, and Patricia Coblentz. *New Discoveries in American Quilts*. New York: E.P. Dutton, 1976.

Heisey, John. *Checklist of American Coverlet Weavers*. Williamsburg, Va.: Colonial Williamsburg Foundation, 1978.

National Gallery of Art. *An American Sampler: Folk Art from the Shelburne Museum*. Washington, D.C.: National Gallery of Art, 1987.

Orlofsky, Patsy, and Myron Orlofsky. *Quilts in America*. New York: McGraw-Hill, 1974.

Safford, Carleton L., and Robert Bishop. *America's Quilts and Coverlets*. New York: E.P. Dutton, 1972.

SCHOOLGIRL ART

By the early nineteenth century, many private schools and academies had been established throughout the Northeast for the education of girls and boys from "privileged" families. Following the thinking of the day in regard to gender, the boys followed a fairly standard academic curriculum, and the girls were taught a less rigorous course to develop their "feminine" talents. While the girls did study history, geography, and literature, the most emphasis was placed on the appreciation of music and acquiring skills in painting and needlework—hallmarks of a "proper" young lady.

THEOREM

One aspect of decorative painting taught extensively at the girls' schools and also by individual instructors was "theorem," or painting with the use of stencils. The theorem painting is essentially a still-life picturing baskets or bowls of fruit and vases of flowers, occasionally with details such as birds. Using stencils made of heavy oiled paper supplied by the instructor or sold in kits, the young ladies created their compositions by building up the individual designs on the surface. Done in oil on canvas, silk, and especially velvet, and watercolor and pastels on paper, the designs could be embellished with freehand details when the artist preferred. Because many theorem paintings were done with similar stencils and techniques they are visually repetitious, and it has been suggested that there were common design sources for the pictures. These small, delicate paintings, ranging in height from about eight inches to about twenty inches, were outward symbols of a genteel lady's artistic accomplishments.

Other subjects deemed suitable for gently reared girls to paint freehand were biblical, historical, literary, and mythological. Often based on contemporary prints or book illustrations, popular subjects included Miss Liberty; "The Lady of the Lake," based on Sir Walter Scott's poem; Adam and Eve; Noah and the

Theorem painting, watercolor and pen-and-ink on paper. American, c. 1840

ark; Napoleon Bonaparte; and "Venus drawn by doves." Usually done in watercolor or pastels on paper, these jewellike scenes displayed the maker's knowledge of artistic conventions and sourcebooks illustrated with engravings.

EMBROIDERY

Traditionally, women have always learned to sew out of necessity, learning mending and simple embroidery stitches while assisting their mothers by making clothing and marking household linen. As part of her studies at an academy or seminary, advanced lessons in needlework assured a girl that she was on her way to becoming "well-educated." Among the first needlework projects made by girls in school were samplers, a basic embroidered picture that featured the letters of the alphabet and numbers from one to ten. As educational devices, they not only taught fundamental writing and numerical skills; they also enabled a young

girl to gain proficiency in a variety of decorative stitches. As she became more accomplished, the student was taught more advanced stitches and began to create more sophisticated examples, usually based on designs particular to one school or teacher. As emblems of educational achievement, samplers were regarded as tangible evidence of a girl's social standing.

Generally, the designs for the samplers were drawn directly on linen or silk, in pen or pencil, and were worked with silk thread. Most motifs were given to students by the teachers and, in addition to the alphabet and numbers, included several stock patterns such as figures, flowers and vines, buildings in a landscape, animals and birds, poetic and lofty verses such as "Remember thy Creator in thy youth," and, of course, the maker's name and sometimes the date. By using a variety of fancy stitches, such as French knots to simulate hair on animals, running stitches for borders, satin stitches to create texture on clothing, and simple cross stitches for letters and numbers, many unusual effects could be created. Many primary colors were used by the stitchers, with landscapes depicted in greens and blues, flowers of many colors, and stylized borders of matching hues. In some cases, the maker may have created a family record by adding the names and dates of her brothers and sisters to the picture.

More elaborate pictorial embroideries, often based on print sources or pattern books, were produced by the more accomplished girls. Outdoor scenes might include a view of the girl's home or garden, or figures and animals in a landscape. Frequently, more exotic threads, such as metallic or chenille, were used to create visual interest in these more advanced needlework exercises. These embroideries, usually done by older girls of fifteen or so, may have been sketched by professional ornamental painters, with the student contributing only the stitchery.

Mourning Pictures

A particular type of embroidered, and sometimes painted, textile was the mourning picture, produced from about 1800. The death of George Washington in 1799 is said to have caused the popu-

larity of memorial pictures that continued throughout the early part of the nineteenth century. A wealth of graphics featuring funereal motifs circulated in the years after Washington's death and were undoubtedly used as design sources for embroideries and paintings commemorating death. Typically, the pictures showed urns, plinths, the weeping willow, the evergreen of ever-lasting life, gravestones, and the departed's name and dates. Usu-ally, figures dressed in black mourning garb are a central feature. Fortunately for posterity, many mourning pictures (and em-broideries) were professionally framed and included the maker's name, school, and date on the reverse-glass-painted glazing. While grief of loss over a loved one was very real, it appears that the mourning pictures were also an illustration of fashionable neoclassical style.

By 1835 educational opportunities for girls had begun to im-prove, and the fancy needlework and painting that had been of great importance in earlier decades began to be replaced with classical studies, more akin to those traditionally offered to boys. The production of decorative needlework waned as education for girls became more academically oriented.

In recent years, scholars have documented the needlework of many eighteenth-century ladies' academies and, through visual and genealogical evidence, have identified the stitchery of several teachers and students.

Mary Balch (1762–1831) taught embroidery skills at her school in Providence, Rhode Island, from about 1785 until 1831. Needlework pictures made by students at the Balch school are among the finest produced in America. Some show important public buildings; one popular design included a house seen in a garden between cross-stitched columns, placed under an arch. Students at the school were taught to combine contrasting colored silk threads to create simulated striated marble memorial stones and lush foliage. Inscriptions on the Balch pictures are meticu-lously embroidered with fine threads.

Judith Foster Saunders (1772–1841) and Clementina Beach (1775–1855) operated an academy in Dorchester, Massachusetts, a section of Boston, from about 1803 until about 1840. Girls trained at Mrs. Saunders' and Miss Beach's Academy created

pictures featuring elegant figures and many designs based on popular prints. Embroidered inscriptions on the unpainted silk beneath the picture are a typical characteristic.

Abby Wright (1774–1842) kept a school for young ladies in South Hadley, Massachusetts, from 1803 until 1811. Girls at Miss Wright's school stitched one of the most important groups of pictorial needlework pictures in America. In a detail seen in the pictures, shrubs and flowers are surrounded by tiny seed stitches to set them apart from the background. On mourning embroideries, epitaphs are handwritten or printed on paper that is then glued to the silk.

Samuel Folwell (1764–1813), an ornamental painter, designed patterns for his wife's school in Philadelphia. The designs, many of which were memorials, were usually oval compositions showing one or more figures surrounded by mourning symbols. Floral borders, crossed weeping willow trees, and hillocks are featured in the backgrounds. Many of Folwell's memorials commemorated the death of George Washington. These almost always read "Sacred to the Memory of the Illustrious Washington" or "Thy Loss Ever Shall We Mourn."

WHAT TO LOOK FOR

CONDITION

Textiles are by nature fragile and are affected by environmental conditions. To evaluate embroideries, check for splitting or tearing of the silk (or linen) supports. Some fabrics, because of years of exposure, will sometimes appear to be held together by dirt. Many colors, particularly yellow, are especially fugitive, so threads should be examined to determine their original color. Often the back of an embroidery will still retain much of the original color. Some fabrics will experience a chemical breakdown resulting in brown, spotted discoloration; check both the front and back of the piece for this damage. Ideally, an embroidered picture will have a stable support, show embroidered stitching

in undamaged condition, and have colored threads that have not faded. Samplers sometimes have missing threads, particularly in birth dates, that may have been removed by the maker as she decided to disguise the year in which she was born. Minor areas of loss or damage are acceptable as long as they do not disturb the dominant design.

GUIDELINES

Over the years, prices for needlework have escalated to astonishing heights, and extensive research documenting ladies' schools, teachers, and students has greatly increased interest. Pictures from the Balch school are especially choice, and those that can be documented to a particular student are always popular. Some elaborate examples, showing intricate designs and numerous varieties of stitches, are eagerly collected. Works that include the original, reverse-glass painted liner and frame with the name of the school are always valuable. Simple family record samplers are often collected by those interested in family and local history.

Most folk art museums, historical societies, and restored villages display numerous examples of needlework.

FURTHER READING

Deutsch, Davida Tenenbaum. "Samuel Folwell of Philadelphia: An Artist for the Needleworker." *The Magazine Antiques*, February 1981.

Ring, Betty. "The Balch School in Providence, Rhode Island." *The Magazine Antiques*, April 1975.

———. *Let Virtue Be a Guide to Thee: Needlework in the Education of Rhode Island Women*. Providence: Rhode Island Historical Society, 1983.

———, ed. *Needlework: An Historical Survey*. New York: Universe Books, 1975.

————. "Needlework Pictures from Abby Wright's School in South Hadley, Massachusetts." *The Magazine Antiques,* September 1986.

————. "Mrs. Saunders' and Miss Beach's Academy, Dorchester." *The Magazine Antiques,* August 1976.

Schorsch, Anita. *Mourning Becomes America: Mourning Art in the New Nation.* Clinton, N.J.: Main Street Press, 1976.

HOOKED RUGS

The hooked rug, a type of floor covering used widely since the nineteenth century, is one of the most popular and enduring of American folk arts. For years, much confusion surrounded the origin of hooked rugs. One of the earliest types of rugs, made from about 1800 until about 1840, was made by sewing yarn through a backing, such as linen or sacking, in a continuous running stitch, leaving loops that formed a pile; named after their method of construction, such rugs were known as "yarn-sewn." Early decorative arts historians, mistaking hooked rugs for yarn-sewn ones, presented theories that suggested that hooked rugs were made during the 1700s. Further research, however, confirmed that hooked rugs were not made until the 1850s, when burlap, made from jute, the fiber of an East Indian tree, was imported and became widely available for use as a backing material.

Hooked rugs are made by pulling narrow strips of fabric over and over through a coarse backing, such as burlap, with a hook. A series of loops is left on the surface, forming a pattern or design; the closer the loops are together, the more durable the rug. The earliest hooked rugs show delicate designs, often floral, that are a derivative of eighteenth- and early nineteenth-century embroidery designs. In fact, some scholars believe that rug hooking began as an extension of "fancy-work" embroidery of the eighteenth century, negating the long-held romantic theory that housewives made the rugs for warmth from scraps of old, wornout clothing. Although instructions for sewing and other types of

embroidery abounded in nineteenth-century ladies' magazines and pattern books, it appears that rug hooking was learned through individual instruction because it was easily taught and executed.

Motifs on many rugs show extraordinary imagination. The hooked rugs of the 1850s resemble yarn-sewn rugs showing florals, vines, houses, and other designs similar to those seen on samplers or embroidered pictures. As the craft developed, other makers used a plethora of subjects: barnyard and domestic animals; houses; landscapes; flowers and vines; ships; exotic animals copied from illustrations; scenes of picnics and parades; and patriotic and fraternal symbols, among others.

As interest in rug hooking grew during the 1860s, popular patterns were produced commercially. A Lowell, Massachusetts, woman, Philena Moxley (1843–1937), stamped patterns of animals, such as horses or dogs, onto burlap for use by rug makers. Although most of her designs were destroyed, those extant indicate that she merely enlarged embroidery patterns for use on rugs. An itinerant peddler from Biddeford, Maine, Edward Sands Frost (1843–1894), made and sold stenciled rug patterns from 1868 until 1876. Frost created one hundred fifty designs of animals, birds, florals, fraternal symbols, and geometrics, and sold them from his cart and through catalogues. Much of the imagination shown in earlier designs suffered after the patterns were mass-produced.

By the early 1900s, however, the designs became creative once more; many makers were influenced by the Arts and Crafts Movement, which rebelled against machine-made products and nurtured individual expression. Some rugs of this period feature Native American and Oriental designs, flat textures, and subtle colorations in contrast to the earlier, brightly colored rugs. Cottage industries, such as those at Cranberry Island, Maine, and the Subbekashe rug industry in Belchertown, Massachusetts, supplied many of the rugs for arts and crafts exhibitions and demonstrations.

Collected avidly since the 1920s, hooked rugs have continued as a needlework tradition. Numerous organizations, formed in

Top:
Pictorial hooked rug.
Early 20th century

Bottom:
Pictorial yarn-sewn rug,
"They Had to Leave."
New England, c. 1840

the 1930s, are dedicated to preserving the craft by offering lessons, lectures, and workshops, and are active throughout the country.

WHAT TO LOOK FOR

CONDITION

Although textiles are fragile and hooked rugs receive particularly hard use, condition does affect value. Ideally, the backing, usually burlap, should be in good condition with no holes or tears, the bindings should be stable, and the colors should not be too badly faded. The earliest rugs were made from fabrics colored with vegetable dyes that faded when exposed to light or water; near the end of the nineteenth century, synthetic dyes that produced more brilliant colors were available for home use, but these, too, faded. Examine the back (underside) of the rug where the colors should be the brightest, and compare it to the front, to check for fading. In general, the more densely hooked rugs were more durable and tend not to exhibit as much wear as the loosely hooked examples.

GUIDELINES

The great variety of subjects used by the creators of hooked rugs affords collectors the opportunity to suit almost every aesthetic taste. Pictorial rugs, showing animals, figures, or other motifs arranged in a manner similar to folk paintings, are among the choicest examples, as are scenes of activities, such as a Fourth of July picnic. For special interests, rugs that show patriotic symbols or fraternal symbols would be important additions to a collection. Some collectors specialize in rugs worked from commercial patterns, but original designs are generally more valuable. The commercial pattern rugs tend to be more symmetrical and less inventive than those crafted by individual makers. Some of the most engaging hooked rugs have been made in the twentieth

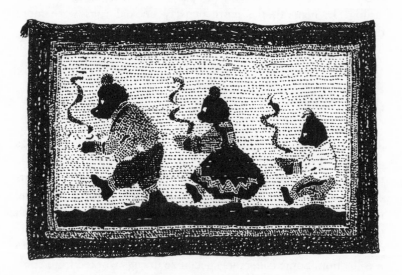

Top:
Hooked rug, "Cow Jumped Over the Moon."
American, c. 1930

Bottom:
Pictorial hooked rug.
Late 19th century/early 20th century

century, so these should not be overlooked. Many contemporary rug-hooking organizations have made rugs based on older, documented examples, and the reproductions are clearly marked with the owner's name and date.

Because of the interest in hooked rugs both as a craft and as a folk art, numerous articles and monographs have been written to explain techniques and illustrate examples. Edward Sands Frost's original stencils are owned by the Henry Ford Museum and Greenfield Village in Dearborn, Michigan, and they sell printed designs based on the patterns. Most folk art museums have representative hooked rug collections, and the Margaret Woodbury Strong Museum in Rochester, New York, owns a selection of later examples.

FURTHER READING

Bishop, Robert. "Edward Sands Frost and His Historic Hooked Rug Patterns." *The Clarion*, Summer 1977.

DiFranza, Happy, and Barbara Franco. "American Hooked Rugs." *The Magazine Antiques*, October 1990.

Kopp, Joel, and Kate Kopp. *American Hooked and Sewn Rugs: Folk Art Underfoot*. New York: E.P. Dutton, 1975.

Little, Nina Fletcher. *Country Arts in Early American Homes*. New York: E.P. Dutton, 1975.

Ring, Betty, ed. *Needlework: An Historical Survey*. New York: Universe Books, 1975.

WHAT IS PAINTING?

GENRE PAINTINGS AND FARM AND TOWN VIEWS

GENRE PAINTINGS

Children playing a game of baseball; a group of women socializing at a quilting bee; farmers working in the fields; the Fourth of July parade; a sleigh ride in the snow—all of these familiar events, when depicted by an artist, are called "genre" painting and show scenes of everyday life. Because genre pictures usually include elaborate detail in costume and setting, and illustrate people engaged in ordinary activities, they are important resources for social historians. Equally they are nostalgic artistic expressions

that evoke memories of times past. Some pictures were copied from print sources, such as newspaper illustrations, but most were products of people who recorded everyday scenes for their own enjoyment. As pictorial records, genre scenes reveal a vital part of the life of the common man that otherwise would have been lost to history.

Genre paintings possess a spontaneity seldom found in other types of art; one frequently senses that the artist himself is an active participant in the scene, sharing a common experience with the viewer. Famous people and important national events are always chronicled by reporters and artists of the day, but a glimpse into ordinary lives can also help illustrate a significant aspect of the past. The makers of most genre scenes remain unknown. Some, however, have been identified and well documented.

Eunice Pinney (1770–1849) was a Connecticut native who began painting with watercolors when she was about thirty-five. Her paintings, which feature figures shown in conversation, children playing, family and friends mourning the death of a loved one, and variations of "mother and child," are created by using areas of bold watercolors with facial and other details added with pen and ink. The compositions are balanced, with figures symmetrical or arranged in an orderly manner. Although she began painting in the first decade of the nineteenth century, Pinney costumed her figures in eighteenth-century garb, such as mob caps and other fashions that would have been outdated by that time. She also painted memorial pictures, landscapes, and religious subjects; her adaptations of historical, literary, and allegorical scenes are based on widely circulated eighteenth-century engravings. The addition of a painted oval spandrel on some of the pictures is reminiscent of schoolgirl paintings and embroidered scenes.

Lewis Miller (1796–1882), a carpenter, created an astonishing body of work that chronicles life and times in York, Pennsylvania, for fifty-five years. From 1810 until 1865, Miller sketched his fellow citizens, recorded public historical events, and illustrated his travels in a group of drawings that numbered over two thousand. Although not a trained artist, Miller possessed extraordi-

nary skills as a pictorial storyteller, filling his pages with innumerable details of the townsfolk, buildings, landscapes, and historical events that he encountered in York. Working on a small, intimate scale, in watercolor and ink on paper, Miller covered seemingly unimportant events—friends visiting, dances, courting lovers, tradesmen working—as well as events of local or national significance, such as the assassination of President Abraham Lincoln in 1865. His small figures are immediately recognizable by costumes or props, and many times Miller actually identified them by name as part of the design. His sketches are characterized by an all-over composition of human and animal figures, appropriate backgrounds or landscapes, buildings, and other minutiae in a variety of perspectives. Movement appears throughout the busy vignettes, and in some examples the artist scripted the action into words to accompany the drawings. It is no surprise that Miller's genre scenes possess an immediacy often lost from memory, because, as he stated in his autobiography, "All of this Pictures Containing in this Book, Search and Examin[e] them. The[y] are true Sketches, I myself being there upon the places and Spot and put down what happened."

FARM AND TOWN VIEWS

Like genre scenes, views of well-kept farms, cultivated fields and gardens, and townscapes that recorded business and commerce graphically announced the new Americans' sense of community and optimism for the young nation. Just as the early years of the nineteenth century found middle-class citizens seeking portraits of themselves to reflect their newly found economic and social status, they also sought depictions of their farms and towns to celebrate their achievement in conquering the wilderness.

One of the better-documented artists who painted scenes of his locality was Joseph Henry Hidley (1830–1872). Hidley made a living as a house painter and decorator, but he is best known today for views of small villages near his home in Poestenkill, New York, just outside Albany. Hidley's paintings, done in the

1860s in oil on canvas or wood panel, are townscapes, showing architecture, figures, carriages, and animals delineated in great detail. A comparison of his town scenes to late-nineteenth-century "bird's-eye views" of the same communities indicated that Hidley took great care to record the scene precisely. Using multiple perspectives and an elevated vantage point, he meticulously depicted each building so it would be immediately recognizable by the townfolk. Although only eight townscapes by Hidley are known to date, his work can be studied and used to evaluate the vast number of town views that remain anonymous.

Working along the Schuylkill River outside Philadelphia was Charles C. Hofman (1821–1882), a German immigrant who painted a series of views of almshouses from the 1860s until the 1880s. Because of periodic bouts of intemperance, Hofman found shelter in several almshouses, including those in Berks County and Montgomery County, and he painted scenes of each site for members of the staff or local citizens. In contrast to what must have been a bleak existence, Hofman's paintings of the buildings and activities throughout the compounds are presented in bright colors and show a seemingly placid, cheerful environment. Most of his views include a legend across the bottom that explains the scene and identifies the buildings. Hofman's pleasing, stylized views, painted in a fairly repetitive manner, indicate that the artist deliberately transformed a scene of grim reality so it would be remembered in a better light.

Fritz G. Vogt (1842–1900) drew small farms and villages in upstate New York from about 1890 until 1899. Using graphite and colored pencils on paper, Vogt minutely detailed residences that have been identified in Fulton, Herkimer, Montgomery, Otsego, and Schoharie counties. In his pictures, Vogt includes every detail in architectural ornamentation; farms are neat and tidy, and a general air of rural harmony and prosperity dominates the scene. He usually signed his pictures at the lower right, dated them at the lower left, and identified the owner of the dwelling across the bottom.

Paul A. Seifert (1840–1921) came to Wisconsin from Germany in the 1860s. Although he raised and sold fruits and flowers for

a living, and worked as a taxidermist, painting was a major preoccupation. From the 1870s until 1915, using watercolors, oils, and tempera, Seifert painted views of neighboring farms that are characterized by intricate detailing in architecture, trees, fences, animals, and farmers going about their daily tasks. Areas of bright colors contrast with linear patterns to create pleasing scenes of the Wisconsin countryside that are surprisingly sophisticated. It is known that Seifert traveled from site to site painting the views and sometimes identified the owner and included the location and date in the margin.

Joseph Shoemaker Russell (b. 1795), a native of New Bedford, Massachusetts, painted a series of watercolors accurately depicting architecture and interior decoration during the 1850s. Descended from a prosperous whaling family, Russell continued the business in 1818, in Philadelphia, where he established a store that sold oil lamps and New Bedford whale oil. While in Philadelphia, Russell, using watercolors on paper, created scenes showing local commercial buildings, including his own, complete with architectural details, goods for sale, advertising signs, and customers. Several particularly engaging pictures show the exterior and interiors of a boarding house, stylishly appointed with a horsehair settee and colorful carpeting. One of Russell's scenes, done from memory in the 1850s, shows the view from his father's mansion in New Bedford, surrounded by houses, looking down to the ocean and ships beyond.

Henry Walton (1804–1865), of Ithaca, New York, memorialized localities in upstate New York through a group of town views created from the 1830s to the 1850s. At first, Walton made small architectural drawings for publications; he learned the art of lithography in New York City in the late 1820s. From the mid-1830s, Walton drew, painted, and sometimes lithographed views of Addison County, Geneva, and Saratoga Springs, among others, but he is best known for his views of Ithaca. Walton's complex scenes documented buildings and topography and often included fashionably dressed figures walking, riding in carriages, or on horseback. The views, sold by subscription for one dollar and fifty cents in 1836, are invaluable records of the commerce and society of the Finger Lakes region of New York State.

WHAT TO LOOK FOR

CONDITION

In works on canvas, the canvas should be taut with no areas of buckling; the stretchers should be secure at the corners. The paint layer should be stable, showing no major losses; an overall, even crackling of paint is a good sign of age and, if not severe, is acceptable. For works of art on paper, check paper for acidification (brown discoloration and brittleness); wood-pulp paper, made after the mid-nineteenth century, will acidify, but rag paper, used prior to that time, will remain stable; surfaces, particularly in watercolors or drawings, will often show areas of dirt that can be cleaned easily by a qualified conservator.

GUIDELINES

Some of the most successful and valuable genre paintings document a scene or activity in great detail: figures are depicted at play or engaged in everyday tasks, with careful attention paid to costumes and tools; vehicles and buildings are realistically painted and animals are rendered in a lifelike manner. The most valuable town and farm views, too, show much detail: buildings and businesses may be identified and the farmyards appear prosperous and orderly. Collectors with an interest in architecture prize the town and farm views as they record different styles and changes in building methods and materials.

Most museums own both high-style and folk art genre scenes and afford an interesting opportunity to compare the examples visually.

FURTHER READING

Armstrong, Thomas N., III. "Joseph H. Hidley, 1830–1872." In *American Folk Painters of Three Centuries*, edited by Jean Lip-

man and Thomas N. Armstrong III. New York: Hudson Hills Press, in association with the Whitney Museum of American Art, 1980.

Jones, Leigh Rehner. *Artist of Ithaca: Henry Walton and His Odyssey.* Ithaca, N.Y.: Herbert F. Johnson Museum of Art, Cornell University, 1988.

Lipman, Jean. "Eunice Pinney, 1770–1849." In *American Folk Painters of Three Centuries,* edited by Jean Lipman and Thomas N. Armstrong, III. New York: Hudson Hills Press, in association with the Whitney Museum of American Art, 1980.

Rumford, Beatrix T., ed. *American Folk Paintings: Paintings and Drawings Other Than Portraits from the Abby Aldrich Rockefeller Folk Center.* Boston: Little, Brown, in association with the Colonial Williamsburg Foundation, 1988.

Shelley, Donald A. *Lewis Miller: Sketches and Chronicles.* York, Pa.: Historical Society of York County, 1966.

SILHOUETTES

The least expensive type of portraiture available in the early nineteenth century was the silhouette, also called "shadow picture," similar in scale to a miniature portrait. The name derives from Frenchman Étienne de Silhouette, a parsimonious eighteenth-century minister of finance to King Louis XV, who was an amateur profile portraitist. The word "silhouette" came to refer to anything cheap and was introduced to this country by artist Auguste Édouart (1789–1861) when he emigrated from France in 1839. Édouart cut silhouettes in America from about 1839 to 1849 in Boston, Washington, D.C., New Orleans, Philadelphia, Charleston, and New York City. Perhaps the best-known silhouette artist, Édouart often cut group silhouettes and embellished them with elegantly painted backgrounds.

Because they could be done quickly, silhouettes were economical for both artists and sitters. They were popular because an exact likeness could be obtained in a very short time. Solid-color

profiles, also called common profiles, cut with scissors, were of two types:

HOLLOW-CUT

In a hollow-cut profile, the sitter's image is cut away from paper or card; the card is then mounted on a dark background of paper or fabric, the contours of the paper defining the image.

CUT-AND-PASTE

In a cut-and-paste profile, the image is cut out of paper or card and adhered to another, contrasting backing. When the paper was doubled, two profiles could be cut at once. The duplicates could be kept by the artist to use as examples of his work.

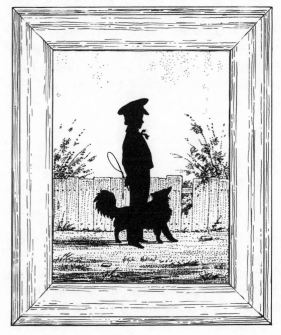

Silhouette portrait of Stephen Matlack and his dog, "Rush"; free-cut black paper on wash ground. Auguste Édouart, 1840

MECHANICAL

In another technique, the artist used a mechanical device to obtain an exact image of the sitter. The subject was placed in front of a glass plate, casting a shadow on the surface; the artist then traced the shadow through the glass plate onto tissue paper. Using a drafting instrument known as a pantograph, the life-sized image could be reduced to miniature scale.

In some cases, artists embellished the silhouettes by including details such as hair, hair ribbons, or facial details, painting them in watercolor or using pencil or ink. Side profile bust-length views were not the only silhouettes; artists cut full-length views and composed group views as well. Some also used printed bodies that were cut out, painted with watercolors, and attached to the silhouette.

Hundreds of artists, including Auguste Édouart, cut silhouettes during the late eighteenth and early nineteenth centuries, but few signed or marked their work. Researchers have identified several other silhouette artists: William M. S. Doyle (1796–1828) was a miniature portrait painter as well as a silhouette artist who worked in the Boston area. Moses Chapman (1783–1821) cut silhouettes in eastern Massachusetts about 1800. William Bache (1771–1845) was an itinerant silhouettist in Philadelphia; Richmond, Virginia; Salem, Massachusetts; and Hartford and New Haven, Connecticut.

WHAT TO LOOK FOR

CONDITION

Like most works made of paper, silhouettes are fragile. To check for authenticity, examine the condition of the paper: if the silhouette is framed, usually the paper will have darkened on the surface where it has been exposed to light; if it was lined with wood, the back of the piece will probably have become discolored.

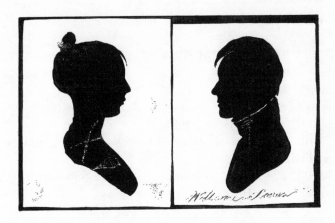

Hollow-cut silhouettes, from Peale's Museum Silhouette Book.
Isaac Collins, Philadelphia, 1830

GUIDELINES

The best profiles are well cut and have no ragged edges; fine details, such as eyelashes or wisps of hair, add great interest and value, as do pasted-on embellishments, such as indications of jewelry. The finest silhouettes, such as those cut by Édouart, feature minute details, such as tiny slit buttonholes and small slit collars. Full-standing or group silhouettes show greater expertise on the part of the artist and are sought by many collectors. Silhouettes of famous people, such as George Washington, were produced in great numbers and widely copied; they are available at reasonable prices.

Sometimes the history of a silhouette can be traced. The sitters in many silhouettes wear stylish costumes of the day; a brief review of fashion styles can help date the pictures. If the subjects have been identified or a location suggested, a quick check of local histories or genealogical sources might document the family and their dates.

Silhouettes can be found in most art museums, folk art collections, history museums, and historical societies.

FURTHER READING

Carrick, Alice Van Leer. *A History of American Silhouettes: A Collector's Guide, 1790–1840*. Rutland, Vt.: Charles E. Tuttle Company, 1968.

Jackson, Mrs. E. Nevill. *Silhouettes: A History and Dictionary of Artists*. New York: Dover, 1981.

Rifkin, Blume J. *Silhouettes in America, 1790–1840*. Burlington, Vt.: Paradigm Press, 1987.

Townsend, E. Jane. "Of Shade Cutters and Silhouettes." *The Clarion*, Winter 1979.

CALLIGRAPHIC DRAWINGS

Calligraphy—meaning "beautiful writing"—forms a small but interesting category of American folk art. Fanciful leaping deer, charging horses, and exotic animals were motifs used by instructors to teach students the art of penmanship, a necessary skill in the nineteenth century. Writing masters had taught penmanship in academies during the eighteenth century, but when public education became available, calligraphy was integrated into the curriculum.

Some communities had writing schools where students, adults as well as children, could learn business script, ledger work for everyday use, and ornamental penmanship and drawing for amusement. Business needs dictated that a person write legibly, but courses also emphasized the artistic side of pen-and-ink line work and embellishment. One of the major sources for calligraphic designs were copybooks that featured examples of fundamental lines and strokes necessary to acquire basic skills and motifs that could be copied as exercises or for exhibitions. Some popular designs, drawn separately or used in combination, included stags, eagles, horses, lions, tigers, birds, patriotic and military emblems, and, of course, the alphabet. Some instruction books were specialized, with lessons for businessmen, ladies, or children. Steel-nibbed pens, at first imported from England, then

manufactured in America, were used with ink to create the pictures that usually followed a fairly formulaic pattern.

Perhaps the most successful author of instruction books was Platt Rogers Spencer (1800–1864), inventor of the so-called Spencerian script, who produced numerous copybooks in the 1850s and employed his family as teachers and sales representatives. Some calligraphic drawings have the maker's name included in the design, but many remain anonymous. As products of students eager to demonstrate their dexterity in pen-and-ink, some of the drawings were hung on the wall as decoration and symbols of accomplishment.

WHAT TO LOOK FOR

CONDITION

Because many calligraphic drawings were done during the mid-nineteenth century on wood-pulp paper, acidification and discoloration are commonly found. The value will not be seriously affected if the discoloration or spotting does not interfere with the design.

GUIDELINES

Signed examples or those attributable to a particular school are fine examples for the collector. Some pictures that show combined motifs, such as an eagle and jumping horses, or soldiers in battle, are choice examples of the art. Pictures that have touches of color are of great interest, although monochromatic examples with interesting patterns are equally sought-after. Calligraphic drawings are available in large numbers and can be found at flea markets, antique shops, and auctions, where they can be purchased for modest prices. Some museums have examples of nineteenth-

century drawing or copybooks that can be researched to determine origins of a specific drawing. Local historical societies are usually good repositories of school records and references.

FURTHER READING

Johnson, Bruce. *Calligraphy: Why Not Learn to Write.* New York: Museum of American Folk Art, 1975.

Rumford, Beatrix, T., ed. *American Folk Paintings: Paintings and Drawings Other Than Portraits from the Abby Aldrich Rockefeller Folk Art Center.* Boston: Little, Brown, in association with the Colonial Williamsburg Foundation, 1988.

MINIATURE PORTRAITS

Collectors who love portraits but have limited display space might find that miniatures are a suitable alternative to full-size pictures. Rivaling large-scale portraits in intricacy of detail and delicacy of facial rendering, miniatures have become a popular collecting specialty. The portrait miniature had its origin in sixteenth-century England, where court painters produced likenesses of royalty and the aristocracy by painting in watercolor on thick card. Because of their small size, many were made into pieces of jewelry to be given to loved ones as symbols of endearment. In America, the earliest miniatures were painted by academically trained artists such as John Singleton Copley (1738–1815) of Boston and Charles Willson Peale (1741–1827) of Philadelphia during the 1760s and 1770s. Like their English prototypes, most of the likenesses were painted on ivory, a support that had come into popular use in the 1720s. Painted mainly for upper-class families of the mid-eighteenth century, American miniatures were also used as jewelry and were sometimes painted on commission to commemorate important occasions such as engagements, marriages, or deaths. Typically, the miniatures were painted in opaque watercolor on ivory and were oval in shape. Some were

as small as one inch by one inch, but a larger size, three inches high by two inches wide, was also commonly seen. The likenesses were protected by an oval cover glass and thin metal bezel. Made into lockets or brooches, the miniatures could be worn around the neck, pinned to clothing, or carried in a pocket.

Like their high-style counterparts, nineteenth-century folk painters, too, produced likenesses in miniature for their clients. For many, the small size afforded the opportunity to create a portrait in a short time, making them economical for both the artist and the subject. The medium of watercolor was suited to the faster methods. By the 1820s, miniatures were used less frequently as jewelry and were painted in a larger, rectangular format and hung on the wall. This new use afforded unlimited opportunity for the artist to create an intimate portrait at a reduced cost.

Some of the best-known folk artists worked in the miniature format:

Rufus Porter (1792–1884) painted dozens of miniature portraits throughout New England from about 1820 until about 1835. Working mainly in watercolor and ink on paper, Porter also offered for sale cut profiles (silhouettes), watercolor profiles, full-face watercolor portraits, and miniatures on ivory. Characteristically, Porter rendered the sitters in a side, half-length pose with delicate detail in faces and clothing. His full-face likenesses were done less frequently, probably because they were more expensive for the client.

Henry Walton (1804–1865), a New York State painter, created engaging miniature portraits in watercolor and ink in the 1830s and 1840s. Walton's sitters were frequently depicted full-length in room settings decorated with brightly colored, figured carpeting or landscapes filled with trees. He frequently included the name of the sitter and the date on the front of the composition.

Until recently, little was known about Joseph H. Davis (1811–1865), who painted more than 130 miniature portraits during the 1830s. Researchers have identified the artist as a resident of Limington, Maine, who worked in his home state and in New Hampshire. His watercolor portraits follow a fairly prescribed, set formula. The sitters are portrayed in profile, almost always placed

on a figured carpet or floor; they are often seated in elaborately grained chairs and are surrounded by children, pets, books, flowers, or other personal accessories; in a calligraphic script across the bottom of the composition, the artist identifies the sitters, notes their ages, and includes the date of the portrait.

Jane Anthony Davis (1821–1855), of Warwick, Rhode Island, drew and painted more than fifty-five distinctive miniature portraits, mainly of family and friends, during the 1840s. Working in pencil and watercolor on paper, the artist depicted the subjects both bust-length and full-standing; many of the seated figures seem to sit uncomfortably in their chairs in odd postures. Davis used a somber palette and included typical props, such as flowers and books, in the small pictures.

James Sanford Ellsworth (1802/3–1874?) completed a remarkable body of miniature profile portraits during the 1830s and 1840s. Working mainly in Massachusetts, Connecticut, and eastern New York State, Ellsworth created over 260 watercolor likenesses that show sitters in profile, often surrounded by a cloudlike halo. He carefully rendered the faces, and individual characteristics are clearly visible.

Jacob Maentel (1763?–1863), a German immigrant, worked in the Lancaster, Pennsylvania, area and, later, in Indiana picturing his family, neighbors, and associates from about 1809 until the 1850s. Maentel's early portraits, in watercolor on paper, show figures in profile, full-length, standing in a landscape. As his painting style developed, he included more detail in the backgrounds, and in the 1820s he began to pose the figures in frontal positions. Among the most successful Maentel portraits are those that show figures in interior scenes where the artist has included dozens of props—flowers, animals, books, stylized carpets, decorated furniture, and personal accessories—to define the characters and create a sense of place.

WHAT TO LOOK FOR

CONDITION

Miniature portraits that were drawn or painted on rag paper, made before the mid-nineteenth century, generally survive in good condition because the paper remains stable and does not acidify. (Rag paper will appear whiter, will often be watermarked, and will sometimes show lines that are evidence of the mold in which it was made.) Wood-pulp paper and board, used after the mid-nineteenth century, will darken, discolor, and become brittle as it acidifies. Ideally, the support should be stable, with no major tears, and the paint surface should be free of dirt. Since many miniatures are framed under glass, the backing should be checked to make certain that it is not acidifying and damaging the work of art. Particularly colorful paintings should be checked for fading; sometimes original colors can be seen when the frame or mat is removed. Cracks or splits in ivory supports greatly diminish the portrait's value.

GUIDELINES

Many collectors specialize in miniatures, and often they are included with silhouettes. The Maentel portraits showing sitters in interiors surrounded by props and decorations are especially desirable. Colorful interior scenes by Joseph H. Davis are sought by many collectors. Full-face Rufus Porter portraits are always popular and more valuable than most of his side views. Folk art portraits on ivory are rare, but are even more valuable when they come on the market. Anonymous portraits of anonymous sitters can be purchased at reasonable prices from a variety of sources, from flea markets and antiques dealers to art galleries and auction houses.

If the sitters have been identified in the portrait, their origins can sometimes be traced through census reports, genealogical records, and local histories. Sometimes, the location of the por-

trait's origin can be a clue to the artist's identity. Some artists who painted full-sized portraits also did miniatures, and vice versa. Attributions should not necessarily be limited by size if documented examples have been discovered.

FURTHER READING

Black, Mary. "Jacob Maentel (1763?–1863)." In *American Folk Painters of Three Centuries,* edited by Jean Lipman and Thomas N. Armstrong III. New York: Hudson Hills Press, in association with the Whitney Museum of American Art, 1980.

Bolton, Theodore. *Early American Portrait Painters in Miniature.* New York: Frederic Fairchild Sherman, 1921.

D'Ambrosio, Paul S., and Charlotte M. Emans. *Folk Art's Many Faces.* Cooperstown: New York State Historical Association, 1987.

Jones, Leigh Rehner. *Artist of Ithaca: Henry Walton and His Odyssey.* Ithaca, N.Y.: Herbert F. Johnson Museum of Art, Cornell University, 1988.

Kern, Arthur, and Sybil Kern. "J. A. Davis Identity Reviewed." *The Clarion,* Summer 1991.

———. "Joseph H. Davis: Identity Established." *The Clarion,* Summer 1989.

Lipman, Jean. *Rufus Porter Rediscovered.* New York: Clarkson N. Potter, Inc., 1980.

Muller, Nancy C. *Paintings and Drawings at the Shelburne Museum.* Shelburne, Vt.: Shelburne Museum, 1976.

Rumford, Beatrix T., ed. *American Folk Portraits, Paintings, and Drawings from the Abby Aldrich Rockefeller Folk Art Center.* Boston: New York Graphic Society, in association with the Colonial Williamsburg Foundation, 1981.

Savage, Gail, Norbert H. Savage, and Esther Sparks. *Three New England Watercolor Painters.* Chicago: The Art Institute of Chicago, 1974.

FOLK PORTRAITURE

By the 1820s, the population of the Northeast had increased dramatically, and citizens of the new middle class demanded portraits of themselves in record numbers. They had conquered and tamed the wilderness, established a republican society, and viewed themselves as the first true Americans. By having a portrait painted—heretofore a luxury enjoyed only by the upper class—they celebrated their achievements and validated their new social standing. As Frenchman Alexis de Tocqueville, a visitor to America, wrote in the 1830s: "Democratic people may amuse themselves momentarily by looking at nature, but it is about themselves that they are really excited." To meet the demand for portraits, craftsmen, such as coach, house, and sign painters, and talented (and not-so-talented) amateurs attempted to capture a sitter's "correct likeness"—the term used most often by these nineteenth-century artisan painters. With varying levels of success, they recorded thousands of faces—family, friends, neighbors, political allies, business acquaintances, and strangers—for posterity, creating one of the largest bodies of work in American art.

Painters created the images in a myriad of different ways, and styles therefore varied greatly from painter to painter. Some characteristics, however, are shared among hundreds of artists. Many portraits, in all media, are linear, or dependent on outlines to take their forms; faces appear flat with few or no contours; features, such as eyes or ears, may appear irregular or may be overemphasized; hair may appear to rest on the head rather than growing; anatomical perspective may be incorrect, showing limbs, torsos, and heads out of scale to each other; the body may be pictured in an awkward position; costume details are delineated with the utmost care and sometimes may dominate the sitter's face. In many cases, colors are dark or muted with bits of brightness seen only on the face. The most successful examples, however, are brightly painted visual masterpieces that display a winsome quality rarely seen in other types of portraiture. Small children, often shown full-length or life-sized, dressed in their finest clothes, hold their animals, toys, or baskets of flowers;

comely young mothers, wearing stylish, frilly bonnets and their best jewelry, proudly hold babies on their laps; serious-looking men are surrounded by books or other symbols of occupation or achievement. Many gaze directly at the viewer, reflecting the optimism and self-confidence that characterize their newly acquired social standing.

The stylistic precedents for such portraits can be found in the work of some painters of the colonial and Revolutionary periods. Very few portraits documented to the seventeenth and early eighteenth centuries survive in America; those that do show close visual ties to the Mannerist-style paintings of England and Europe. The artists of these highly stylized portraits emphasized decoration and surface pattern rather than the faces of the sitters. Other European influences, primarily Dutch, are seen in the work of a group of portraitists who were active in New York State, particularly near Albany in the early eighteenth century.

One of the most significant of the Albany group was Pieter Vanderlyn (c. 1687–1778), who portrayed members of the newly established, prosperous middle class. His style was dependent somewhat on European Renaissance models, but he attempted to individualize faces by making them the focal point of an overall design. Many of Vanderlyn's portraits, done in the 1730s and 1740s, show a sensitivity previously unseen in American painting.

By later in the century, a style of painting, mainly derived from the work of sophisticated Boston artists, developed among several portraitists in Connecticut that would also foreshadow folk portraiture of the nineteenth century.

Winthrop Chandler (1747–1790), of Woodstock, Connecticut, began painting life-sized portraits of his neighbors and acquaintances about 1770. The massive, straightforward likenesses show sitters garbed in their best clothing, surrounded by books or other indications of their middle-class status. An analysis of facial details reveals that the artist took great care to delineate the sitters' faces realistically.

A contemporary of Chandler, Ralph Earl (1751–1801), executed portraits in a similar but more technically accomplished manner for a similar clientele. Painting in a style influenced by

his exposure to Boston painter John Singleton Copley (1738–1815) and his travels in England, Earl pictured successful citizens of rural Connecticut in a manner remarkable for its scope and scale. Earl painted his subjects nearly life-sized, concentrated on their faces, and added details, such as landscapes or backgrounds, that indicated their occupations and social status. It is significant that Earl changed his style to accommodate different patrons; he painted in a more academic manner to suit his urban clients and in a plainer style to please the rural republicans.

Born a deaf-mute in Hampton, Connecticut, John Brewster, Jr. (1766–1854) was the son of an eminent physician. Brewster was fortunate to be reared in an enlightened household that encouraged his artistic talents and helped him to overcome his disability. Working in Connecticut and Maine, he painted full-sized and bust-length likenesses in a simple style that immediately captured the sitters' personalities. Faces are rendered with shading to produce natural, serene expressions. Like Chandler and Earl, Brewster included props or backgrounds to illustrate the social standing of the sitters. The colonial painters of New York State and the Connecticut folk painters of the late eighteenth century were a direct influence on the vast number of portraitists who recorded the faces of Jacksonian Americans during the nineteenth century.

Painting techniques and media varied widely among the hundreds of artisans who "took likenesses." Those who had access to urban markets often used commercially prepared artists' supplies; others in more isolated rural areas improvised with materials that could be purchased locally. This resulted in an extraordinarily diverse group of paintings, created from oil paints on canvas; oil on prepared wood panel (such as poplar); oil on wood planking; oil on cardboard; oil on glass (reverse glass painting); oil on other fabrics (such as mattress ticking); pastel on paper; watercolors on paper; pen, ink, and crayon on paper; and hundreds of other combinations that were dictated by the artists' whims and the materials that were readily available.

Styles also were exceptionally diverse and depended largely on the training (if any) and talent of the artist. Some painters,

such as Erastus Salisbury Field (1805–1900), had some instruction from academic painters of the period. For three months in 1824, Field studied in the New York City studio of Samuel F. B. Morse (1791–1872), known at that time as a celebrated portrait painter rather than an inventor. Others, such as William Matthew Prior (1806–1873), were exposed to the work of high-style painters in the city. It is known that Prior studied the work of society portraitist Gilbert Stuart (1755–1828) in Boston. Still others, such as Joseph Whiting Stock (1815–1855), relied on drawing books, anatomical studies, and art treatises to improve their talents. Many brought skills learned from ornamental painting to the portraits. John S. Blunt (1798–1835) did military, sign, and Masonic painting and gilded ship ornaments; M. W. Hopkins (1789–1844) worked at house, sign, and fancy painting, and decorated chairs; and Rufus Porter (1792–1884), the miniature painter, was also noted for his wall murals and decorations. Gifted amateurs, such as Ruth Henshaw Bascom (1772–1848), painted portraits more for pleasure than monetary compensation. One of the most technically accomplished portraitists, Ammi Phillips (1788–1865), whose training, if any, has not yet been discovered, worked in three distinctly different styles over a period of about sixty years. The artistic backgrounds of countless others remain obscure.

The introduction of the daguerreotype (the first photographic process) to America from France in 1839 affected the portrait painters significantly. Some lost commissions to the practicing daguerreotypists, who could produce a sitter's exact image in a short time. Some painters attempted to paint in the realistic manner of the daguerreotype, and others learned the process themselves. As photography became the medium of choice to capture likenesses in the 1850s, the earlier portraits were considered old-fashioned and went out of favor.

Over the past fifty years, research on individual portrait painters has revealed not only biographical information but has shattered some of the myths that first surrounded them. Many early folk art histories described the artists as "outsiders" segregated from mainstream society, traveling throughout the countryside randomly searching for commissions. Recent studies have shown,

however, that many were established citizens who owned land, participated in civic affairs, and pictured sitters who were related through a network of family, social, or business connections. Many participated in social reform movements of the period. Some, such as William Matthew Prior, M. W. Hopkins, Noah North (1809–1880), Deacon Robert Peckham (1785–1877), and Sheldon Peck (1797–1868), among others, were well-known as Abolitionists, antislavery activists, and temperance advocates. Vermont portraitist Horace Bundy (1814–1883) was an Adventist minister, and Susan C. Waters (1823–1900) was an early supporter of woman's suffrage.

In many folk art histories, it has been assumed or implied that the artists were full-time portraitists. Recent research has revealed that many artists had to pursue a number of diverse vocations to support themselves and their families. It appears that they were "part-time" painters who developed shorthand solutions to problems of perspective, rendering, and modeling that allowed them to obtain accurate likenesses but afforded little opportunity for stylistic development.

New studies by cultural historians have included portrait painters as members of a group of "artisan-entrepreneurs" who transformed the nineteenth-century rural economy. By creating likenesses that were emblems of social status, the painters helped to generate a commercial market for scarce commodities in rural areas.

The meaning and appropriate interpretation of nineteenth-century folk art portraits continues to be debated among art historians, who stress aesthetic values, and cultural historians and folklorists, who emphasize social implications. Regardless of the point of view, the opportunity to come face to face with images of our ancestors offers an enlightening glimpse into the past.

WHAT TO LOOK FOR

CONDITION

For paintings on canvas, the support should be tight with no tears or areas of buckling; the stretchers should be sturdy and

the corner joints tight; the paint layer should be stable with no areas of major loss; some crackling of the paint layer is to be expected and is a good indication of age. Minor areas of wear or damage diminish the value but are of little concern unless they are in the face or body areas. Many portraits done in oil on wood suffer cracks and resultant paint loss, which decrease the value; unless the damage is major, overall wear, nicks, or abrasion are acceptable if not in a major part of the composition. Wood panel paintings that are seriously warped have a lower value.

For works of art on paper or cardboard, check for acidification (brittleness and discoloration) and surface dirt. Works in good condition are always more valuable than those that have been damaged. If a pastel picture is framed under glass, DO NOT unframe it; some of the medium could be lost as a result. Examination of paintings with an ultraviolet light (commercially available at reasonable prices) in a darkened room can reveal areas of overpainting, repairs, or previous images.

GUIDELINES

Unquestionably, the most valuable portraits sought by collectors are those of children, dressed in colorful clothing, with toys and pets at their side. If the portrait is signed, the sitter identified, and the date or location included, it becomes a high-value folk art treasure. Portraits of two or more children also command high prices. Portraits of attractive young women wearing their finest bonnets and clothing are also valuable, and sometimes pairs of portraits are equally as popular. Single portraits of men wearing somber clothing are not as visually exciting for collectors and bring much lower prices. Those done in a reasonably amateurish manner are equally as valuable as those painted realistically; in fact, some collectors prefer the portraits that are less technically accomplished. Documented (signed and dated) paintings are always desirable, but an aesthetically bad picture, even if it was done by a well-known artist, is seldom a wise investment.

In fact, prices vary widely in the work of single, known artists; a "masterpiece" may sell for $50,000 or so, but a less successful portrait may bring only a few thousand dollars in a sale. When the name or location of the sitter is known, some portraits can be researched by using genealogies and local histories. Sometimes they can be attributed to a particular artist, based on style and knowledge of the sitter's and artist's whereabouts. Some recently created paintings, done on old canvas and represented as authentic, have fooled the most knowledgeable experts. Generally, if a painting contains every component imaginable (an adorable child, frisky pets, baskets of flowers, painted furnishings, toys) or looks "too good to be true," caution should be taken before purchase, and the painting should be thoroughly researched to determine authenticity. Proof of provenance (who owned the portrait, where, and for how long) helps to prove that the portrait is original.

Most folk art museums, art museums, historical societies, and restored villages have portrait collections that can be viewed and studied to learn about various artists and their styles. Comprehensive collections of folk portraits can be found at the Abby Aldrich Rockefeller Folk Art Center, Williamsburg, Virginia; the Fruitlands Museums, Harvard, Massachusetts; Genesee Country Museum, Mumford, New York; New York State Historical Association, Cooperstown; Old Sturbridge Village, Sturbridge, Massachusetts; and the Shelburne Museum, Shelburne, Vermont.

Many large art and history museums, as well as historical societies, have folk portraits in their collections: Albany Institute of History and Art, Albany, New York; The Art Institute of Chicago; Chicago Historical Society; Cincinnati Historical Society; Connecticut Historical Society, Hartford; Memorial Art Gallery, University of Rochester, New York; Metropolitan Museum of Art, New York City; Museum of Fine Arts, Boston; National Gallery of Art, Washington, D.C.; Ohio Historical Society, Columbus; Princeton University Art Museum, Princeton, New Jersey; Western Reserve Historical Society, Cleveland; and the Whitney Museum of American Art, New York City. The

Museum of American Folk Art, New York City, regularly mounts exhibitions focusing on the work of nineteenth- and twentieth-century folk portraitists.

THE HUNDRED
BEST-KNOWN
FOLK PORTRAITISTS

Not surprisingly, the styles of portrait painters are significantly varied. By studying different signed or attributed portraits, and comparing and contrasting them to others, the viewer can learn to differentiate the artists. While enjoying the portraits aesthetically, the novice can train the eye to recognize the work of one painter from another.

The following list includes basic information about one hundred documented American folk portrait painters: their dates, the major locations where they worked, the media they used, and a major book or article reference for further study. It is comprehensive but not definitive, because folk art research continues and changes daily. New studies may prove that the artists painted in additional locations and media; the listing, however, can be used as a guide for folk art enthusiasts to gain further information and develop connoisseurship.

Andrews, Ambrose
Active 1824–1859.
Schuylerville, Troy, New York; Stockbridge, Massachusetts; New Haven, Connecticut; New Orleans, Louisiana.
Oil on canvas.
"Primitives on View in Chicago," *The Magazine Antiques,* November 1950.

Arnold, John James Trumbull
1812–c. 1865.
York County, Pennsylvania; West Virginia; Virginia; maybe Washington, D.C.

Watercolor, pencil, ink on paper; oil on canvas.

Beatrix T. Rumford, ed., *American Folk Portraits: Paintings and Drawings from the Abby Aldrich Rockefeller Folk Art Center* (Boston: Little, Brown, 1981).

Badger, Joseph
1708–1765.
Boston, Massachusetts.
Oil on canvas.

Beatrix T. Rumford, ed., *American Folk Portraits: Paintings and Drawings from the Abby Aldrich Rockefeller Folk Art Center* (Boston: Little, Brown, 1981).

Balis, Calvin
c. 1817–after 1856.
Utica, New York, area.
Oil on canvas.

Cynthia Sutherland, "The Search for the Elusive C. Balis," *The Clarion,* Fall 1984.

Bartlett, Jonathan Adams
1817–1902.
South Rumford, Maine.
Oil on canvas.

J. E. Martin, *Jonathan Adams Bartlett (1817–1902): Folk Artist from Rumford Center, Maine* (Rumford, Maine, 1976).

Bartoll, William Thompson
1817–1859.
Probably Marblehead, Massachusetts.
Oil on canvas.

Narcissa G. Chamberlain, "William T. Bartoll, Marblehead Painter," *The Magazine Antiques,* November 1982.

Bascom, Ruth Henshaw
1772–1848.
Franklin County, Massachusetts.
Pastel on paper; tinfoil, crayon on paper.

Mary Eileen Fouratt, "Ruth Henshaw Bascom: Itinerant Portraitist," *Worcester Art Museum Journal,* 5, 1981–82.

The Beardsley Limner (a.k.a. Sarah Perkins?)
Active 1785–1805.
Connecticut; Massachusetts.
Oil on canvas.
Christine Skeeles Schloss, "The Beardsley Limner and Some of His Contemporaries," Exhibition Catalogue, Abby Aldrich Rockefeller Folk Art Center, 1972; Colleen Cowles Heslip and Helen Kellogg, "The Beardsley Limner Identified as Sarah Perkins," *The Magazine Antiques,* September 1984.

Bears, Orlando Hand
1811–1851.
New York, Connecticut.
Oil on canvas.
Nancy C. Muller, *Paintings and Drawings from the Shelburne Museum* (Shelburne, Vt.: Shelburne Museum, 1976).

Belknap, Zedekiah
1781–1858.
Massachusetts, New Hampshire, Vermont.
Oil on wood panel; oil on canvas.
Elizabeth R. Mankin, "Zedekiah Belknap," *The Magazine Antiques,* November 1976.

Billings, Richardson
1815–1847.
Vermont.
Oil on wood panel.
Agnes M. Dods, "Connecticut Valley Painters," *The Magazine Antiques,* October 1944.

Blunt, John S.
1798–1835.
Portsmouth, New Hampshire; coastal New England; Providence, Rhode Island.
Oil on canvas.
Robert Bishop, "John S. Blunt," *The Magazine Antiques,* November 1977.

Blyth, Benjamin
c. 1746–c. 1787.

Salem, Massachusetts.

Pastel on paper.

Ruth Townsend Cole, "Limned by Blyth," *The Magazine Antiques,*
April 1956.

Bradley, J. (?)

Active 1831–47.

New York City.

Oil on canvas.

Mary Childs Black and Stuart Feld, "Drawn by I. Bradley from
Great Britton," *The Magazine Antiques,* October 1966.

Brewster, John, Jr.

1766–1854.

Maine; Massachusetts; Connecticut; eastern New York.

Oil on canvas.

Nina Fletcher Little, "John Brewster, Jr., 1766–1854: Deaf-Mute
Portrait Painter of Connecticut and Maine," *Connecticut Historical Society Bulletin,* October 1960.

Broadbent, Dr. Samuel

1759–1828.

Wethersfield, Connecticut, area.

Oil on canvas.

William Lamson Warren, "Dr. Samuel Broadbent, 1759–1828:
Itinerant Limner," *Connecticut Historical Society Bulletin,* October
1973.

Brokaw, D. (David?)

Active 1830s.

Rochester, New York area; Oberlin, Ohio.

Oil on canvas.

Marcia Goldberg and Molly Anderson, *Ancestors* (Oberlin, Oh.:
Oberlin College, 1980).

Brown, J.

Active 1803–1808.

Massachusetts.

Oil on canvas.

Paul S. D'Ambrosio and Charlotte M. Emans, *Folk Art's Many*

Faces: Portraits in the Collection of the New York State Historical Association (Cooperstown: New York State Historical Association, 1987).

Brunton, Richard
d. 1832.
Connecticut.
Oil on canvas.
William L. Warren, "Richard Brunton, Itinerant Craftsman," *Art in America,* April 1951.

Budington, Jonathan
1779–1823?
Fairfield, Connecticut area.
Oil on canvas.
Nina Fletcher Little, "Little-Known Connecticut Artists, 1790–1810," *Connecticut Historical Society Bulletin,* October 1957.

Bundy, Horace
1814–1883.
Vermont, New Hampshire.
Oil on canvas.
Hortense O. Shepard, "Pilgrim's Progress: Horace Bundy and His Paintings," *The Magazine Antiques,* October 1964.

Canfield, Abijah
1769–1830.
Derby, Connecticut.
Oil on canvas.
Kenneth Scott, "Abijah Canfield of Connecticut," *The Magazine Antiques,* March 1951.

Chandler, Joseph Goodhue
1813–1884.
Northwestern Massachusetts.
Oil on canvas.
John W. Keefe, "Joseph Goodhue Chandler (1813–1884): Itinerant Painter of the Connecticut River Valley," *The Magazine Antiques,* November 1972.

Chandler, Winthrop
1747–1790.

Woodstock, Connecticut; Worcester and Boston, Massachusetts.
Oil on canvas.
Nina Fletcher Little, "Winthrop Chandler," *Art in America,* April
1947.

Cook, Nelson
1817–1892.
Saratoga and Rochester, New York.
Oil on canvas.
Nancy C. Muller, *Paintings and Drawings at the Shelburne Museum*
(Shelburne, Vt.: Shelburne Museum, 1976).

Corwin, Salmon W.
1829–1855.
Massachusetts, New York.
Oil on canvas.
Beatrix T. Rumford, ed., *American Folk Portraits: Paintings and
Drawings from the Abby Aldrich Rockefeller Folk Art Center* (Boston:
Little, Brown, 1981).

Crafft, R. B.
Active 1836–1866.
Indiana; Kentucky; possibly Tennessee.
Oil on canvas.
Beatrix T. Rumford, ed., *American Folk Portraits: Paintings and
Drawings from the Abby Aldrich Rockefeller Folk Art Center* (Boston:
Little, Brown, 1981).

Dalee, Justus
Active 1826–1847.
Connecticut; Albany, Buffalo, Rochester, and Troy, New York.
Watercolor, pencil, ink on paper.
Beatrix T. Rumford, ed., *American Folk Portraits: Paintings and
Drawings from the Abby Aldrich Rockefeller Folk Art Center* (Boston:
Little, Brown, 1981).

Darby, Henry
c. 1828-29–1897.
Washington, D.C.; New York City; New York State.
Oil on canvas.
Laura C. Luckey, "Family Portraits at the Museum of Fine Arts,
Boston," *The Magazine Antiques,* November 1976.

Davenport, Patrick Henry
1803–1890.
Kentucky.
Oil on wood panel.
Charles Pettenger, Jr., and Elizabeth Perkins, *Patrick Henry Davenport, Kentucky Portrait Maker* (Frankfort, Ky.: Kentucky History Museum, 1982).

Davis, J. A. (Jane Anthony)
Active 1832–1854.
Rhode Island; Connecticut.
Watercolor, pencil on paper.
Arthur and Sybil Kern, "J. A. Davis Identity Reviewed," *The Clarion*, Summer, 1991.

Davis, Joseph H.
Active 1832–37.
Maine; New Hampshire.
Watercolor, pencil, ink on paper.
Gail and Norbert Savage and Esther Sparks, *Three New England Watercolor Painters* (Chicago: The Art Institute of Chicago, 1974).

Earl, Ralph
1751–1801.
Connecticut; Massachusetts; England; New York City.
Oil on canvas.
Elizabeth Mankin Kornhauser, *Ralph Earl: The Face of the Young Republic* (Hartford, Ct.: Wadsworth Atheneum, 1991).

Ellis, A.
Active c. 1830.
Readfield, Maine, area.
Oil, pencil on wood panel.
Paul S. D'Ambrosio and Charlotte M. Emans, *Folk Art's Many Faces: Portraits in the New York State Historical Association* (Cooperstown: New York State Historical Association, 1987).

Ellsworth, James Sanford
1802/3–1874?
Connecticut; western Massachusetts; maybe New York State.

Watercolor on paper.

Lucy B. Mitchell, *The Paintings of James Sanford Ellsworth: Itinerant Folk Artist 1802–1873* (Williamsburg: Abby Aldrich Rockefeller Folk Art Center, 1974).

Emmons, Alexander H.

1816–?

Hartford and Norwich, Connecticut.

Watercolor on paper.

Frederic Fairchild Sherman, "American Miniatures by Minor Artists," *The Magazine Antiques*, May 1930.

Evans, J.

Active 1827–34.

Portsmouth, New Hampshire; Boston, Massachusetts.

Watercolor on paper/board.

Gail and Norbert Savage and Esther Sparks, *Three New England Watercolor Painters* (Chicago: The Art Institute of Chicago, 1974).

Field, Erastus Salisbury

1805–1900.

Leverett, Massachusetts; western Massachusetts.

Oil on canvas.

Mary Black, *Erastus Salisbury Field: 1805–1900* (Springfield, Mass.: Museum of Fine Arts, 1984).

Finch, E. E.

Active 1833–50.

Maine.

Oil on canvas; pen and ink on paper.

Jean Lipman and Alice Winchester, *Primitive Painters in America, 1750–1850: An Anthology* (New York: Dodd, Mead, 1950).

Fisher, Jonathan

1768–1847.

Blue Hill, Maine.

Oil on canvas.

Alice Winchester, *Versatile Yankee: The Art of Jonathan Fisher* (Princeton, N.J.: Pyne Press, 1973).

Fitch, Captain Simon
1758–1835.
Connecticut.
Oil on canvas.
William Lamson Warren, "Captain Simon Fitch of Lebanon, 1758–1835: Portrait Painter," *Connecticut Historical Society Bulletin*, October 1961.

Fletcher, Aaron Dean
1817–1902.
Vermont; Essex County area, New York; Indiana.
Oil on canvas.
Virginia M. Burdick and Nancy C. Muller, "Aaron Dean Fletcher, Portrait Painter," *The Magazine Antiques*, January 1979.

Freeman, George
1789–1868.
Albany and Utica areas, New York; Montreal; England; Philadelphia, Pennsylvania; Hartford, Connecticut; Boston, Massachusetts; Baltimore, Maryland.
Watercolor on paper.
Paul S. D'Ambrosio and Charlotte M. Emans, *Folk Art's Many Faces: Portraits in the New York State Historical Association* (Cooperstown: New York State Historical Association, 1987).

Gassner, George
1811–1861.
Boston and Lowell, Massachusetts.
Oil on canvas.
Nina Fletcher Little, *Little by Little* (New York: E. P. Dutton, 1984).

Gillespie, J. H.
Active 1828–38.
Maine; Baltimore, Maryland; Philadelphia, Pennsylvania.
Watercolor, gouache, pencil on paper.
Beatrix T. Rumford, ed., *American Folk Portraits: Paintings and Drawings from the Abby Aldrich Rockefeller Folk Art Center* (Boston: Little, Brown, 1981).

Goldsmith, Deborah
1808–1836.
Central New York.
Watercolor, pencil on paper.
Sandra C. Shaffer, "Deborah Goldsmith, 1808–1836: A Naive Artist in Upstate New York." (M.A. thesis, State University of New York, 1975).

Goodell, Ira Chaffee
1800–c. 1875.
New York City; Columbia County, New York; Massachusetts.
Oil on wood panel.
Ruth Piwonka and Cynthia Seibels, *Painted by Ira C. Goodell* (Kinderhook, N.Y.: Columbia County Historical Society, 1977).

Goodwin, Edwin Weyburn
1800–1845.
Albany, Auburn, and Ithaca, New York, areas.
Oil on canvas.
"The Editor's Attic," *The Magazine Antiques,* March 1951; "The Editor's Attic," *The Magazine Antiques,* September 1944.

Greenleaf, Benjamin
1769–1821.
Massachusetts; New Hampshire; Maine.
Oil on glass; oil on canvas; oil on wood panel.
Sybil B. and Arthur B. Kern, "Benjamin Greenleaf: Nineteenth-Century Portrait Painter," *The Clarion,* Spring/Summer 1985.

Greenwood, Ethan Allen
1779–1856.
Boston and Hubbardston, Massachusetts.
Oil on canvas.
Clara Endicott Sears, *Some American Primitives* (Boston: Houghton, Mifflin, 1947).

Guild, James
1797–1841.
Vermont; New York; New York City; Boston, Massachusetts; Baltimore, Maryland.
Oil on wood panel.

Arthur and Sybil Kern, "James Guild: Quintessential Itinerant Portrait Painter," *The Clarion,* Summer 1992.

Hamblin, Sturtevant J.
Active 1837–56.
Maine; Boston, Massachusetts.
Oil on canvas; oil on board.
Paul S. D'Ambrosio and Charlotte M. Emans, *Folk Art's Many Faces: Portraits in the New York State Historical Association* (Cooperstown: New York State Historical Association, 1987).

Hanks, Jarvis (Jervis) F.
1799–c. 1852.
Cleveland and Cincinnati, Ohio; New York.
Oil on canvas.
Nancy C. Muller, *Paintings and Drawings from the Shelburne Museum* (Shelburne, Vt.: Shelburne Museum, 1976).

Hartwell, George C.
1815–1901.
Massachusetts; Maine.
Oil on canvas; oil on board.
Colleen Cowles Heslip, *But Were They Good Likenesses?* (New York: Hirschl and Adler Folk, 1989).

Hathaway, Rufus
1770–1822.
Duxbury, Massachusetts.
Oil on canvas.
Nina Fletcher Little, "Doctor Rufus Hathaway, Physician and Painter of Duxbury, Massachusetts: 1770–1822," *Art in America,* Summer 1953.

Hopkins, M[ilton]. W[illiam].
1789–1844.
Genesee, Orleans County, New York, area; Cleveland, Columbus, and Cincinnati, Ohio.
Oil on wood panel; oil on canvas.
Jacquelyn Oak et al., *Face to Face: M. W. Hopkins and Noah North* (Lexington, Mass.: Museum of Our National Heritage, 1989).

Howes, Samuel P.
1806–1881.
Lowell, Massachusetts, area.
Oil on canvas.
Paul S. D'Ambrosio, *Samuel P. Howes: Portrait Painter* (Lowell, Mass.: Whistler House Museum, 1986).

Jennys, Richard
Active 1766–98.
Connecticut; Charleston, South Carolina; Savannah, Georgia.
Oil on canvas.
William Lamson Warren, "The Jennys Portraits," *Connecticut Historical Society Bulletin*, October 1955.

Jennys, William
Active 1793–1807.
Connecticut; New York City; Massachusetts; Vermont; New Hampshire.
Oil on canvas.
William Lamson Warren, "The Jennys Portraits," *Connecticut Historical Society Bulletin*, October 1955.

Johnson, Joshua
Active 1800–1824.
Baltimore, Maryland.
Oil on canvas.
Carolyn J. Weekley et al. *Joshua Johnson*. (Baltimore, Md.: Maryland Historical Society, 1987).

Jordan, Samuel
1803/4–after 1831.
Boston, Massachusetts; New Hampshire.
Oil on canvas.
Paul S. D'Ambrosio and Charlotte M. Emans, *Folk Art's Many Faces: Portraits in the New York State Historical Association* (Cooperstown: New York State Historical Association, 1987).

Kemmelmeyer, Frederick
Active 1788–1816.
Maryland; Alexandria, Virginia.
Pastel on paper; oil on canvas; oil on paper; oil on cardboard.

E. Bryding Adams, "Frederick Kemmelmeyer, Maryland Itinerant Artist," *The Magazine Antiques,* January 1984.

Kennedy, William W.
1818–after 1870.
Oil on canvas; oil on board.
Beatrix T. Rumford, ed., *American Folk Portraits: Paintings and Drawings from the Abby Aldrich Rockefeller Folk Art Center* (Boston: Little, Brown, 1981).

Maentel, Jacob
1763–1863.
New Harmony, Indiana; Pennsylvania.
Watercolor, ink, gouache on paper.
Mary Black, "Jacob Maentel, 1763?–1863," in *American Folk Painters of Three Centuries,* ed. Jean Lipman and Thomas N. Armstrong III (New York: Whitney Museum of American Art, 1980).

Mason, Benjamin Franklin
1804–1871.
Vermont; Boston, Massachusetts; Buffalo, New York.
Oil on canvas.
Alfred Frankenstein and Arthur K. D. Healy, *Two Journeyman Painters* (Middlebury, Vt.: The Sheldon Museum, 1950).

Mason, Sanford
1798–1865.
Rhode Island; Connecticut; Boston, Massachusetts.
Oil on canvas.
Meet Your Neighbors (Sturbridge, Mass.: Old Sturbridge Village, 1992).

Miller, Samuel
c. 1807–1853.
Charlestown, Massachusetts.
Oil on canvas.
Paul S. D'Ambrosio and Charlotte M. Emans, *Folk Art's Many Faces: Portraits in the New York State Historical Association* (Cooperstown: New York State Historical Association, 1987).

Mote, Marcus
1817–1898.

Lebanon, Ohio.

Oil on canvas.

Hazel Spencer Phillips, "Marcus Mote of Ohio," *The Magazine Antiques,* March 1951.

Moulthrop, Reuben

1763–1814.

Connecticut.

Oil on canvas.

Ralph W. Thomas, "Reuben Moulthrop, 1763–1814," *Connecticut Historical Society Bulletin,* October 1956.

Negus, Nathan

1801–1825.

Western Massachusetts; Boston, Massachusetts; Savannah, Georgia; Mobile, Alabama.

Oil on canvas.

Agnes M. Dods, "Connecticut Valley Painters," *The Magazine Antiques,* October 1944.

North, Noah

1809–1880.

Genesee and Orleans counties, New York, areas; Cleveland and Cincinnati, Ohio.

Oil on wood panel; oil on canvas.

Jacquelyn Oak et al., *Face to Face: M. W. Hopkins and Noah North* (Lexington, Mass.: Museum of Our National Heritage, 1989).

Palmer, Randall

1807–1845.

Albany, Syracuse, and Rochester areas, New York.

Oil on canvas.

Laurence B. Goodrich, "Randall Palmer (1807–1845): Artist of Seneca Falls and Auburn, New York," *New York History,* April 1964.

Park, Asa

?–1827.

Lexington, Kentucky.

Oil on canvas.

Nina Fletcher Little, *Little by Little* (New York, E. P. Dutton, 1984).

Peck, Sheldon
1797–1868.
Vermont; New York; Illinois.
Oil on wood panel; oil on canvas.
Marianne Balazs, "Sheldon Peck," *The Magazine Antiques,* August
1975.

Peckham, Deacon Robert
1785–1877.
Northampton, Massachusetts; Worcester County, Massachu-
setts.
Oil on cardboard; oil on canvas.
Dale T. Johnson, "Deacon Robert Peckham, Delineator of the
'Human Face Divine,' " *American Art Journal,* January 1979.

Penniman, John Ritto
1782–1841.
Boston, Massachusetts, area.
Oil on canvas; watercolor on paper.
Carol Damon Andrews, "John Ritto Penniman (1782–1841), an
Ingenious New England Artist," *The Magazine Antiques,* July 1981.

Perkins, Sarah (a.k.a. The Beardsley Limner?)
Active 1785–1805.
Connecticut.
Oil on canvas.
Christine Skeeles Schloss, *The Beardsley Limner and Some of His
Contemporaries* (Williamsburg, Va.: Abby Aldrich Rockefeller
Folk Art Center, 1972); Colleen Cowles Heslip and Helen Kel-
logg, "The Beardsley Limner Identified as Sarah Perkins," *The
Magazine Antiques,* September 1984.

Phillips, Ammi
1788–1865.
Western Connecticut; western Massachusetts; Columbia County,
New York, area.
Oil on canvas.
Barbara C. and Lawrence B. Holdridge with Mary Black, *Ammi
Phillips: Portrait Painter, 1788–1865* (New York: Clarkson N.
Potter, 1968).

Polk, Charles Peale
1767–1822.
Maryland; Virginia.
Oil on canvas.
Linda Crocker Simmons, *Charles Peale Polk 1767–1822: A Limner and His Likenesses* (Washington, D.C.: Corcoran Gallery of Art, 1981).

Pollard, Luke
Active c. 1840.
Massachusetts.
Oil on canvas.
Clara Endicott Sears, *Some American Primitives* (Boston: Houghton Mifflin, 1941).

Porter, Rufus
1792–1884.
New England; Virginia.
Watercolor, ink on paper.
Jean Lipman, *Rufus Porter: Yankee Pioneer* (New York: Clarkson N. Potter, 1969).

Powers, Asahel Lynde
1813–1843.
Springfield, Vermont, area.
Oil on wood panel.
Nina Fletcher Little, *Asahel Powers: Painter of Vermont Faces* (Williamsburg, Va.: Abby Aldrich Rockefeller Folk Art Center, 1973).

Prince, Luke
Active 1840s.
Haverhill and Beverly, Massachusetts.
Oil on canvas.
Jean Lipman and Alice Winchester, *Primitive Painters in America, 1750–1850: An Anthology* (New York: Dodd, Mead, 1950).

Prior, William Matthew
1806–1873.
Maine; Massachusetts.
Oil on canvas; oil on board; oil on glass.

Paul S. D'Ambrosio and Charlotte M. Emans, *Folk Art's Many Faces: Portraits in the New York State Historical Association* (Cooperstown: New York State Historical Association, 1987).

Ryder, David
Active 1848.
Probably Middleboro, Massachusetts.
Oil on canvas.
Beatrix T. Rumford, ed., *American Folk Portraits: Paintings and Drawings from the Abby Aldrich Rockefeller Folk Art Center* (Boston: Little, Brown, 1981).

Sheffield, Isaac
1798–1845.
New London, Connecticut, area.
Oil on canvas.
Edgar deN. Mayhew, "Isaac Sheffield, Connecticut Limner," *The Magazine Antiques*, November 1963.

Shute, Ruth Whittier, and Shute, Dr. Samuel Addison
1803–1882; 1803–1836.
New Hampshire; Massachusetts; Vermont; New York.
Watercolor on paper; oil on canvas.
Helen Kellogg, "Ruth W. and Samuel A. Shute (1803–?; 1803–1836)," in *American Folk Painters of Three Centuries,* ed. Jean Lipman and Thomas N. Armstrong III (New York: Whitney Museum of American Art, 1980).

Slafter, Alonzo
1801–1864.
Vermont; New Hampshire; Massachusetts.
Oil on canvas.
"Museum Accessions," *The Magazine Antiques*, November 1976.

Smith, Royall Brewster
1801–1855.
Maine.
Oil on canvas.
Arthur and Sybil Kern, "Painted by Royall B. Smith," *The Clarion*, Spring 1988.

Steward, Joseph
1753–1822.
Connecticut.
Oil on canvas.
Newton C. Brainard, "Joseph Steward and the Hartford Museum," *Connecticut Historical Society Bulletin,* January–April 1953.

Stock, Joseph Whiting
1815–1855.
Springfield, Massachusetts, area; Connecticut; Rhode Island; New York.
Oil on canvas.
Juliette Tomlinson, ed., *The Paintings and Journal of Joseph Whiting Stock* (Middletown, Ct.: Wesleyan University Press, 1976).

Thompson, Cephas
1755–1856.
New England; South Carolina.
Oil on canvas; oil on panel.
Beatrix T. Rumford, ed., *American Folk Portraits: Paintings and Drawings from the Abby Aldrich Rockefeller Folk Art Center* (Boston: Little, Brown, 1981).

Utley, William Lawrence
1813–1887.
Genesee County, New York; Ohio.
Oil on canvas.
Lynette F. Rhodes, *American Folk Art from the Traditional to the Naïve* (Cleveland: Cleveland Museum of Art, 1978).

Vanderlyn, Pieter
c. 1687–1778.
Albany, New York, area.
Oil on canvas.
Mary Black, "Pieter Vanderlyn, c. 1687–1778," in *American Folk Painters of Three Centuries,* ed. Jean Lipman and Thomas N. Armstrong III (New York: Whitney Museum of American Art, 1980).

Wales, Nathaniel F.
Active 1803–15.

Connecticut.

Oil on canvas.

Nina Fletcher Little, "Little-Known Connecticut Artists, 1790–1810," *Connecticut Historical Society Bulletin*, October 1957.

Walton, Henry

1804–1865.

Ithaca, New York, area.

Oil on canvas; watercolor on paper.

Leigh Rehner Jones, *Artist of Ithaca: Henry Walton and His Odyssey* (Ithaca, N.Y.: Herbert F. Johnson Museum of Art, Cornell University, 1988).

Ware, Thomas

1803–1826/7.

Woodstock, Vermont.

Oil on canvas.

Arthur B. and Sybil B. Kern, "Thomas Ware: Vermont Portrait Painter," *The Clarion*, January 1984.

Waters, Susan C.

1823–1900.

Southern New York State.

Oil on canvas; oil on wood panel.

Colleen Cowles Heslip, *Mrs. Susan C. Waters: Nineteenth-Century Itinerant Painter* (Farmville, Va.: Longwood Fine Arts Center, Longwood College, 1979).

Williams, Micah

1782–1837.

Monmouth County, New Jersey, area.

Pastel on paper; oil on canvas.

Irwin F. Cortelyou, "Micah Williams: New Jersey Primitive Portrait Artist," *Monmouth Historian*, II, Spring 1974.

Woolson, Ezra

1824–1845.

New Hampshire.

Oil on canvas.

Meet Your Neighbors (Sturbridge, Mass.: Old Sturbridge Village, 1992).

WHAT ARE SHAKER OBJECTS?

The largest and most successful Utopian venture in America was started by an Englishwoman, Ann Lee (1736–1784), and was called the "United Society of Believers in Christ's Second Appearing," better known as the Shakers. Having received a "heavenly vision," Lee and her followers, fleeing religious persecution, came to America in 1774 to establish a communal society based on the principles of equality and divine order. First known as the "Shaking Quakers," then "Shakers," the group was so named because of the intense, emotional movements demonstrated in their early dance worship. Intent on practicing a godlike lifestyle, the group was celibate, devoted to work and worship, and intent upon separation from the outside world. Settling in Watervliet, New York, near Albany, about 1776, Lee and her group began to attract new converts, eager to live in a society free from violence and greed, and dedicated to spiritual concerns. By 1840 the Shakers numbered between four thousand and six thousand, and lived in eighteen communities they had established from Maine to Kentucky.

To be self-sustaining, the Shakers had to provide food, clothing, and shelter for themselves. Life centered on the community, guided by Elders and Eldresses, and members were organized into families, each having its own dwelling house, shops, and barns. Called Brothers and Sisters, the Shakers shared the dwelling house but had separate, but equal, entrances and sleeping quarters. Daily tasks were regimented, and the Believers worked six days a week in a variety of trades. To remain independent of the "world"—their term for everything outside the community—the Shakers performed a wide variety of duties: they were builders, carpenters, cooks, farmers, herbalists, inventors, physicians, printers, tailors, weavers, and much more. Shaker-made goods, produced for use in the communities or sometimes sold to the "world," comprise an array of work unique in American culture. Above all, the Shakers believed that the outward appearance revealed the inner spirit, and that the greatest value an object can possess is its capacity for being useful. They translated their tenets of order, harmony, and balance into their products, creating superbly crafted, beautiful objects that have very little extraneous ornament and affectation.

The largest category of Shaker objects is furniture; Shakers produced storage cupboards (where goods could be kept clean and in order, in compliance with the basic tenets of the community); chests of drawers; work counters; work stands and desks (frequently used as Sisters' sewing stands); tables; ladderback side chairs (occasionally with a "tilter" or ball-and-socket on the back feet, to allow the chair to tilt backward); rocking chairs; revolving chairs (also called "turning chairs" because the seat could spin around); washstands; clocks; and large trestle tables and benches, as one might expect in a communal society. The furniture-makers generally used local woods—birch, butternut, cherry, maple, pine, and poplar—and, although they seldom used veneers for embellishment, some woods were stained. Pulls on chests of drawers or stands were usually simply turned wood. Occasionally, more decorative woods such as tiger or bird's-eye maple or figured cherry, in their natural state, were used. Some furniture was painted as well as stained; red-orange, yellow, bluish-green, blue, and black, among other colors, have been

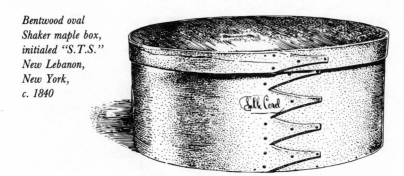

Bentwood oval Shaker maple box, initialed "S.T.S." New Lebanon, New York, c. 1840

found on Shaker furniture. The furniture is characterized by simple, clean lines with all components arranged in elegant, pleasing proportions. Chairs were one of the leading Shaker products; plain ladderbacks were made by the hundreds with rush, woven tape, splint, and cane seats, as were rocking chairs, first made for use by aged or infirm Shakers.

Household articles, too, reflected the Shakers' desire for cleanliness and order. In workshops, dwellings, and meeting houses, strips of pegboard were hung around the sides of the room and many objects—such as tools, clothing, equipment, clocks, and chairs (hung upside down to keep the seats free from dust)—were suspended. Among the most recognizable Shaker products were oval boxes, usually made of mixed woods, intended for storage use in the shops and dwellings. Distinctively constructed, the boxes were made of a band of maple that was steamed, then wrapped around an oval mold; the "swallowtails," or slender fingers of wood, used as joints, were secured by tacks. The boxes ranged in size from about two inches by two inches, to about eight inches by sixteen inches. An adaptation of the oval box was the carrier—simply a box with a handle. Other household implements include textile equipment, wooden buckets and pails, tubs, brushes and brooms, dippers, baskets, and other accessories for the buttery and kitchen. Other items of household use were made of metal by the Brothers; woodburning stoves, some designed by the Shakers, were used to heat the buildings; tin farm tools and custom machinery were also produced.

Two Shaker rocking chairs.
Second half 19th century

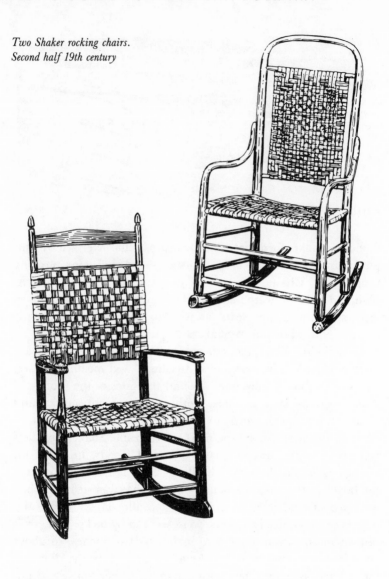

Some of the best-known Shaker furniture-makers include Henry Blinn (1824–1905), Canterbury, New Hampshire; Henry Green (1844–1931), Alfred, Maine; and Orren N. Haskins (1815–1892) and David Rowley (1779–1855), New Lebanon, New York.

SHAKER WATERCOLORS

SHAKER VILLAGE VIEWS

Paintings or drawings, or anything decorative, were not displayed in Shaker dwellings or shops because they were considered to be artistic distractions. Village views, however, were permitted because they documented Shaker landholdings and property and served as plans for future development. They also may have been regarded spiritually as evidence of the Shakers' "heaven on earth." The views, drawn with multiple perspectives and attention to realistic detail, illustrate the community's buildings, roads, and gardens, and sometimes have figures and an identification key included. Drawn like maps, usually in pen, pencil, and watercolor on paper, in red, yellow, green, brown, blue, and black, the views are among the most engaging examples of American folk art. Among the communities pictured are: Alfred, New Glouces-

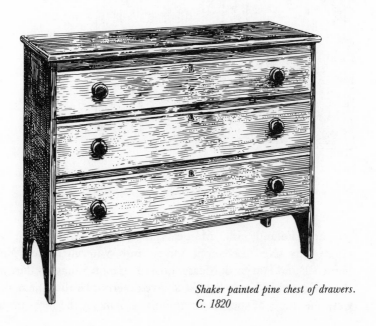

Shaker painted pine chest of drawers. C. 1820

Shaker painted pine cabinet with drawers. Hancock, Massachusetts, early 19th century

ter, and Poland Hill, Maine; Canterbury and Enfield, New Hampshire; New Lebanon, Sodus, and Watervliet, New York; Hancock and Harvard, Massachusetts; Union Village, Ohio; and West Union, Indiana. Scholars have determined that the makers were members of specific communities. Among the most prolific

were Joshua H. Bussell (1816–1900) of Alfred, Maine, and Isaac N. Youngs (1793–1865) of New Lebanon, New York.

SPIRIT DRAWINGS

Small drawings, known as "gift" drawings or "spirit" drawings, were allowed because they graphically represented divine visions and were seen as spiritual communications. The majority have been documented to the New Lebanon, New York, and Hancock, Massachusetts, communities. The drawings were designed much like schoolgirl samplers and some frakturs, with delicate motifs such as birds, flowers, stylized geometrics, symbols, musical instruments, and calligraphic verses or messages such as "I am Strength, I am Power. I am Comfort every Hour." The drawings were done in the mid-nineteenth century when the great wave of reform movements, including spiritualism and perfectionism, swept over New England and New York State. The Sisters who made the spirit drawings may have felt the influence of these worldly concerns.

WHAT TO LOOK FOR

CONDITION

Because of their superb craftsmanship, Shaker items have survived in relatively large quantities in good condition. Prospective buyers should check the furniture to determine if the structure is stable, pulls or handles are secure, and surfaces show only normal wear. Original paint or stain will often show overall wear, which is acceptable. Check for wear on chair seats, especially those made of woven tape, as well as on feet. Paper items, such as the views or spirit drawings, should be examined for acidification (discoloration and brittleness) and surface dirt.

GUIDELINES

Collectors prize case pieces and other furnishings with the original paint or stains intact. Many objects were marked with the community name, and some were marked by the maker and/or user. The documented pieces are valuable and sought by collectors. Because Shaker chair production was extensive, many examples are available and are popular. Shaker boxes are also a collecting specialty.

Many Shaker communities have been restored and are open to the public. Some of these include Hancock Shaker Village, Hancock, Massachusetts; the Museum at Lower Shaker Village, Enfield, New Hampshire; Shaker Heritage Society, Albany, New York; Shaker Village, Inc., Canterbury, New Hampshire; Shaker Village of Pleasant Hill, Harrodsburg, Kentucky; Shakertown at South Union, South Union, Kentucky; and the United Society of Shakers, Sabbathday Lake, Maine. Many art and history museums have collections of Shaker materials.

FURTHER READING

Andrews, Edward Deming, and Faith Andrews. *Religion in Wood: A Book of Shaker Furniture*. Bloomington: Indiana University Press, 1966.

Butler, Linda, and June Sprigg. *Inner Light: The Shaker Legacy*. New York: Alfred A. Knopf, 1985.

Emlen, Robert P. *Shaker Village Views*. Hanover, N.H.: University Press of New England, 1987.

Patterson, Daniel W. *Gift Drawing and Gift Song: A Study of Two Forms of Shaker Inspiration*. Sabbathday Lake, Maine: The United Society of Shakers, 1983.

Sprigg, June. *By Shaker Hands*. New York: Alfred A. Knopf, 1975.

———. *Shaker Design*. New York: Whitney Museum of American Art, in association with W.W. Norton and Company, 1986.

WHAT IS PENNSYLVANIA GERMAN FOLK ART?

The art of German immigrants who settled in southeastern Pennsylvania is distinctive and immediately recognizable by its use of traditional symbols and ornamental motifs. Bringing a style of decoration that originated in Germanic areas of Europe, mainly the Rhineland, Holland, and Switzerland, the settlers transmitted an ancient, visual vocabulary to generations of craftsmen through their material culture. For those who joined William Penn in his "holy experiment" in the New World in the 1680s, religion was a primary preoccupation. Early inventories have revealed that almost every household, rural and urban, owned printed books, at the very least a family Bible and a hymnal. The books contained traditional motifs such as calligraphic lettering, stylized tulips, angels, hearts, and geometric borders that had originated in Europe and were widely copied by craftsmen in their new homeland.

One of the arts produced extensively by the German immigrants was *Fraktur-schriften*, or fraktur-writing, a type of illumi-

nated calligraphy that was seen on medieval manuscripts. The frakturs were family records of births, baptisms, marriages, and deaths—a recording practice that had been required by law in Europe and was continued by Germans in America. The first frakturs were produced by members of the religious center at the Ephrata Cloister, near Lancaster, where they had established a printing press and publishing bureau about 1730. As most Pennsylvania German children were educated in church-related schools, the craft was taught by pastors or schoolmasters who reinforced the religious themes. As the art developed in America, the calligraphic pages became more elaborate. The *Taufschein,* or birth and baptismal certificate, was the most commonly-produced; the *Vorschrift,* or writing example, such as pages of songbooks, rewards of merit, and plates for hymnals and testaments, was made in large quantities by schoolmasters for students to copy. Usually small in size, anywhere from eight to sixteen inches high, the small pictures frequently have a central motif, surrounded by borders and all-over design. In early examples, the illustrations were religious or of a moral nature, and were subordinate to the alphabet and inscriptions. As the craft developed, the ornamental drawings became more important, often visually depicting religious principles and scenes from the Bible. Usually done in pen-and-ink or brightly colored watercolors on paper, the frakturs featured biblical characters, such as Adam and Eve; hearts; flowers, notably tulips; vines; birds; human figures; geometrics; angels; and religious terms, in addition to names and dates.

As the country became a more unified nation after the Revolution, the fraktur took on a more worldly style, less dependent on religious themes as a source. Small drawings and paintings in the fraktur style were made as tokens of love and remembrance or as commemoratives of a special event. Patriotic symbols, such as the eagle and shield, military soldiers on horseback, and even likenesses of George Washington appeared in some examples. The fraktur tradition died out after the 1830s when the Commonwealth of Pennsylvania established a free public or "common" school system to educate the young without religious instruction.

Watercolor drawing, "Laedy Washington."
The Washington-Sussel artist, Berks County, Pennsylvania, c. 1780.
Watercolor and pen-and-ink on laid paper

Scholars have identified several fraktur artists. Friedrich Krebs (possibly 1770–1815), one of the most prolific artists, lived and worked in Dauphin County, Pennsylvania, near Harrisburg. As a schoolmaster, Krebs taught the fraktur arts during the 1790s. He used cutout designs, borders of a single color, hearts, flowers, and birds, among many other standard motifs. Daniel Otto (c. 1770–c. 1820), once known as the "flat tulip" artist, created some of the most interesting decorative pictures produced in central

Fraktur bookplate, watercolor and pen-and-ink on paper. American, 1840

Pennsylvania. His compositions often feature rampant lions and other beasts, and usually include a characteristic wide-open tulip with petals divided into small areas of alternating colors. Jacob Strickler (1770–1842), one of the most imaginative fraktur artists, worked in the Massanutten area of Virginia, a region settled by Mennonites from Pennsylvania. Strickler's writing exercises, the

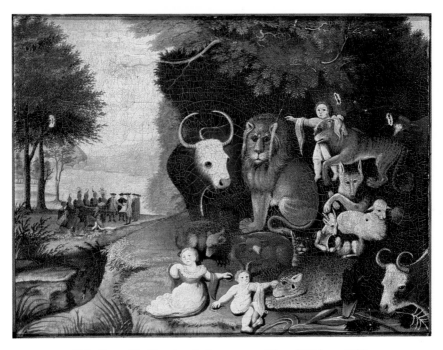

"The Peaceable Kingdom," oil on canvas. Edward Hicks, c. 1838.
Courtesy of Sotheby's

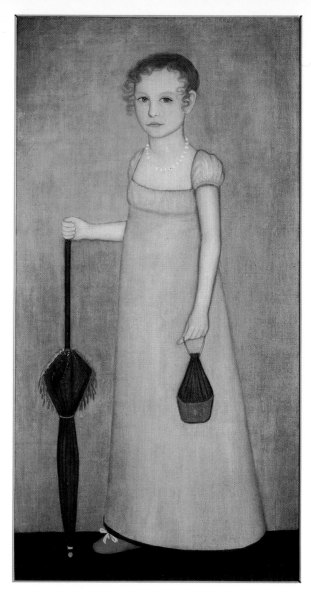

"Harriet Campbell," oil on canvas. Attributed to Ammi Phillips, Greenwich, New York, c. 1815. Sterling and Francine Clark Art Institute, Williamstown, Massachusetts

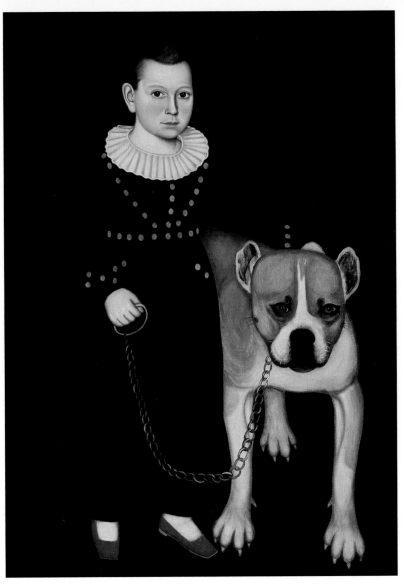

"Pierrepont Edward Lacey and His Dog, Gun," oil on canvas. Attributed to M. W. Hopkins, probably Scottsville, New York, c. 1836. Memorial Art Gallery, University of Rochester, Rochester, New York

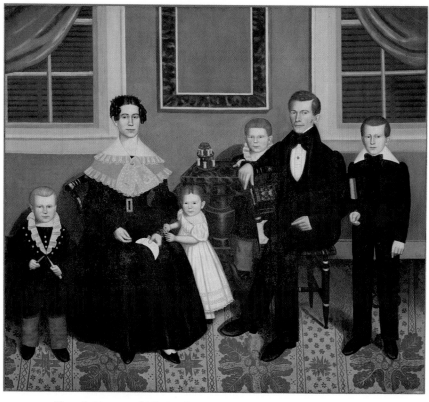

"Joseph Moore and His Family," oil on canvas. Erastus Salisbury Field,
Ware, Massachusetts, 1839. Museum of Fine Arts, Boston:
M. and M. Karolik Collection

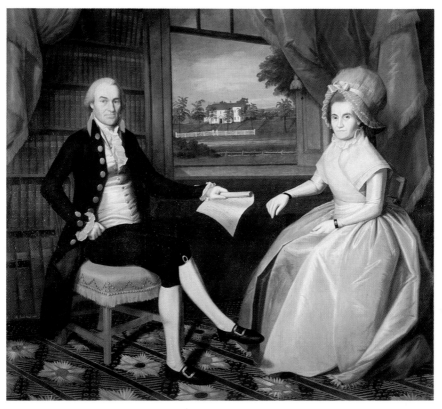

"Oliver and Abigail Wolcott Ellsworth," oil on canvas. Ralph Earl, Windsor, Connecticut, 1792. Wadsworth Atheneum, Hartford, Connecticut

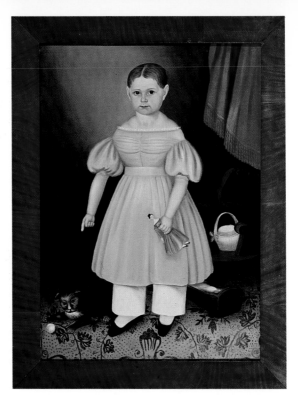

"Mary Jane Smith," oil on canvas. Joseph Whiting Stock, Springfield, Massachusetts, 1838. Abby Aldrich Rockefeller Folk Art Center, Williamsburg, Virginia

"Young Girl with Ringlets," watercolor and pencil on paper. Rufus Porter, c. 1840. Collection of Susan and Raymond Egan

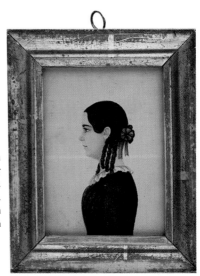

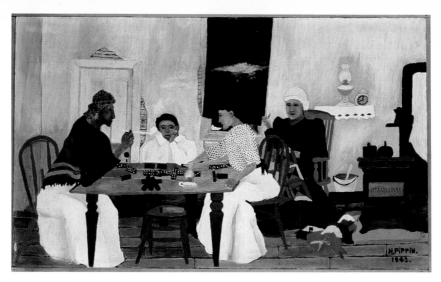

"Domino Players," oil on composition board. Horace Pippin, 1943. The Phillips Collection, Washington, D.C.

"The Musicians," crayon and pencil on paper. Martin Ramirez, c. 1950–60. Courtesy of Sotheby's

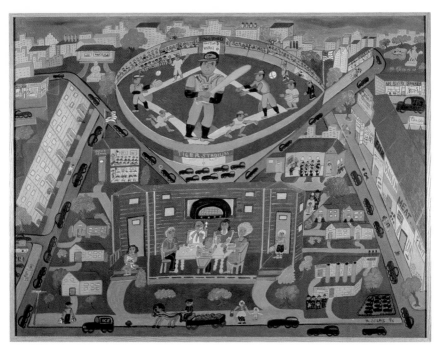

"Homage to Hank Greenberg," oil on masonite. Malcah Zeldis, 1991. New York
State Historical Association, Cooperstown

Paint-decorated pine "Unicorn" blanket chest.
Probably Berks County, Pennsylvania, c. 1785

earliest done in 1787, include the embellished alphabet and numerals, framed by an upper row of flowers, with flourishes throughout.

The Pennsylvania Germans also made and decorated furniture, most notably chests and wardrobes, using traditional, European-inspired designs such as vases of flowers, especially tulips, compasses, hearts, and stylized birds. The blanket chests, used to store linens and personal possessions, were essentially large boxes, sometimes with drawers, with lift-top lids attached with decorative iron hinges. Most of the elaborately decorated examples were used in the main bedchamber of the house and are readily identifiable as Pennsylvania German products. A variety of woods were available in Pennsylvania, but the favorite of the rural cabinetmaker was called "tulip poplar," actually a species of magnolia, although real poplar was also used. The six-board chest was joined at the corners by dovetailing and frequently had panels. Ball feet or turned feet were sometimes included on some examples. The construction was secondary, however, to the distinctive surface decoration. The painted decoration had its origins in Bavaria in the 1600s, when makers stenciled plain border patterns in black on natural wood. Later, in the eighteenth and early nineteenth centuries, the decoration became more elaborate, some resembling frakturs with an all-over pattern of florals

177

or geometrics. Some chests were painted a single color or grain-painted; hundreds more were imaginatively decorated by craftsmen who remembered styles of the Old World. Seen on the panels of chests were subjects such as birds; hearts; flowers; stars; the tree of life; figures on horseback; lions; the mythical unicorn, representing purity; doves, emblematic of marital bliss; the peacock, signifying resurrection; and griffins or pelicans, representing Christ. After the Revolution, patriotic symbols, such as the eagle and images of George Washington, appeared. Sometimes the name or initials of the owner were incorporated into the composition. Methods of painting varied, and some makers scribed the overall design onto the bare wood before applying the paint; some may have worked from templates. Attempts by scholars to identify the decorators have revealed little documented information. Some, however, have been identified: Christian Selzer (1749–1831); his son, John (1774–1845); and brothers John Rank (1763–1828) and Peter Rank (1765–1851) decorated chests in Johnstown from the 1770s until the late 1820s. The chests show vases containing flowers centered in rectangular or arch-shaped panels, and were signed with the maker's name. They are usually painted in bright red, green, and black on a light ground. Johannes Spitler (1774–1837), born in Virginia, worked in a traditional Germanic style. Researchers have attributed a group of furnishings, including chests and clock cases, to Spitler, who painted them using geometric patterns. Spitler often signed and numbered his pieces.

One of the most interesting and well-documented American folk artists came from Pennsylvania; religious themes dominate his paintings. Edward Hicks (1780–1849) was born and reared in Bucks County, where, at age thirteen, he became a coach-maker's apprentice. To supplement his income, Hicks became a journeyman painter, using his skills to decorate furniture, fire-buckets, and trade and tavern signs. Having joined the Society of Friends in 1803, Hicks became a Quaker preacher about 1813, traveling thousands of miles through the countryside "spreading the word." His artwork reflected his religious fervor. About 1820, Hicks painted the first of some sixty versions of the "Peaceable Kingdom," a composition illustrating the biblical Isaiah's proph-

ecy (11:6) of a world at peace: "The wolf also shall dwell with the lamb, and the leopard shall lie down with the kid; and the calf and the young lion and the fatling together; and a little child shall lead them." Various versions of the painting show a small child who rests its arm on the head or neck of a lion, along with other animals, such as calves, leopards, lions, and wolves, both awake and at rest; the paintings often include a tableau of William Penn making his famous treaty with the Indians in the background. Using skills acquired as a sign painter, Hicks usually inscribed a verse on the border: "When the great PENN his famous treaty made With indian chiefs beneath the elm tree's shade. The lion with the fatling on did move. A little child was leading them in love." Although the compositions varied and changed over the years (it is said that he was working on a "Peaceable Kingdom" the night before his death), the sentiment remained the same. Hicks also painted thirteen versions of William Penn's treaty with the Indians. Basing his composition on an engraving after artist Benjamin West's version of the treaty, Hicks depicted Penn as a somberly dressed Quaker, surrounded by similarly garbed colonists, meeting with Indians who carry the pipe of peace. It appears that Hicks viewed Penn's treaty as tangible evidence of God's promise of a peaceable kingdom on earth, and used it as a recurring theme throughout his career.

WHAT TO LOOK FOR

CONDITION

As is the case with other types of decorated wood, the painted surface of Pennsylvania German chests is the most fragile element. Ideal examples will have the paint layer intact, with motifs intact and minimal paint loss. Many, however, because of years of wear, exhibit some overall nicks and abrasions, which is to be expected. Check for normal areas of wear on lids and feet. The structure itself should be stable with no loose parts or joints. Since fraktur was done on paper, evaluate its condition by check-

ing for brittleness, tears, rips, and discoloration. Minor surface dirt can usually be removed. Preferably, the colors should still be bright and display minimal fading.

GUIDELINES

Some of the most valuable Pennsylvania German chests were signed and dated by their makers. Those that display a variety of motifs, such as birds or vases of flowers in a complex combination, are of great appeal. Those that can be attributed to a specific maker or area are always popular. Fraktur that are signed and dated are always desirable, especially if they are composed of interesting motifs. The finest examples will display the original colors with little, if any, discoloration or fading. Some designs can be traced to particular artists or areas and are more valuable than anonymous examples. The paintings of Edward Hicks are among the icons of American folk art. His versions of the "Peaceable Kingdom" stand as one of the most popular scenes ever depicted, and collectors treasure them.

The Winterthur Museum, in Winterthur, Delaware, contains an outstanding collection of Pennsylvania German materials, as does the Philadelphia Museum of Art. Many folk art museums own selected examples. The Abby Aldrich Rockefeller Folk Art Center, Williamsburg, Virginia, has the largest single collection of paintings by Edward Hicks. Scholars have identified many fraktur artists, and numerous references list names and places where they worked.

FURTHER READING

Fabian, Monroe H. *The Pennsylvania-German Decorated Chest*. New York: Universe Books, 1978.

Ford, Alice. *Edward Hicks, Painter of the Peaceable Kingdom*. Philadelphia: University of Pennsylvania Press, 1952.

Garvan, Beatrice B. *The Pennsylvania German Collection.* Philadelphia: Philadelphia Museum of Art, 1982.

——, and Charles F. Hummel. *The Pennsylvania Germans: A Celebration of Their Arts 1683–1850.* Philadelphia: Philadelphia Museum of Art, 1982.

Mather, Eleanore Price. *Edward Hicks: A Peaceable Season.* Princeton: Pyne Press, 1973.

Rumford, Beatrix T., ed. *American Folk Paintings and Drawings Other Than Portraits from the Abby Aldrich Rockefeller Folk Art Center.* Boston: Little, Brown, in association with the Colonial Williamsburg Foundation, 1988.

Weiser, Frederick S. *Fraktur: Pennsylvania German Folk Art.* Ephrata, Pa.: Science Press, 1973.

\mathscr{W}HAT ARE REGIONAL STUDIES?

Much of what has been traditionally considered folk art was produced in New England and the Northeast because the population and commerce centers were concentrated there. Accordingly, most of the research and documentation have centered on the objects from these areas. In recent years, however, many states, museums, and historical agencies have undertaken projects to identify folk art from specific regions and have found that ethnic, racial, and cultural heritages have influenced folk art of individual areas. Michigan was one of the first states to identify and record folk art systematically. Many traditional forms, especially small carved scenes of the logging and lumbering camps, a vital industry for the early settlers, were produced in great numbers by "whittlers" who re-created views of workers processing wood. The rural, agricultural nature of Vermont is revealed in many pieces of folk art, such as carvings, hooked rugs, and quilts that feature agrarian motifs. Many ethnic influences, such as the traditions of French Canada, are also evident in folk

art of the state. Hispanic cultures greatly affected the folk art of the Southwest. Scholars are currently investigating the crosscultural heritage expressed by artists in this area. Throughout the South, art historians and folklorists concentrate on the material culture produced by folk artists working in many mediums. Because research is ongoing, undoubtedly many more folk art forms will come to light. Many of the regional studies have been published as books and catalogues. Some include the following:

CALIFORNIA

Los Angeles Collects Folk Art. Los Angeles: Craft and Folk Art Museum, 1977.

CONNECTICUT

Grave, Alexandra. *Three Centuries of Connecticut Folk Art.* New Haven: Art Resources of Connecticut, 1979.

DELAWARE

In Touch with Tradition: A Sampler of Delaware Folk Arts and Crafts. Newark, Del.: Folklore and Ethnic Art Center, University of Delaware, 1981.

GEORGIA

Wadsworth, Anna. *Missing Pieces: Georgia Folk Art, 1770–1976.* Atlanta: Georgia Council for the Arts and Humanities, 1976.

ILLINOIS

Alliband, Terry. *Expressions: Folkways in Southern Illinois.* Carbondale: Southern Illinois University, 1979.

Chicago Historical Society. "Folk Art of Illinois." In *Chicago History,* Winter 1981–82.

IOWA

Henry, Darrell D., Marion J. Nelson, and Roger L. Welsch. *Norwegian-American Wood Carving of the Upper Midwest.* Decorah, Ia.: Vesterheim Norwegian-American Museum, 1978.

KENTUCKY

Archbold, Annie. *The Traditional Arts and Crafts of Warren County, Kentucky.* Bowling Green, Ky.: Bowling Green–Warren County Arts Commission, 1980.

Taylor, Ellsworth. *Folk Art of Kentucky: A Survey of Kentucky's Self-Taught Artists.* Lexington: University of Kentucky, 1976.

LOUISIANA

Fagaly, William A. *Louisiana Folk Paintings.* New York: Museum of American Folk Art, 1973.

Louisiana Folk Art. Baton Rouge: Anglo-American Art Museum, 1972.

MARYLAND

Carey, George C. *Maryland Folklore and Folklife.* Centerville, Md.: Tidewater Publications, 1970.

MICHIGAN

Dewhurst, C. Kurt, and Marsha MacDowell. "Expanding Frontiers: The Michigan Folk Art Project." In *Perspectives on American Folk Art,* edited by Ian M. G. Quimby and Scott T. Swank. New York: W. W. Norton, 1980.

———. *Michigan Folk Art: Its Beginnings to 1941.* East Lansing: Michigan State University, 1976.

MISSISSIPPI

Made by Hand: Mississippi Folk Art. Jackson, Miss.: Department of Archives and History, 1980.

NEW HAMPSHIRE

Doty, Robert M. *By Good Hands: New Hampshire Folk Art*. Manchester, N.H.: Currier Gallery of Art, 1989.

NEW JERSEY

Cohen, David Steven. *The Folklore and Folklife of New Jersey*. New Brunswick, N.J.: Rutgers University Press, 1983.

NEW MEXICO

Boyd, Elizabeth. *Popular Arts of Spanish New Mexico*. Santa Fe: Museum of New Mexico Press, 1974.

Mather, Christine, ed. *Colonial Frontiers: Art and Life in Spanish New Mexico*. Santa Fe: Ancient City Press, Museum of International Folk Art, 1983.

Wechter, Elizabeth. *Ape to Zebra: A Menagerie of New Mexican Woodcarvings/The Animal Carnival Collection at the Museum of American Folk Art*. New York: Museum of American Folk Art, 1985.

NEW YORK

American Folk Art in Chautauqua County. Fredonia, N.Y.: Michael C. Rockefeller Arts Center Gallery, State University of New York, 1976.

Barons, Richard. *The Folk Tradition: Early Arts and Crafts of the Susquehanna Valley*. Binghamton, N.Y.: Roberson Center for the Arts and Sciences, 1982.

Chittenden, Varick A. *Found in New York's North Country: The Folk Art of a Region*. Utica, N.Y.: Munson-Williams-Proctor Institute, 1982.

Groft, Tammis Kane. *The Folk Spirit of Albany*. Albany, N.Y.: Albany Institute of History and Art, 1978.

OHIO

Doty, Robert M. *American Folk Art in Ohio Collections*. New York: Dodd, Mead, in conjunction with the Akron Art Institute, 1976.

Governar, Alan B. *Ohio Folk Traditions: A New Generation*. Columbus: Ohio Arts Council and the Ohio Program in the Humanities, 1981.

Quilts and Carousels: Folk Art in the Firelands. Oberlin, Oh.: Firelands Association for the Visual Arts, 1983.

OKLAHOMA

American Folk Art: From the Ozarks to the Rockies. Tulsa, Okla.: Philbrook Art Center, 1975.

Folk Art in Oklahoma. Oklahoma City: Oklahoma Museums Association, 1981.

OREGON

Jones, Suzi, ed. *Webfoots and Bunchgrassers: Folk Art of the Oregon Country*. Eugene: Oregon Arts Commission, 1980.

SOUTH CAROLINA

Stanley, Tom; John Kelley; and Roger Manley. *Worth Keeping: Found Arts of the Carolinas*. Columbia, S.C.: Columbia Museums of Art and Science, 1981.

Terry, George D., and Lynn Robertson Myers. *Southern Made: The Southern Folk Heritage*. Columbia: McKissick Museum, University of South Carolina, 1981.

TEXAS

Steinfeldt, Cecelia. *Texas Folk Art*. Austin: Texas Monthly Press, 1981.

UTAH

Cannon, Hal. *Utah Folk Art: A Catalogue of Material Culture*. Provo, Ut.: Brigham Young University Press, 1980.

VERMONT

Beck, Jane, ed. *Always in Season: Folk Art and Traditional Culture in Vermont*. Montpelier: Vermont Council on the Arts, 1982.

VIRGINIA

Moore, J. Roderick, and Walter H. Hathaway. *A Virginia Sampler: Eighteenth, Nineteenth, and Twentieth Century Folk Art*. Ferrum, Va.: Ferrum College and the Roanoke Fine Arts Center, 1976.

THE SOUTH

Morton, Robert. *Southern Antiques and Folk Art*. Birmingham, Ala.: Oxmoor House, 1976.

Rubin, Cynthia Elyce. *Southern Folk Art*. Birmingham, Ala.: Oxmoor House, 1985.

\mathcal{W}HAT IS TWENTIETH-CENTURY FOLK ART?

As technology increasingly altered the nature of American society during the late nineteenth century, the demand for hand-made objects decreased substantially. The popularization of photography diminished the need for the folk portraitist, and mechanical processes, such as lithography, made artwork available to the masses. Advertising and merchandising, too, changed as literacy increased and print media became more prevalent. Mass production made hand-crafted, functional objects obsolete. Although the demand for folk art declined, the artists' creative impulse continued. Perhaps in response to an invasive technological world, twentieth-century folk artists have produced an intensely personal body of work that graphically communicates intimate expressions of self.

Although twentieth-century folk art looks significantly different from its predecessors—even challenging our traditional notions of beauty—some common themes unite the two bodies of work. Religion is a pervasive element in the folk art of the twen-

tieth century. Bessie Harvey's abstract root sculptures are created, as she states, in "collaboration" with God; Sister Gertrude Morgan's paintings illustrate her version of the Revelations and often show her, dressed in white, as she prepares to become the bride of Christ; Howard Finster's expressive paintings and wooden cutouts include scenes from the Bible and religious verses; and many other artists consider religion to be a motivating force in their work. Ethnicity has influenced many artists. Ralph Fasanella's paintings, done with photographic-like precision, chronicle his working-class, Italian background; Malcah Zeldis's colorful paintings tell the story of the family life and rituals of her Jewish heritage. Regional and cultural customs have directly affected some artists. Felipe Archuleta's Hispanic background influenced his animal carvings, and Mattie Lou O'Kelley's childhood memories of rural Georgia form the basis of many of her paintings. Although folk art's form has changed drastically, it is alive and well in the twentieth century.

Twentieth-century folk art was virtually unrecognized and unappreciated until the late 1950s and 1960s, when a few collectors began to take notice. One of the first to acquire and study contemporary work was Herbert W. Hemphill, Jr. (b. 1929), who had been a longtime collector of modern painting and African sculpture. While serving as curator of the Museum of American Folk Art in the 1960s and 1970s, Hemphill installed a series of exhibitions that brought the work to public attention. Among the most influential and, at the time, controversial were "Twentieth-Century Folk Art and Artists," 1970; "Tattoo," 1971; and "Occult," 1973. His book *Twentieth-Century Folk Art and Artists,* written with Julia Weissman and published in 1974, was the first scholarly book on the subject. Part of Hemphill's collection was acquired by the National Museum of American Art in Washington, D.C., in 1986 and was exhibited there in 1990. Another proponent of twentieth-century folk art, Michael D. Hall (b. 1941), is a sculptor himself. He and his wife, Julie, were introduced to Hemphill and his collection in the 1960s and were immediately impressed with the significance of the artwork. Throughout the 1970s and 1980s, Hall discovered numerous twentieth-century folk artists and authored many insightful, critical essays on folk

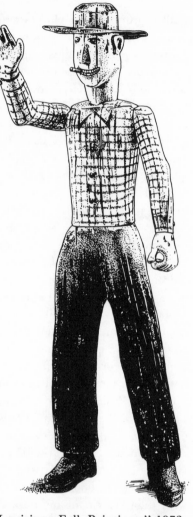

Carved and painted white oak figure,
"Smiling Cowboy."
Connecticut or Massachusetts,
c. 1920

art in general. Influenced by Hemphill, the Halls formed their own folk art collection and lived with it until a major portion was acquired by the Milwaukee Art Museum in 1989. The museum developed a major traveling exhibition of the collection that will circulate until 1995.

Since the 1970s, a number of museums have hosted landmark exhibitions of twentieth-century folk art. In 1974 the Walker Art Center in Minneapolis installed a monumental exhibition entitled "Naïves and Visionaries," which examined folk art built environments in depth. The Museum of American Folk Art in New York City has featured the work of hundreds of twentieth-century artists since it opened in 1963. Among many others, these exhibitions include "Louisiana Folk Paintings," 1973; "The Icons of John Perates," 1981; "A Prairie Vision: The World of Olof Krans," 1982; "The World of Grandma Moses," 1984; "Muffled Voices: Folk Artists in Contemporary America," 1986; and "Malcah Zeldis: American Self-Taught Artist," 1988.

The variety of twentieth-century folk art is astonishing in scope, ranging from personal interpretations of worldly concerns to full-scale, man-made environments that surround the viewer

*Carved and painted
figure of a bear.
American,
early 20th century*

with the artist's visions. While many, including those few whose brief biographies follow, have been "discovered" and their work has come to national attention, countless others await investigation.

FELIPE ARCHULETA

A sculptor of wooden animals, New Mexican artist Felipe Archuleta (1910–1991) began to carve in the 1970s. Having worked variously as a farm laborer, sheep herder, and cook, Archuleta earned a living as a carpenter for thirty years. In the mid-1960s, he received, by his own admission, a vision from God that told him to "carve wood." Departing from Hispanic woodworking traditions that included two distinct occupations, *carpenteros*, who made architectural pieces and furniture, and *santeros*, makers of saints, Archuleta produced large animal carvings using cottonwood, a chainsaw, a hatchet, and a Swiss army knife. After roughing out the animal's figure from a log with a chainsaw, and refining it with a hatchet, or chisel and gouges, he attached legs with filler paste and whittled facial features with a knife. Many

of the animals wear ferocious expressions, an effect the artist created by carving and painting white teeth that contrast with dark snouts. Frequently, hair, tails, and whiskers were added by using straw or hemp. When the animals were painted, Archuleta often included details such as spots or other markings. Among the forty-five species he created are creatures such as baboons, bears, birds, elephants, fish, giraffes, lions, pigs, rams, sheep, tigers, and snakes. Discovered by folk art collectors in the early 1970s, Archuleta's animals are among the most popular twentieth-century folk art sculptures.

EDDIE ARNING

Eddie Arning was born in Austin County, Texas, in 1898 and spent his early years working on the family farm. Because of recurring periods of depression and instability, in the late 1920s he was committed to a mental institution where he would spend the next forty-five years. While hospitalized, Arning was given artists' supplies and encouraged to draw and paint as part of his therapy. His first drawings were of farm animals he remembered from childhood; as he gained confidence, he introduced human figures into his work and, gradually, drew figures that interacted with one another. Using crayons, oil pastels, and pencil on paper, Arning created flat scenes that have figures and backgrounds defined by large areas of bold colors—bright red, green, blue, purple, and yellow. He would fill the entire surface with a single motif, such as a flower in a vase, or a pair of birds, or with a narrative scene, such as a man fishing, or a pair of gravediggers at work. Some of the scenes have stylized backgrounds composed of geometric designs. As Arning became more interested in art, he used magazine illustrations and advertisements as a source of inspiration. Arning continued to draw for a period of about ten years, during which he produced about two thousand pictures. His work came to public attention in the mid-1960s and has been included in many exhibitions. He stopped drawing in the 1970s and died in 1992.

MILES BURKHOLDER CARPENTER

Interest in the work of carver Miles Burkholder Carpenter (1889–1985) developed among scholars and collectors in the early 1970s. Carpenter worked in the lumber business in Waverly, Virginia. Upon his retirement about 1955, he opened a roadside vegetable stand that he promoted by carving outdoor trade signs to attract attention. Although he had carved small animal and human figures all his life, about 1966 he began to carve large figures, which he called "advertisements" and displayed in the back of his pickup truck, parked prominently in front of the stand. Among the diverse carvings was a large, articulated figure of an Indian woman, wearing the clothes of Carpenter's late wife, shown hooking a rug; a bull's head, made of wood, rubber, and thread; and a realistic watermelon. Carpenter is well-known for his so-called root monsters, creatures made from tree roots that he painted in bright oranges, reds, and yellows, accented with bold stripes. Depending on the root's shape, some of the monsters had multiple heads and articulated jaws baring teeth. Throughout the 1970s, Carpenter's carvings were included in numerous local and national exhibitions. After his death in 1985, his family established the Miles B. Carpenter Museum in Waverly.

RALPH FASANELLA

Painting scenes from his immediate, urban experiences, Ralph Fasanella creates canvases full of energy and personal associations. Born in 1914 in New York's Greenwich Village, Fasanella became a union organizer as a young man and was active in local politics. He began to paint in the 1940s, partially to ease the pain in his arthritic fingers. Using his New York City neighborhoods as settings, he creates paintings that exhibit minute details of commonplace, working-class experiences: family dinners, games of stickball, a church festival, the union shop, factories, storefront businesses. The scenes pulse with figures in action: walking, working, driving in cars, running for the subway—all engaged

Carved and painted figures.
c. 1920

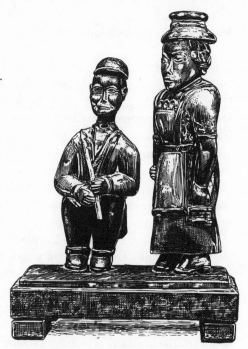

in pursuits typical of city life. Done in oil, the canvases almost resonate with an overall pattern created by the juxtaposition of figures, vehicles, buildings, and highly stylized backgrounds and details. Painted in bright, almost garish colors (red, orange, green, black, brown, blue, among others), the pictures have a surrealistic, photographic quality that projects the animation of the city. One of his most remarkable paintings, done in 1957, is a triptych fifty inches high and over nine feet long that shows a somewhat compressed view of the buildings, bridges, rivers, and citizens of New York City. While it is somewhat schematic, some neighborhoods and landmarks are readily identifiable. Fasanella's paintings came to public attention in 1972 and have been widely exhibited and studied in subsequent years. He has commented, "There is no place like New York . . . I make a portrait of every window. Every face is a person I know."

THE REVEREND HOWARD FINSTER

The Reverend Howard Finster describes himself as a "cartoonist from God . . . a man of visions now on this earth." Born in 1916 in Valley Head, Alabama, he dropped out of school at twelve and received "a call" to the Baptist ministry at sixteen. According to his own account, to obtain additional money he worked at

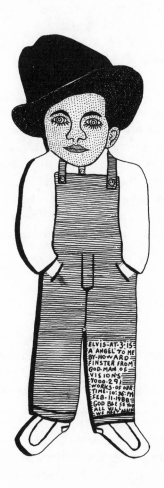

Cutouts, "The Trumpeting Angel" and "The Elvis at 3," oil on wood panel.
Howard Finster, 1989 and 1990

numerous occupations—carpentry, plumbing, and piano tuning—wrote religious treatises for local newspapers, and repaired televisions and bicycles. After retiring from the ministry, Finster allegedly heard a "word from God" that directed him to create a "Paradise Garden" near his home in Summerville, Georgia. Using found objects, leftover items remaining from his various repair businesses, Finster constructed a folk environment made up of individual add-on sculptures dedicated to human inventors. Calling it "The World's Folk Art Church, Inc.," Finster intends it to be a memorial to God. Moved by yet another Divine call, he produced hundreds of paintings of biblical scenes that include verses and references. Done after 1976, the compositions show an overall pattern comprising various religious motifs, symbols, plants, animals, and verses pertinent to the subject. Most of the paintings are in oil on board and display his expressionistic interpretations of events chronicled in the Bible. Finster is also well-known for thousands of wooden cutout sculptures that feature portraits of himself, well-known personalities, and historical figures. Painted in polychrome, the cutouts also have religious verses included, as well as a notation of the date and time they were created. Finster's work has been exhibited in many museums and galleries.

JOHN ORNE JOHNSON FROST

Marblehead, Massachusetts, native John Orne Johnson Frost (1852–1928) recorded scenes of his hometown and its inhabitants in eighty paintings done from about 1919 until his death. At sixteen, Frost went to sea for a short while and, upon his return in 1870, went into the restaurant business.

As a form of therapy after his wife's death, he began painting the series of townscapes that would become a veritable pictorial history of Marblehead. Beginning with a scene depicting the arrival of the white man in the seventeenth century, Frost, who had no formal art training, painted the events, occupations, and pastimes that related directly to local history: the Revolution, the Civil War, fishing, militia musters, and harbor commerce. The

pictures, usually done in oil on wallboard, display intimate details of Marblehead neighborhoods: houses are carefully delineated, ships are accurately rendered, and people are shown performing their daily tasks and recreations. When some facts, such as names and dates, could not be drawn, Frost added descriptive captions to communicate the thoughts. He exhibited the paintings in Marblehead, charging twenty-five cents for admission, apparently with little success. It would be twenty years after his death before the pictures were publicly acclaimed.

BESSIE HARVEY

Bessie Harvey creates sculptures out of tree branches and roots, which she describes as a collaboration with "God and nature." Born in Georgia in 1928, Harvey married young, bore eleven children, and struggled to provide food and shelter for her family. When her children were older, Harvey, a deeply religious woman, began to create what she calls her "dolls," having found inspiration in meditation and prayer. The faces that she sees in the visions appear to her in the wood she finds near her home. Harvey's stick sculptures, closely related to Congo root charms, are made of unusually shaped branches or roots to which she adds other pieces of wood, putty, beads, paint, glitter, and hair. Facial features are almost always abstracted in her works, creating an exotic image rather than a realistic portrait. Some of her more complex pieces may represent entire families, showing multiple faces in a single sculpture. Many of the "dolls" are named, and several represent scenes from Harvey's rural upbringing: a farmer plowing a field, a woman milking a cow, a woman washing clothes, and a church congregation praying. Concerned that future generations will forget the contributions of their ancestors, Harvey has entitled this series "Africans in America."

MORRIS HIRSHFIELD

An early career in the textile and garment industry influenced the painting of Russian-Polish immigrant Morris Hirshfield (1872–1946). He came to the United States at eighteen when he found employment in a women's coat factory. In subsequent years, he and his brother manufactured women's coats and suits, operating under the trade name of Hirshfield Brothers in New York City. After retirement at age sixty-five, Hirshfield took up painting for recreation in 1937. His large format paintings, done in oil on canvas, feature human and animal figures and backgrounds rendered in overall patterns and designs reminiscent of various types of fabric and decorative stitching. Dual figures— both human and animal—are often mirror images, an artistic device that one might expect from a patternmaker. Bright colors, patterns on patterns (similar to warp and weft), stylized props, and subtle religious symbolism can also be found in his paintings. Hirshfield was one of the first self-taught, twentieth-century painters to be recognized by the museum and gallery community in the 1940s.

SHIELDS LANDON ("S.L.") JONES

Shields Landon ("S.L.") Jones, born in 1901 in Franklin County, Virginia, began carving about 1967 after retiring from the Chesapeake and Ohio Railroad, Jones carved free-standing human figures, about two feet tall, and life-sized busts from poplar, maple, walnut, and other hardwood logs. Made both singly and in groups, the figures have full bodies, firm stances, and straightforward gazes. Some have props, such as musical instruments, an appropriate addition since Jones plays the fiddle. The early figures were unpainted, but in the late 1960s Jones began to embellish them with paint, stain, and pencil; by the 1970s he was using opaque paints. His carvings have been included in many public exhibitions, and he has received many commissions from collectors.

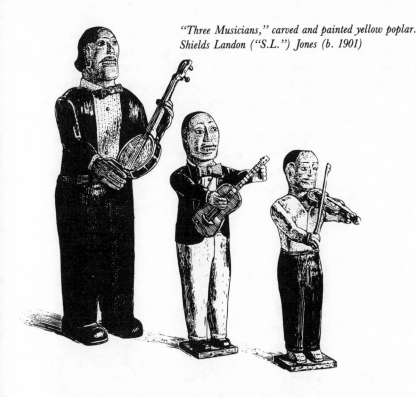

"Three Musicians," carved and painted yellow poplar.
Shields Landon ("S.L.") Jones (b. 1901)

OLOF KRANS

For Swedish immigrant Olof Krans (1838–1916), painting scenes of life in the utopian community Bishop Hill Colony in Illinois was a major occupation. Having come to Illinois from Sweden with his parents in the 1840s, Krans enlisted in the Illinois Volunteer Infantry and served in the Civil War. Returning to Bishop Hill after an injury, Krans's first exposure to pictorial art came when he worked as a photographic assistant. In subsequent years, he found employment as a journeyman painter, working as a house painter and decorator and in a variety of related jobs. He is known to have painted signs, decoys, stage scenery, hung wallpaper, glazed mirrors, and decorated churches. In the 1890s, he was commissioned to paint a view of Bishop Hill, as it looked in 1855, as a panorama for a stage curtain for the community center. Stimulated by this work, Krans began to document the everyday

life of the colony. Characteristically, Krans's oil paintings are straightforward narratives marked by large areas of color. His scenes of regimented workers in the field reveal minimal backgrounds that direct the viewer's eye to the figures. Blue sky and white clouds contrast strongly with the dark brown earth being cultivated by members of the community. In later years, Krans also painted portraits, some copied from photographs. These, too, show figures defined by large areas of color with attempts at facial shading and detailing in costumes and props. Before his death in 1916, Krans donated some ninety-odd pictures to the Bishop Hill Old Settlers Association, where they are permanently on view.

"SISTER" GERTRUDE MORGAN

"Sister" Gertrude Morgan's expressive, religious paintings are a by-product of her evangelical ministry. Born in Lafayette, Alabama, in 1900, Morgan, always active in the Southern Baptist Church, received a divine message to "go and preach" in the 1930s. After delivering sermons in Georgia and Alabama, she settled in New Orleans, where she built a chapel and orphanage in the 1940s. To augment her preaching, she painted brightly colored scenes, often including a figure of herself, and religious messages in the small compositions. Using crayons, pens, and other inexpensive materials, Morgan created pictures crowded with figures, psalms, and verses of scripture that function as "visual" sermons. In the 1950s, she received yet another sacred message indicating that she would become the bride of Christ. From that time on, she dressed only in white and continued to make drawings to illustrate her version of the Revelations and the hereafter. Morgan's artwork received public notice when she sold several pieces in New Orleans about 1970. She stopped painting, having been given divine direction to do so, two years before her death in 1980.

"GRANDMA MOSES"

Anna Mary Robertson Moses, known as "Grandma Moses," remains one of the twentieth century's best-known and best-loved primitive painters. Born on a farm in upstate New York in 1860, Anna Mary loved to draw and paint as a child. Duties as a farm wife and mother precluded her art activities for many years but she began painting again at age seventy-seven. As she revealed in her autobiography, at first she copied illustrations from books but, when she gained confidence, her scenes, which include every detail of her immediate landscape, gradually developed into her own distinctive style. "Grandma Moses" deliberately depicted the people, places, and events that played a part in her own life in rural America. Working in oils on canvas, she created a busy, overall pattern on the canvas by using figures, buildings, animals, and landscape details to chronicle her own experiences. Included in her compositions are minutely rendered farm and town buildings, figures engaged in everyday tasks or at play, vehicles such as wagons and sleighs, and barnyard animals skillfully arranged to suggest action and vitality. Typical farm chores such as soap making were elevated to new heights by her documentation; titles of her pictures, such as "Sugaring Off," "Harvest Time," "Wash Day," and "Home for Thanksgiving," give an indication of the homely scenes she painted. Her work was first exhibited in the 1940s and has received wide public attention ever since. She died in 1961.

INEZ NATHANIEL-WALKER

The stylized portraits drawn by Inez Nathaniel-Walker are among the most intriguing of the twentieth century. Born in Sumter, South Carolina, in 1910, she married young and supported four children. After working in Philadelphia, she moved farther north for employment in a New York apple processing plant. In 1970 she was imprisoned for the manslaughter of a male acquaintance who had abused her. While in the correctional

facility, she began to draw portraits, usually of women, in pen, pencil, and crayon on paper. In her drawings, the subjects' heads are oversized and the facial features are exaggerated, yet they are rendered with great precision. Some of the linear compositions also have abstract backgrounds that help to reinforce the major motif of the heads. The figures' direct gazes, lack of correct proportion, and details in costume are reminiscent of folk portraits of the 1830s. An instructor at the facility recognized Nathaniel-Walker's talent and brought her artworks to the attention of the art community. Her drawings have been widely exhibited and are in numerous public and private collections. Before her death in 1990, she commented about her work: "I just sit down and go to drawing . . . I don't look at nothing to draw by. Just make 'em myself."

MATTIE LOU O'KELLEY

Mattie Lou O'Kelley was born in 1908 on her father's farm in Banks County, Georgia, where she has spent most of her life. Entirely self-taught, she began to paint when she was sixty. Working in oil on canvas, O'Kelley fills her genre and memory scenes with figures, animals, vehicles, and buildings that form an all-over pattern that draws the viewer's eye. In many of her canvases, she applied paint as dots to build up the forms in a technique similar to pointillism. Each design element is painted in a different bright color that draws attention to each one equally and gives the canvas kinetic energy. To the most minute detail, she records scenes and memories from her rural past and provides titles for the paintings: "Workers in the Fields Picking Cotton," "A Baptism in the Churchyard," "Churning on the Front Porch," "Chopping Cabbage and Making Kraut," "Killing the Hogs," "Mama Reading the Funnies." Other favorite subjects include flowers, cats, and peaceful landscapes of the Georgia countryside. O'Kelley's paintings first came to public view in the 1970s, and she won Georgia's Governor Award in the Arts in 1976. Her work is included in many private and public collections.

JOHN W. PERATES

Coming to the United States from his native Greece, John W. Perates (1895–1970) settled in Portland, Maine. Following his family tradition of woodcarving, he became a cabinetmaker, specializing in reproductions of antique furniture. In his spare moments during the late 1930s, he began to carve a series of religious icons, a pulpit, and an altar that he intended to give to the local Greek Orthodox church. Based on Byzantine painting designs and Greek traditions, the icons, made of ironwood, walnut, cherry, or pine, display a central figure, surrounded by bands of symbols and classical motifs pertinent to the subject. The individual elements of the carvings are highlighted in bright paints— various shades of red, blue, and brown—and some show areas of gilding. Perates carved over forty icons, each about four feet high, that included images of the saints, such as St. Matthew, St. Mark, and St. Nicholas, and the Madonna and Child. After his death in 1970, the icons were found in his workshop and soon came to public attention.

ELIJAH PIERCE

Born in Mississippi to a former slave, Elijah Pierce (1892–1984) worked on his father's farm until about 1917, when he became a barber. In the 1920s he moved his family to Columbus, Ohio, where he found work. Although he had always whittled, Pierce did not produce any major carvings until the 1920s. Beginning with small animal sculptures, Pierce soon began to carve figures and religious subjects. Having been ordained a Baptist minister about 1920, religious themes were of particular interest to him. Carving with a knife, Pierce produced scenes in bas-relief featuring human figures, animals, plants, and attendant objects that covered the wood surface. Pierce used paint in blue, green, white, red, brown, and black to emphasize the carving and increase visual interest. Pierce based many of his characters on cartoons, happenings of daily life, and his own conception of the Bible.

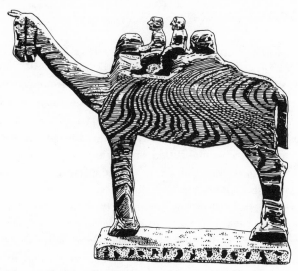

Camel with two riders, carved and painted wood, with rhinestone eye.
Elijah Pierce, Columbus, Ohio, probably 1970s

Many parables such as the story of Job, the Crucifixion, and the blind man restored to sight are found in his carvings. Many of his secular carvings also illustrate individual responsibility, duty, and moral purpose. Pierce sold his sculptures at churches and country fairs during the 1920s and 1930s, explaining the symbolism of his work to the public. His carvings received national recognition in the 1970s. He died in 1984.

HORACE PIPPIN

Horace Pippin (1888–1946) began drawing with crayon and pencil when he was a child in his native West Chester, Pennsylvania. As a boy, he worked as a laborer to support his mother. He enlisted in the army in 1917 and was sent to France, where he documented his war experiences by drawing in a diary, recording scenes in pencil and crayon. Wounded in his right arm, he returned to West Chester. About 1929, his art interests were renewed and, using his left arm to support his right, Pippin began

to use oil on canvas to paint his recollections of the war and memories of his childhood. As might be expected, his war scenes are painted in dark, drab colors and the military figures appear flat, formed by simple brush strokes. The pictures of his life experiences are considerably brighter and figures are more competently painted, with attempts at shading and contour in faces and bodies. In these genre-type scenes, Pippin records the interiors in minute detail: lamps, clocks, and pictures; vases of flowers; chairs decorated with antimacassars; and figured carpets that form Matisse-like patterns on the canvas. Pippin's most well-known painting, "John Brown Going to His Hanging," shows the famous Abolitionist tied and bound, riding on his own coffin; dark-coated figures surround the procession that is framed by ominous, flat, leafless trees; it is said that Pippin painted the scene after hearing about it from his grandmother and, on the lower right of the canvas, he has included a woman who faces the viewer, perhaps representing her. Pippin's work was publicly noticed in the late 1930s and has been included in numerous exhibitions and public and private collections since then.

MARTIN RAMIREZ

The idiosyncratic drawings of Martin Ramirez (1885–1960) have been included in virtually every important exhibition of twentieth-century folk art since the 1970s. Born in Mexico, Ramirez came to the United States as a young man to work on the railroads. He was overcome with the stress of his new life, became delusional, was diagnosed a paranoid schizophrenic, and institutionalized. As part of his treatment, he began to draw about 1948, using whatever materials were readily available: scrap paper, wrapping paper, bits of discarded letters and the like. He produced about three hundred drawings, usually in crayon, pencil, or watercolor, varying from small sizes to twelve feet. Typically, he used striated patterns and repetitive lines to frame a centrally located figure. Sometimes, the compositions are nearly symmetrical, and black crayon lines contrast with other areas of

color seen in the design. His subject matter reflected his life in the Southwest: religious subjects, such as the Virgin Mary; Mexican architecture; cowboys; soldiers; animals; desert landscapes; and characters from Mexican folklore. His work was encouraged by his doctor, and through him, Ramirez's drawings were introduced to the local art community.

JOHN SCHOLL

German-born John Scholl (1827–1916) settled in Germania, Pennsylvania, in 1853. He worked as a farmer and carpenter and, during the 1870s, built an elaborate Victorian house embellished with carved, architectural ornaments for his own family. At the age of eighty, in 1907, Scholl, who had always whittled, began to create the intricately carved, assembled, free-standing sculptures for which he is best known. Using locally available materials and carpenter's tools, Scholl created small whittled puzzles, flat constructions, mechanized toys, and large free-standing sculptures. Many motifs commonly seen in the art work of the Pennsylvania Germans—birds, crosses, and tulips, in addition to abstract shapes of his own design—were employed by Scholl as he carved and painted small pieces of wood. By joining the individual pieces of wood with screws, tacks, and glue, he created fanciful sculptures reminiscent of Victorian architectural ornament. For several years, prior to his death in 1916, Scholl displayed his sculptures in the parlor of his home and gave guided tours, explaining the significance of the works to the public. Of the forty-five pieces of sculpture that Scholl made, forty-two survive.

MOSE TOLLIVER

The son of a sharecropper, Mose Tolliver was born about 1919 near Montgomery, Alabama. Attending school only to the second grade, he later worked on the farm and learned to make and

upholster furniture. He began to paint in the late 1960s after an accident left him disabled. Using oils, sometimes housepaint, on plywood or wood panel, Tolliver creates surrealistic faces, figures, animals, religious subjects, and abstracts that have a childlike quality. Human faces that fill the entire wood surface have grossly distorted features and are disproportionate to one another. Forms are created by broad, flat brush strokes to suggest volume. Tolliver sometimes includes patterned backgrounds by using small daubs of paint in contrasting colors to accent the surrealistic faces. Light colors, usually pastels, accented with dark outlines, characterize his palette. Tolliver's work has been collected since the 1970s and has been included in many exhibitions nationwide.

EDGAR TOLSON

As a young man in Kentucky, where he worked at a variety of jobs (chairmaker, carpenter, coal miner, shoemaker, and

"Expulsion," carved and painted white poplar and pencil.
Edgar Tolson, c. 1969

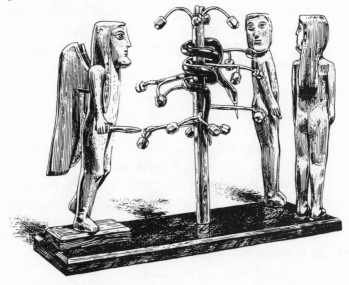

preacher), Edgar Tolson (1904–1984) often whittled but did not begin carving seriously until a stroke left him partially disabled in 1957. His early carvings of farm animals, birds, and individual figures no doubt reflect the strong craft traditions of the Appalachian region where he grew up. By the mid-1960s, Tolson's carvings had come to the attention of the art department of the University of Kentucky, and they commissioned him to carve a biblical scene of Adam and Eve that Tolson called "Temptation." During the next few years, Tolson created a series of sculptures depicting related scenes of the Bible, including Adam and Eve in Paradise, their expulsion from Paradise, the birth of Cain, Cain slaying Abel, and Cain going into the world. The eight sculptures, called the "Fall of Man," brought Tolson widespread recognition.

Using local woods, such as poplar and cedar, and a pocket knife, Tolson carved his approximately one-foot-high figures in a simple style. The characters are still and loglike, with fixed eyes and relatively expressionless faces. The placement of the figures and their relation to one another, however, suggest powerful human emotion. The unpainted figures illustrate well-known stories with a humanistic quality seldom seen in woodcarvings. Throughout his life, Tolson continued to carve nonreligious subjects featuring animals and occasionally figures, and created scenes that show topics of contemporary media attention. He is best remembered, however, for his personal interpretation of the origins of man.

BILL TRAYLOR

Bill Traylor was born a slave in 1854 on a plantation in Alabama. He remained there working as a farmhand until 1938, when he moved to nearby Montgomery. There he was employed in a shoe factory and eventually was forced to go on relief. He began drawing and painting while living on the streets of Montgomery, using cardboard and other supplies he could easily find. The torn, irregular bits of cardboard and paper he scavenged dictated the

*"Leopard and Black Bird," pencil and tempera on cardboard advertisement.
Bill Traylor, c. 1939–47*

design of the entire composition. Using a small stick as a straight-edge, Traylor drew human, animal, and bird figures that began with simple geometric forms such as triangles and rectangles. The completed figures are flat and spare and are sometimes

filled in to suggest volume. They appear to be suspended in midair, and their placement creates negative spaces that emphasize their actions, although they do not interact with one another. No backgrounds are included by the artist, but costume details, such as hats, canes, and umbrellas, add visual interest and personality. Traylor's use of color could be considered unusual by traditional standards; a woman has a green head, for example, and a pig is painted purple. Generally, however, he used primary colors, usually tempera and watercolors, in addition to brown and black. During a three-year period, Traylor penciled and painted between one thousand and two thousand images, which he sold on the street in Montgomery. Although Traylor's figures were often compared to those seen in Egyptian wall paintings, and his work was known locally for its sophistication, his paintings did not receive significant national attention until the late 1970s.

MALCAH ZELDIS

After a traditional career as a wife and mother, Malcah Zeldis (b. 1931) discovered her own artistic talent in the early 1970s. Living with her family on a kibbutz in Israel during the 1950s, Zeldis experimented with painting but received little satisfaction or encouragement. She returned to the United States, completed college, majoring in early childhood education, and, for extra credit to obtain a teaching certificate, submitted some of her paintings to the faculty. Heartened by their positive comments, Zeldis began to paint seriously, developing her own personal style.

Working in oils on Masonite boards, Zeldis creates scenes from quick pencil sketches that feature people particular to her life experiences: weddings, Jewish religious rituals, street scenes, and historic events are part of her repertoire. Her expressionistic paintings exhibit vibrant colors and overall patterns created by figures, props, and landscape details. Using vivid reds, oranges, yellows, and blues, Zeldis paints scenes that illustrate

"Blue Man with Umbrella and Suitcase," pencil and tempera on cardboard boxtop. Bill Traylor, c. 1939–47

personal, yet universal, experiences that pulsate with activity and familiar imagery. As Zeldis explains, "I believe that people look at my work and recognize something from their own experience."

WHAT TO LOOK FOR

CONDITION

Twentieth-century folk art presents unusual problems in maintenance and conservation. Because many artists work with "found" materials—organic substances, discarded paper, fabric, cardboard—the life of the art may be limited. However, its condition can be evaluated in traditional ways. Works on paper should be checked for acidification (discoloration and brittleness), rips, tears, and surface dirt. Paintings on canvas should be examined for rips or tears, and loss of paint; the canvas should be taut; if painted on wood, the wooden support should be stable, with no cracks or splits. Carvings will undoubtedly show some overall nicks, but this is to be expected. Obviously, works in good condition are more valuable than those that show deterioration or wear. Because of their unstable nature, some twentieth-century works may require professional conservation in the future.

GUIDELINES

During the past twenty years, twentieth-century folk art has become a collecting specialty. Numerous examples are available at auction, and several artists are represented by individual dealers and galleries. The deceptively simple works of Bill Traylor are especially prized by collectors. Mose Tolliver's unconventional paintings appeal to many who admire his abstract images. Enthusiasts seek out early Howard Finster "cutouts," which are easily identifiable because most are dated. Mattie Lou O'Kelley's traditional depictions of rural Georgia are usually more valuable than her flower studies, although both are collectible.

Because twentieth-century folk artists are still being discovered, some of their works can be purchased at reasonable prices. It is a new collecting field, however, and collectors should visit galleries or shops and museum exhibitions to learn more about contemporary folk art.

FURTHER READING

Anderson Gallery. *Miles Carpenter: The Woodcarver from Waverly.* Richmond, Va.: Anderson Gallery School of the Arts, Virginia Commonwealth University, 1985.

Barrett, Didi. "A Time to Reap: Late Blooming Folk Artists." *The Clarion,* Fall 1985.

———. "Folk Art of the Twentieth Century." *The Clarion,* Spring/ Summer 1987.

Bishop, Robert. *American Folk Sculpture.* New York: E.P. Dutton, 1974.

Cardinal, Roger. *Outsider Art.* New York: Praeger Publishers, 1972.

Cincinnati Art Museum. *Twentieth-Century American Icons: John Perates.* Cincinnati, Oh.: Cincinnati Art Museum, 1974.

Columbus Gallery of Fine Arts. *Elijah Pierce, Wood Carver.* Columbus, Oh.: Columbus Gallery of Fine Arts, 1973.

Emans, Charlotte. "In Celebration of a Sunburst: The Sculpture of John Scholl." *The Clarion,* Fall 1983.

Everts-Boehm, Dana, and Jeannette De Bouzek. "New Mexican Hispano Animal Carving in Context." *The Clarion,* Summer 1991.

Hall, Michael D. "The Problem of Martin Ramirez: Folk Art Criticism as Cosmologies of Coercion." *The Clarion,* Winter 1986.

———. *Stereoscopic Perspective: Reflections on American Fine and Folk Art.* Ann Arbor, Michigan: UMI Research Press, 1988.

———. "You Make It with Your Mind: The Art of Edgar Tolson." *The Clarion,* Spring/Summer 1987.

Hartigan, Lynda Roscoe. *Made with Passion: The Hemphill Folk Art Collection in the National Museum of American Art.* Washington, D.C.: Smithsonian Institute Press, 1990.

Hemphill, Herbert W., Jr., and Julia Weissman. *Twentieth-Century American Folk Art and Artists.* New York: E.P. Dutton, 1974.

Janis, Sidney. *They Taught Themselves: American Primitive Painters of the Twentieth Century.* New York: Dial Press, 1942.

Lipman, Jean, and Armstrong, Thomas N. III, eds. *American Folk Painters of Three Centuries.* New York: Hudson Hills Press, in association with the Whitney Museum of American Art, 1980.

Little, Nina Fletcher. "J. O. J. Frost, 1852–1928." *American Folk Painters of Three Centuries,* edited by Jean Lipman and Thomas N. Armstrong III. New York: Hudson Hills Press, in association with the Whitney Museum of American Art, 1980.

Luck, Barbara R., and Alexander Sackton. *Eddie Arning.* Williamsburg, Va.: Abby Aldrich Rockefeller Folk Art Center, 1985.

Mather, Davis. "Felipe Archuleta Folk Artist." *The Clarion,* Summer 1977.

Maresca, Frank, and Roger Ricco. *Bill Traylor: His Art, His Life.* New York: Alfred A. Knopf, Inc., 1991.

Milwaukee Art Museum. *Common Ground/Uncommon Vision: The Michael and Julie Hall Collection of American Folk Art.* Milwaukee: Milwaukee Art Museum, 1993.

Morris, Shari Cavin. "Bessie Harvey: The Spirit in the Wood." *The Clarion,* Spring/Summer 1981.

Murray, Anna Wadsworth. "Olof Krans: Images of Bishop Hill Colony." *The Clarion,* Spring/Summer 1981.

Niemann, Henry. "Malcah Zeldis, Her Art." *The Clarion,* Summer 1988.

O'Kelley, Mattie Lou. *Mattie Lou O'Kelley, Folk Artist.* Boston: Little, Brown, 1989.

Rosenberg, Willa S. "Malcah Zeldis, Her Life." *The Clarion,* Summer 1988.

Sparks, Esther. "Olof Krans, 1838–1916.) In *American Folk Painters of Three Centuries,* edited by Jean Lipman and Thomas N. Armstrong III. New York: Hudson Hills Press in Association with the Whitney Museum of American Art, 1980.

Turner, J. F. *Howard Finster, Man of Visions.* New York: Alfred A. Knopf, 1989.

Wadsworth, Anna, et al. *Missing Pieces: Georgia Folk Art, 1770–1976.* Atlanta: Georgia Council for the Humanities, 1976.

Watson, Patrick. *Fasanella's City.* New York: Ballantine Books, 1974.

HERE TO START

WHERE TO SEE THE BEST EXAMPLES

To develop connoisseurship, the best training is to "educate the eye"—look everywhere for folk art. Museums are excellent places for viewing, but their "hands-off" policies prohibit handling the objects. Galleries and dealers, especially those that specialize in folk art, are good places to learn because most allow the visitor to examine the objects closely. By reading books, attending museums, and going to galleries and dealers' shops, the collector can become a skilled observer and judge of American folk art.

Several large museums specialize in folk art and have many different forms permanently on display. Many regularly mount interpretive exhibitions using their own and borrowed collections. Among them are:

THE ABBY ALDRICH ROCKEFELLER FOLK ART CENTER

WILLIAMSBURG, VIRGINIA

Recently reinstalled in a new facility; especially strong in portraits, landscape and genre paintings, sculpture, coverlets, twentieth-century material, ceramics, and painted furniture.

MUSEUM OF AMERICAN FOLK ART

NEW YORK, NEW YORK

The museum installs changing exhibitions on every aspect of folk art.

THE NEW YORK STATE HISTORICAL ASSOCIATION

COOPERSTOWN, NEW YORK

Regularly displays folk art at its headquarters, Fenimore House; particularly strong in portraits, paintings, sculpture, and twentieth-century examples; a fine collection of academic paintings for comparison and contrast; decorative interior painting can be observed in their village area, the Farmers' Museum.

OLD STURBRIDGE VILLAGE

STURBRIDGE, MASSACHUSETTS

A restored village of the 1800–40 period; many types of folk art are on display in individual buildings; fine collection of portraits, painted furniture, and interior decoration.

SHELBURNE MUSEUM
SHELBURNE, VERMONT

An outdoor museum with many types of folk art on exhibition in restored buildings and art gallery; particularly strong in portraits, genre and landscape paintings, painted furniture, interior decoration, sculpture; largest public collections of quilts and decoys in the United States.

The following museums, listed by state, have examples of folk art in their permanent collections:

ALABAMA

Mobile
Fine Arts Museum of the South

ARKANSAS

Mountain View
The Ozark Folk Center

CALIFORNIA

Los Angeles
Craft and Folk Art Museum
Los Angeles County Museum of Art
San Francisco
Fine Arts Museum of San Francisco
San Francisco Craft and Folk Art Museum

CONNECTICUT

Bridgeport
The Barnum Museum

Hartford
Connecticut Historical Society
Wadsworth Atheneum
Litchfield
Litchfield Historical Society
Mystic
Mystic Seaport
New London
Lyman Allyn Art Museum
Riverton
Hitchcock Museum

DELAWARE

Winterthur
H. F. du Pont Winterthur Museum

DISTRICT OF COLUMBIA

Daughters of the American Revolution Museum
National Gallery of Art
National Museum of American Art
National Museum of American History

FLORIDA

Sarasota
John and Mable Ringling Museum of Art

GEORGIA

Atlanta
Atlanta Historical Society
High Museum of Art
Columbus
The Columbus Museum

ILLINOIS

Bishop Hill
Bishop Hill Heritage Museum
Chicago
The Art Institute of Chicago
Chicago Historical Society
Terra Museum of American Art

INDIANA

Fort Wayne
Allen County–Fort Wayne Historical Society Museum
Peru
Circus City Festival Museum

IOWA

Decorah
Vesterheim Norwegian-American Museum

KANSAS

Lawrence
Spencer Museum of Art, University of Kansas

KENTUCKY

Berea
Berea College Museums
Frankfort
Kentucky Historical Society
Harrodsburg
Shaker Village of Pleasant Hill
Louisville
The Filson Club
South Union
Shakertown at South Union

LOUISIANA

Alexandria
Alexandria Museum of Art
New Orleans
Louisiana State Museum

MAINE

Augusta
Maine State Museum
Bath
Maine Maritime Museum
Blue Hill
Parson Fisher House
Sabbathday Lake
United Society of Shakers
Rockland
William A. Farnsworth Library and Art Museum
Saco
York Institute
Southwest Harbor
Wendell Gilley Museum
Waterville
Colby College Museum of Art

MARYLAND

Baltimore
Baltimore Museum of Art
Havre de Grace
Havre de Grace Decoy Museum
Rockville
Latvian Museum
Saint Michaels
Chesapeake Bay Maritime Museum
Salisbury
Ward Museum of Wildfowl Art

MASSACHUSETTS

Boston
Museum of Fine Arts
Society for the Preservation of New England Antiquities
Deerfield
Historic Deerfield
Memorial Hall Museum, Pocumtuck Valley Memorial
Association
Hancock
Shaker Museum
Harvard
Fruitlands Museums
Lowell
New England Quilt Museum
New Bedford
New Bedford Whaling Museum
Salem
Peabody Essex Museum
Sandwich
Heritage Plantation of Sandwich
Sharon
Kendall Whaling Museum
Springfield
Museum of Fine Arts
Sturbridge
Old Sturbridge Village
Worcester
Worcester Art Museum
Worcester Historical Museum

MICHIGAN

Dearborn
Henry Ford Museum and Greenfield Village
Detroit
Detroit Historical Museum
Detroit Institute of Arts

East Lansing
Michigan State University Museum
Grand Rapids
Grand Rapids Public Museum

MINNESOTA

Minneapolis
The Minnesota Institute of Arts
St. Paul
Minnesota Historical Society

MISSOURI

Kansas City
The Nelson-Atkins Museum of Art
St. Louis
The Dog Museum
Missouri Historical Society
St. Louis Art Museum

NEW HAMPSHIRE

Canterbury
Shaker Village
Concord
New Hampshire Historical Society
Manchester
Currier Gallery of Art
Portsmouth
Strawbery Banke

NEW JERSEY

Freehold
Monmouth County Historical Association
Newark
The Newark Museum

Oceanville
Noyes Museum
Trenton
New Jersey State Museum

NEW MEXICO

Santa Fe
Museum of International Folk Art
Museum of New Mexico

NEW YORK

Albany
Albany Institute of History and Art
Shaker Heritage Society
Bellport
Bellport-Brookhaven Historical Society and Museum
Binghamton
Roberson Museum and Science Center
Brooklyn
The Brooklyn Museum
Cooperstown
New York State Historical Association
Kingston
Senate House State Historic Site
Mumford
Genesee Country Museum
New York City
Metropolitan Museum of Art
Museum of American Folk Art
Old Chatham
The Shaker Museum
Rochester
Memorial Art Gallery, University of Rochester
The Strong Museum
Stony Brook
The Museums at Stony Brook

Utica
Munson-Williams-Proctor Institute

NORTH CAROLINA

Asheville
Folk Art Center
Chapel Hill
The Ackland Art Museum
Winston-Salem
Museum of Early Southern Decorative Arts

OHIO

Cincinnati
Cincinnati Art Museum
Cincinnati Historical Society
Cleveland
Cleveland Museum of Art
Western Reserve Historical Society
Columbus
Ohio Historical Center
Coshocton
Roscoe Village
Massillon
The Massillon Museum
Oberlin
Allen Memorial Art Museum, Oberlin College
Oxford
Miami University Art Museum
Portsmouth
Southern Ohio Museum and Cultural Center
Zoar
Zoar State Memorial

PENNSYLVANIA

Doylestown
Mercer Museum of the Bucks County Historical Society
Harrisburg
Pennsylvania Historical and Museum Commission
The State Museum of Pennsylvania
Hershey
Hershey Museum of American Life
Lancaster
Landis Valley Museum
Rock Ford Plantation
Lenhartsville
Pennsylvania Dutch Folk Culture Society
Philadelphia
Philadelphia Maritime Museum
Philadelphia Museum of Art
Waynesboro
Renfrew Museum and Park
West Chester
Chester County Historical Society
York
The Historical Society of York County

RHODE ISLAND

Providence
Rhode Island Historical Society

SOUTH CAROLINA

Columbia
The University of South Carolina McKissick Museum
Edgefield
Pottersville Museum

TENNESSEE

Knoxville
Knoxville Museum of Art
Nashville
Tennessee State Museum
Norris
Museum of Appalachia

TEXAS

Dallas
Dallas Museum of Art
Houston
The Bayou Bend Collection
The Museum of Fine Arts, Houston
Round Top
University of Texas at Austin Winedale Historical Center

VERMONT

Bennington
The Bennington Museum
Brownington
Old Stone House Museum
Middlebury
The Sheldon Museum
Vermont Folklife Center
Montpelier
Vermont Museum
Shelburne
The Shelburne Museum

VIRGINIA

Ferrum
Blue Ridge Institute and Farm Museum

Newport News
The Mariners' Museum
Norfolk
The Chrysler Museum
Richmond
Valentine Museum
Roanoke
Roanoke Museum of Fine Arts
Williamsburg
Abby Aldrich Rockefeller Folk Art Center
Bassett Hall

WISCONSIN

Baraboo
Circus World Museum
Madison
State Historical Society of Wisconsin
Milwaukee
Milwaukee Art Museum
Milwaukee Public Museum
Villa Terrace Decorative Arts Museum

WHERE AND HOW TO BUY FOLK ART

Any history of collecting abounds with tales of collectors finding priceless treasures in attics, barns, or roadside stands where they went unrecognized for decades. Stories of paintings being salvaged from garbage dumpsters and eighteenth-century furniture being used to hold paint cans have circulated in the antiques community for years. Some accounts may be true, others may be folklore, but as scholarship increased and collectors became more sophisticated, the likelihood of finding "buried treasure" waned. Fortunately for collectors, however, the antiques business is healthy, and many options are available to purchase historic objects and beautiful works of art.

Some general hints will allow collectors to acquire quality folk art from a variety of sources. In every case, the informed consumer can make the most intelligent choices. Learn about the objects being considered for purchase. Ask questions; do not be intimidated. Remember that almost any object can be researched. Many dealers are willing to share information and appreciate customers who express a willingness to learn. Pick up the objects (CAREFULLY!); examine them completely before purchase. Most antiques businesses are honest, but always remember, *"Caveat emptor"*—"Let the buyer beware"!

HOW TO FIND THE SALES

Many antiques publications, such as *The Magazine Antiques* and *Colonial Homes,* have listings of upcoming flea markets, antiques shows, and auctions, both regional and national. Several weekly and monthly trade journals, such as *Antiques and the Arts Weekly* and *Maine Antique Digest,* also have up-to-date information and carry current advertisements and bulletins. By calling or writing, collectors can receive mailing lists, calendars, and announcements for future sales from most auction houses. Local newspapers often have flea market, auction, and estate sale information in the classified sections.

FLEA MARKETS

Flea markets range in size from one-person efforts to highly organized, several-day events with hundreds of dealers. Some bargains are to be found at flea markets if the buyer can identify the choice pieces. In general, goods are seldom described and the "buyer beware" admonition should be taken seriously. For sophisticated shoppers, however, the flea market offers the opportunity to purchase goods well under their true value. Many flea markets are advertised in local newspapers and trade journals throughout the year. Do not overlook local church or club sales

when searching for bargains. Strength and stamina are important when looking for treasures at flea markets. Invariably, the collector will have to sort through all kinds of miscellaneous materials (junk!) to find a prize. Aficionados, however, find the experience exciting and many loyal flea-market-goers make it an event.

ANTIQUES DEALERS

Some antiques dealers have a broad selection of merchandise, but others may specialize in a specific area. Most reputable dealers will authenticate their goods (often in writing) and assure that they are represented accurately in advertisements. Reputable dealers will be willing to buy objects back if the customer is unsatisfied or if there is a question about authenticity. Caution should be taken if a dealer has no buy-back policy or refuses to guarantee merchandise. A good practice is to select dealers who belong to professional antiques associations that have a code of ethics that members are required to follow in business. The National Antique and Art Dealers Association of America, Inc., for example, states that objects offered by members must be "honestly represented as to authenticity, provenance, and condition." Many states have antiques-dealer associations that adhere to similar guidelines. The advice of fellow collectors can also be sought to receive recommendations for honest antiques dealers. Many dealers are extremely helpful to novice collectors and eagerly offer information about many types of objects. Antiques dealers are found in cities, in rural areas, and in mid-sized towns, and opportunities for purchase are virtually endless. Most will allow collectors to examine merchandise at their leisure.

ANTIQUES SHOWS

Hundreds of antiques shows are held throughout the year in cities and even in small communities. Dealers bring goods to be sold

during the events that usually last two or three days. Many collectors find shows a convenient way to purchase objects because many dealers are selling in one place and access is readily available. Some shows are built around a theme, but most have some variety of American or folk art. Antiques shows are advertised in local newspapers, trade journals, and other antiques-related periodicals. Essentially, shows are a collection of dealers. The variety allows collectors to survey many types of antiques at a single site. Some of the more well-known antiques shows include the Winter Antiques Show, New York City, January; the Philadelphia Antiques Show and the Connecticut Antiques Show (Hartford), spring and fall; and the Fall Antiques Show at the Pier, New York City. Many state antiques dealers associations sponsor antiques shows throughout the year.

AUCTION HOUSES

Auctions offer collectors the opportunity to purchase goods at a range of prices. Auction houses and businesses come in a variety of sizes from large, internationally based operations to smaller, local companies. Many large auction houses produce lavishly illustrated catalogues to enable prospective buyers to see photographs of the objects, and smaller companies offer detailed brochures with similar information. The catalogues feature photographs of the objects with accompanying detailed descriptions, dates, medium, and sometimes provenance and scholarly references; a low and high dollar estimate is often included. Customers can consult the catalogues to determine when each object will be offered. Most companies encourage buyers to view the items in person, on site, prior to the auction, and many have specialists available to answer questions about the pieces for sale. Like reputable antiques dealers, auction houses will guarantee or warrant their merchandise; most list "conditions of sale" and "terms of guarantee" in writing in their catalogues or other literature. Most auction houses charge a buyer's premium based on the successful bid price. Fifteen percent is fairly standard but varies from busi-

ness to business. The buyer's premium usually decreases as the bid price increases in preestablished intervals listed in the catalogues. Usually, prospective buyers register with the auction house and receive a bidding number or paddle. The auctioneer recognizes the bids by number and records the winner. Usually, bills are paid before the items are released from the site. Some auctioneers fancy themselves as comedians, and many people attend their sales for entertainment.

LOCAL AUCTIONS AND ESTATE SALES

Local auctioneers conduct business much like the larger companies but many are more informal. The buyer's premium may also vary. Often, the merchandise can be inspected prior to the auction. Many valuable objects may have been owned in families for years and do not come to light until estates have to be settled. Estate goods can be auctioned or sold privately through banks or other executors. Local newspapers often carry advertisements and descriptions of upcoming estate sales and auctions. Estate sales usually contain the contents of a private home, but sometimes auctioneers add objects from other sources. Usually, objects can be inspected the day or morning prior to the sale.

HOW TO PROTECT YOUR FOLK ART TREASURES

Part of being a responsible collector involves proper maintenance of works of art. Just as museums concentrate on regulating environmental conditions, storage, and correct exhibition installation to safeguard their objects, collectors, too, should be aware of potential hazards that could damage fragile and valuable works of art. Any change in the object's original condition, with some exceptions, decreases an object's monetary value and reduces its worth as a piece of history. A few guidelines, and common sense, will ensure that the objects we prize and admire today will remain for future generations to enjoy. Collectors should be aware of proper display and storage techniques but should not be deterred from building a collection if ideal conditions cannot always be maintained. Most of these objects were made with superb craftsmanship and have acclimated to changes in temperature and humidity. A "common sense" approach will often allow precious objects to be protected and enjoyed.

What Is a Professional Conservator? . . . or, "When in Doubt, Don't!"

An analogy can best serve to explain this occupation: a conservator is to an object what a doctor is to a patient: a trained professional, skilled both in science, usually chemistry, and in art history, archaeology, or other disciplines related to a specialty. Through extensive training and apprenticeships, the conservator has had practical experience in identifying and evaluating materials and structure, and "hands-on" work repairing damage. Most conservators work in historical agencies, libraries, museums, or privately, and generally specialize in the treatment of a particular type of object: rare books, decorative arts, ethnographic items, furniture, paintings, paper, photographs, and textiles, among others. It is *imperative* to remember that no one should attempt to clean or repair an art object who is not professionally trained to do so. Remember . . . it takes a doctor to diagnose pneumonia and a conservator to restore works of art.

While different types of objects wear differently and deteriorate in different ways and rates, some basic conditions are harmful to almost every variety of material culture. Light damages all artifacts made of organic matter, such as ivory, fabric, paper, or wood. The ultraviolet and infrared radiation, the intensity of the light, and the length of time the object is exposed all contribute to deterioration. Another element that causes damage to organic objects is the relative humidity, or the level of moisture in the air. When the humidity level is low, such as in a heated building during a cold, dry winter, moisture is drawn out of organic materials. Wood panels might separate, causing splits, and canvas will shrink, causing the layers of paint to crack. In extremely high humidity, paper expands or buckles, mold can grow in fabric or leather, and metals can rust. It may be nearly impossible to live with the low light levels and achieve the stable humidity that

is safest for most objects, but a few common-sense preventive actions can be taken to protect artifacts. Furniture, paintings (especially those on paper), and textiles should never be hung in direct, natural light; in fact, significant protection can be given by simply darkening the room by closing the draperies or blinds; commercially made ultraviolet filters and films, used by museums, can be applied to windows to reduce radiation. Also, objects should be rotated into a dark storage area to "rest" whenever possible while others go on display. A humidity level of 50 percent (plus or minus 5 percent) is suitable for most objects but is virtually impossible to maintain without sophisticated climate-control systems. (Even museums have difficulty maintaining a constant environment. The small instrument located in many museum galleries is a hygrothermograph, a device that continuously records temperature and humidity.) A simple test can indicate if the humidity is too low: if static electricity is a problem, the room is too dry; artifacts should be moved to a cooler room and away from sources of heat. A room humidifier can also be of help, but, ideally, the humidity should still be monitored. High humidity causes problems. Obviously, objects should not be stored in spaces that are naturally damp, such as basements. Good ventilation, air movement, and dehumidifiers can be beneficial.

Modern scientific technology has increased our understanding and preservation of the man-made world enormously, but some tendencies cannot be changed. All organic objects possess what is commonly termed "inherent vice," best described by one expert as the "ability of bread to turn stale." That is, organic objects "remember" what they were originally and try to return to that natural form, essentially destroying themselves. Once a tree, wood warps and curves, destroying joints or releasing metal handles; residual acid from wood causes paper eventually to turn itself into powder; textiles become brittle and split as a result of chemical dyes used in their manufacture. While some conditions cannot be changed, proper care will greatly extend the lives of these pieces of the past.

How to Care for
Metal

In general, metals are very durable but, under certain conditions, they are unstable and will change over time. The substance begins as ore, a rocklike material that is mined, processed, and turned into metal, then made into an object. Almost immediately, it begins to corrode or oxidize in an attempt to return to its natural state. (Automobile rust is an example of oxidation.) The relative humidity, temperature, and air pollution affect the metal in significant ways.

Moisture is the key ingredient in causing corrosion; for display and storage, a relative humidity of 35–40 percent and a temperature of 65 degrees F. is suggested. Obviously, the storage area should be in a dry place, away from a water source. Metal objects are also affected by gases, such as formaldehyde, given off by composite wood products such as plywood and particle board. Storage shelving should be made of enameled metal; if wood has to be used, it should be formaldehyde-free and sealed. Acid-free papers are fine for wrapping metal objects, but most plastics should be avoided as they emit gases that can affect metal surfaces. To prevent damage from skin oils on metal surfaces, clean cotton gloves should be used when handling metal objects.

Metal can be dusted with a soft bristle brush, such as badger or sable, or a clean cotton cloth. If corrosion becomes a problem, a metals conservator can propose a treatment for stabilization.

How to Care for
Needlework

Textiles are familiar to everyone who wears clothing, snuggles under quilts or coverlets, walks on rugs, or sits on upholstered furniture. As historical artifacts, textiles must receive particular attention to remain in good condition.

Natural fibers are the basis of historic textiles: silk and wool,

of animal origin, and linen and cotton, made from plants. As such, they are particularly susceptible to the effects of light, mold and mildew, and insect infestation. Ideally, textiles should be stored flat, placed under a dust cover, such as clean muslin, and placed in a cool, dry room away from the sun. Larger textiles, such as quilts, may be rolled and stored in the same manner. Acid-free boxes and paper can also be used as storage containers.

If they are to be displayed, smaller needlework items such as samplers or embroidered pictures should be backed with archival board or paper (or muslin) and framed under UF-3 Plexiglas to filter damaging light radiation. They should be hung where they receive as little light as possible. If the textile is in stable condition, one way to mount quilts or coverlets on the wall is to sew the soft side of a strip fastener, such as Velcro, across the top of the fabric; the other strip, with the loops, can be mounted on the wall; when pressed together, the textile will be attached to the wall. As is the case with all historic objects, NEVER attempt to repair damage. Do not attempt to wash historic textiles. Colors may bleed and textiles may shrink. Large textiles such as quilts are very heavy when wet and can easily tear during handling or washing. Consult with a textile conservator for evaluation and treatment.

How to Care for
Paintings

Essentially, a painting consists of layers, not unlike a cake; a support, such as canvas, wood panel, ivory, or paper; a ground, such as chalk or gesso, to make the surface smooth; a paint layer, such as oil or watercolor; and a protective covering of varnish. Each layer responds differently to variations in temperature and humidity, and the layers may weaken gradually and separate. The vast range of materials used by folk artists makes their work extremely vulnerable to changing environmental conditions. In low humidities, wood panels may split and canvas may shrink; in high humidities, chemical reactions may occur, making the

support susceptible to molds or insect infestation. Throughout these fluctuations, the fragile paint layers may become brittle, crack, and even flake off the support. In general, a relative humidity of 50 percent and a temperature of 68 degrees F. are suggested for paintings but may be difficult to maintain. Sudden changes in temperature and humidity, however, are more damaging than gradual or seasonal ones. Storing or displaying in steady or gradually changing temperatures away from heat sources and light will slow the rate of deterioration.

Common sense and good housekeeping will prolong a painting's life. Do not touch the painting's surface or back, as oils from the skin can affect the surface. Aerosol sprays and other airborne pollutants such as tobacco smoke may settle on the surface. Avoid hanging paintings near work spaces, fireplaces, radiators, or other areas where extreme heat or moisture may pose problems. Periodically, check the surface for missing or loose paint, cracks in wood, tears or punctures in canvas, discoloration, and dirt. If a stable painting (a painting in good condition, exhibiting no loss or deterioration) becomes dusty, a light dusting with a soft bristle brush, such as sable or badger, available in art supply stores, may be done. NEVER use a feather duster or cloth for dusting and NEVER attempt to clean a painting or elaborate frame. If a painting requires cleaning or consolidation, consult with a qualified conservator.

How to Care for
Decorated Furniture

Because furniture is composed of many types of material—wood, metals, paint—environmental conditions are important for its protection. Light radiation damages furniture in several ways; it can break down the finish, heat the glues, and cause the wood to lose moisture. The relative humidity also affects wood; high humidity causes wood to absorb water and swell, and can allow molds to form; low humidity dries wood, causing it to shrink. These fluctuations may cause the wood to warp, split, or break.

A relative humidity of 55 percent and temperature of 68 degrees F. has been advised for wooden objects.

Wood is also subject to insect infestation. The term "wood-worm" refers to pests such as beetles, termites, silverfish, and others that can attack woods. Examine the object to determine if it is infested: light-colored wood powder will be visible in exit holes if insects are present. A conservator should be contacted to propose a form of pest control if insects are found.

Furniture should be displayed and stored away from sources of direct heat and moisture, and light levels should be kept to a minimum. While stored, furniture may be covered with a clean muslin cloth to prevent dust accumulation.

Dusting must be done carefully to avoid chipping or snagging the wood. Clean, lint-free rags may be used but NO aerosols, oils, or dust attractors should be applied. Painted surfaces should be dusted only if there are no areas of loose, flaking paint. If damage occurs to structural elements, finishes, or painted surfaces, a conservator should be consulted.

HOW TO CARE FOR
WORKS OF ART ON PAPER

Many miniature portraits, fraktur paintings, small landscapes, or town vignettes are examples of works of art created by the application of watercolors, pastels, pen, pencil, or other media to paper. They demand special attention to avoid damage and retard inherent vice.

Until the mid-nineteenth century, paper was made of cotton or linen rags and was highly stable and durable. With increased literacy the demand for printed materials increased also and less expensive paper made from highly acidic wood pulp began to be manufactured and used for books, newspapers, prints, and artwork. Over time, acidic paper becomes brittle and gradually crumbles into dust. Conservators can stabilize paper through a process called deacidification or acid neutralization, but the rescue of individual works of art on paper, which have a combination

of inks or paints, is more complicated. To safeguard works of art on paper, several steps should be taken to frame the objects correctly. Many paper artworks have been degraded by the acidic wooden backing placed against them in the frame, a common practice during the nineteenth century. They should be matted with acid-free board and backed with the same archival material. Only those papers and boards that are buffered or acid-free should touch the art work. Ideally, the art should be framed using UF-3 Plexiglas to filter out some of the ultraviolet radiation. If it is not framed, the surface may be covered with a sheet of acid-free paper or neutral glassine and stored flat in an archival folder.

Light is a leading factor in the destruction of paper. Works of art should be displayed with the absolute minimum of light, a maximum of five foot-candles in a cool environment. Damage from light is cumulative, so a recommended preservation practice is to rotate works of art on paper to dark storage every few months. A temperature of 60–70 degrees F. and a relative humidity of 45–55 percent is suitable. At high humidities, molds can grow and a discoloration of brown spots called "foxing" can occur, completely altering the work of art. Using good judgment and common sense, the layman can purchase archival materials and store paper works of art properly. The professional advice of a paper conservator should be sought when extensive damage has occurred and repair is needed.

How to Care for
Ceramics

Inorganic materials, such as ceramics, glass, stone, and metal, are reasonably stable relative to light, humidity, temperature, and insect infestation. Most damage is caused by human error in handling, display or storage. Extreme, sudden changes in temperature, such as placing a hot dish into cold water, can cause breakage and should be avoided. When handling, always support the object by the base, or center of gravity; never use handles or

spouts. Separate parts of the object, such as stands or lids, should be removed and transported by themselves. Padding, such as soft cloth or foam, in boxes or baskets greatly reduces the risk of breakage when moving objects. Ideally, ceramics should be stored in a safe, clean, dust-free location, such as a closet away from extreme heat or cold. Shelving can be padded with cloth, such as muslin, or acid-free paper to prevent chipping. Artifacts should not be crowded together on the shelf or stacked. If space is limited, plates or saucers may be stacked with padding in between each item to prevent abrasion or chipping. Obviously, objects that have minor damage, such as a hairline crack, or have been repaired should not be stacked on the bottom. For easy retrieval, objects can be sorted and stored by type.

Ceramics can be most safely displayed in enclosed cases or cabinets with glass fronts. If left out in the open, or on unsteady areas, individual pieces can be secured to the display surface using a dot of softened, microcrystalline, museum-quality wax.

For maintenance, dust ceramics with a clean, cotton cloth or a soft brush using NO cleaning agent. If more extensive cleaning is needed, because of accumulated dirt or grime, most ceramics, except those that have been overpainted or are unglazed, can be wiped safely with room-temperature water. If an object gets broken, save ALL fragments and sherds for repair by a conservator.

HOW TO CARE FOR
COMPOSITE OBJECTS

Many folk art objects are made of several different materials; conservators call them "composite objects." Such objects pose special concerns for their conservation.

To be called a composite object, an artifact must be made of at least two of the following substances: animal material; ceramic; glass; man-made material; metal; paper; plant material; textile; or wood. All are affected differently by levels of light, relative humidity, and temperature. In addition, they react differently in combination with one another. For example, a metal knife may

have a wooden handle; moisture retained by wood in high relative humidity can corrode the metal. The best advice for composite objects is to keep the relative humidity at 50 percent and the temperature at 68 degrees F., and to avoid abrupt changes of condition. The most fragile part of the object, such as light-sensitive ribbon on a silver trophy, should govern storage conditions.

How to Care for
Scrimshaw

Ivory specifically refers to elephant tusks, but the word is also used to describe the teeth of whales and other animals, which is composed of dentin, a material similar to calcium carbonate that is highly sensitive to relative humidity. In low humidity, the material will shrink and crack; in high humidity, it will swell or warp. Intense light levels bleach and discolor the surface.

Scrimshaw should be stored and displayed in a constant environment with a relative humidity of 45–55 percent and at 65–72 degrees F., away from bright light. Bone and baleen, a membrane found in the whale's mouth, also react dramatically to the environment and should be stored and displayed with the same caution.

Because of the complexity of their composition, and the detrimental effects of cleaning agents and water, scrimshaw objects should be cleaned and repaired only by a conservator.

FINDING A CONSERVATOR

The American Institute for Conservation of Historic and Artistic Works is an organization of conservators that publishes many materials relating to state-of-the-art conservation practices; its not-for-profit affiliate, the Foundation of the American Institute for Conservation, offers grants, programs, and a conservators'

referral system. Information is available and includes a pamphlet entitled "Guidelines for Selecting a Conservator" by request.
• The American Institute for Conservation of Historic
 and Artistic Works and Referral System
 1717 K Street, N.W.
 Washington, D.C. 20006

The National Institute for the Conservation of Cultural Property offers literature and forums on conservation and related topics.
• National Institute for the Conservation of Cultural Property
 3299 K Street, N.W., Suite 403
 Washington, D.C. 20007

The Getty Conservation Institute offers programs in scientific research, training, and publications. The Conservation Information Network is administered by:
• Canadian Heritage Information Network
 Communications Canada
 365 Laurier Avenue N.W.
 Ottawa, Ontario, Canada K1A 0C8

The American Association for State and Local History offers technical leaflets and publications regarding conservation and storage of historic objects.
• American Association for State and Local History
 172 Second Avenue North
 Nashville, Tennessee 37201

Many museums and historical agencies have conservators on their staffs who also work privately. Conservators, curators, and registrars at local museums are sometimes able to provide names of qualified conservators and guidelines for selection.

CONSERVATION AND
ARCHIVAL MATERIALS

A selection of archival materials suitable for object storage is available commercially. Papers and mounting boards, boxes, and photographic sleeves that are acid-free (i.e., they are neutral and will not deteriorate) are good for storing many types of objects. An acrylic plastic, called UF-3 Plexiglas by one company, has been impregnated with a substance that filters out ultraviolet radiation and helps reduce light damage when used as a glazing material.

A distributor of conservation materials is:

- Conservation Materials, Ltd.
 P.O. Box 2884
 1165 Marietta Way
 Sparks, Nevada 89431

Some distributors of archival materials are:

- Light Impressions Corporation
 439 Monroe Avenue
 Rochester, New York 14603
- University Products, Inc.
 P.O. Box 101
 Holyoke, Massachusetts 01041
- Gaylord Brothers
 P.O. Box 4901
 Syracuse, New York 13221

FURTHER READING

American Association for State and Local History. Technical Leaflet Series. Nashville, Tenn.: American Association for State and Local History.

Macleish, A. Bruce. *The Care of Antiques and Historical Collections.* Nashville, Tenn.: American Association for State and Local History, 1985.

National Committee to Save America's Cultural Collections. *Caring for Your Collections*. New York: Harry N. Abrams, Inc., 1992.

INSURANCE AND APPRAISALS

Protecting one's investment can be time-consuming but is absolutely necessary in a complicated world that thrives on seemingly endless paperwork. For insurance purposes, complete and accurate documentation of a collection will simplify procedures if damage or loss occurs.

A simple system, similar to that used by museum registrars, can provide the basis of the documentation. Bills of sale should be saved to verify dates, prices, and origins of purchase. A simple note of condition at the time of purchase can be helpful. Ideally, photographs of each object should be taken when an object enters a collection; written descriptions, however, should be included because photographs do not always illustrate the object's material; sterling silver, for example, could look like another metal in a photograph. Any research materials, such as references to makers or similar objects, can be included to help to authenticate the item. Videotapes or other electronic devices can accurately record room inventory, but these, too, should be accompanied by written descriptions. Ideally, copies of photographs, tapes, and descriptions should be stored off the premises in a secure place such as a safety deposit box so that the information could be retrieved in the event of a disaster.

If original documentation for every object is not available (Great-aunt Martha's portrait has been in the family since 1860, for example, and no one has the paperwork), a qualified appraiser can help to set accurate values. Many appraisers advertise their services commercially and can be easily found in the telephone directory. Many museums, insurance companies, and banks can make recommendations. Two professional organizations, the American Society of Appraisers and the International Society of Appraisers, require their members to meet strict requirements, including educational courses and testing. Most auction houses and some dealers have appraisal services available to the public.

Services will vary among different companies, but if a collection is of substantial value, a fine arts rider or floater, beyond the usual homeowners' insurance, might be recommended. Some companies specialize in fine arts insurance and are well versed in the proper way to insure treasures.

Because fair market values change with time, going both up and down, it is a good idea to have a collection appraised every five years or so to assure adequate insurance coverage.

GLOSSARY

Baleen A membrane, made of keratin, found in a whale's mouth; used to make scrimshaw.

Bowsprit A timber projecting from the bow of a vessel.

Busk A thin strip of whalebone or baleen worn in front of a corset or bodice.

Calligraphy Beautiful penmanship; ornamental writing.

Cathead A projection on the bow of a ship to which the anchor line is attached.

Chalkware Figures made from gypsum, similar to plaster of Paris; popular in the nineteenth century.

Chenille A fuzzy cord of yarn (silk, cotton, wool) having a pile on all sides; used in embroidery.

Coverlet A woven bedcovering usually made of wool, linen, and cotton.

Daguerreotype One of the earliest photographic processes, invented in 1839; the image is recorded on a silver-coated, light-sensitive metallic plate.

Decoy A likeness of a bird, used to lure game.

Dentin Calcified substance that forms the body of a tooth.

Embroidery A type of ornamental needlework.

Figurehead A carved ornamental figure located on the prow of a ship.

Fireboard A board, sometimes decorated, that closes a fireplace opening.

Folk art Utilitarian and decorative objects made outside of academic traditions.

Foxing Light-brown spots or stains appearing on paper as a result of decay.

Fraktur A Pennsylvania-German stylized picture, sometimes a family record, containing motifs and script in an ornamental manner.

Genre painting A type of painting that features views of everyday life.

Gilt Yellow-colored, in imitation of gold.

Glaze A thin, transparent glossy covering; in ceramics, used over base material.

Graining Paint or stain applied to imitate figured wood.

Hippocampus A carousel figure having the head of a horse and the tail of a fish.

Hygrothermograph A calibrated device that records temperature and relative humidity.

Inherent vice Property found in a material that causes it to degrade.

Kilt Short, pleated skirt worn by Highland Scottish men; a sporran is a skin pouch, worn on the front of a kilt. Kilts and sporrans are seen on tobacconists' figures.

Lithograph A print produced from a design drawn on stone.

Memorial picture A type of ornamental picture, often embroidered, drawn, or painted, that commemorates a death.

Mortar A bowl-type vessel in which material can be crushed; a pestle is an implement for crushing; together they are used as the symbol of an apothecary.

Overmantel painting Section of panel, usually located over the fireplace, that has been decorated, usually with a landscape or town scene.

Oxidation Changes in an element that cause it to unite with oxygen; frequently happens to metals, resulting in discoloration.

Panbone Flat portion of a whale's jawbone; used for scrimshaw.

Pantograph A drafting instrument used to copy, enlarge, or reduce an image.

Polychrome Composed of many colors; usually paint.

Quilt A bedcover made by stitching layers of materials together in a variety of ways.

Rosette Ornament or decoration resembling a rose.

Sampler A type of needlework that uses a variety of embroidery stitches to spell out a verse, the alphabet, or information about an individual, sometimes used as a family record.

Scrimshander One who makes scrimshaw.

Scrimshaw Utilitarian or decorative objects made from the bone, teeth, or membrane of a whale.

Sherd A ceramic fragment (analogous to a shard, or glass fragment).

Silhouette Profile image having its outline filled in with uniform color.

Slip Liquid clay; used by potters, usually for decoration.

Spermaceti Waxy substance from the head of a whale; used to make candles.

Sternboard A wide board, located at the aft or stern of a vessel; sometimes decorated with ornamental carving.

Swags Decorative motifs or patterns resembling loops or roping.

Swift A device for winding yarn, sometimes found in scrimshaw.

Taufschein A Pennsylvania German ornamental picture, usually composed of writing; sometimes a family record.

Theorem painting Still-life painting, usually done by using stencils (also called theorems) to transfer paint onto a background.

Trade signs Figures or carvings used to advertise trades or wares.

Triton Mythological Greek sea god, having the head of a man and tail of a fish; said to have been one of the first weathervane figures.

Trompe l'oeil Literally, "fool the eye"; decorative, imitative painting.

Vorschrift A Pennsylvania German type of ornamental writing exercise; includes alphabets and numerals.

Weft Cross threads in cloth; long threads that cross the weft are called the warp.

Whirligig Ornamental, decorative device that revolves in the wind; usually carved wood.

\mathcal{S}ELECTED

BIBLIOGRAPHY

Ames, Kenneth. *Beyond Necessity: Art in the Folk Tradition*. New York: W. W. Norton for the H. F. du Pont Winterthur Museum, 1977.

Seminal publication that accompanied the exhibition of folk art from the Winterthur Museum collection in 1977. One of the first books to examine folk art from a social and cultural point of view. Controversial essay continues to be quoted by folklorists and art historians.

Becker, Jane S., and Barbara Franco, eds. *Folk Roots, New Roots: Folklore in American Life*. Lexington, Mass.: Museum of Our National Heritage, 1988.

Publication that accompanied the exhibition of the same name. Provocative essays on folklore and folk art.

Bishop, Robert. *American Folk Art: Expressions of a New Spirit*. New York: Museum of American Folk Art, 1982.

Catalogue that accompanied exhibition of the same name. Good photographs with minimal text.

———. *American Folk Sculpture*. New York: E. P. Dutton, 1974.

One of the first books to concentrate on the subject; still useful although some information is outdated.

Black, Mary, and Jean Lipman. *American Folk Painting*. New York: Clarkson N. Potter, 1966.

Some information is outdated but still useful, particularly because of the artist listings.

Bronner, Simon J. *American Folk Art: A Guide to Sources*. New York: Garland Publishing, 1984.

Extremely helpful annotated bibliography and guide to folk art research.

Cahill, Holger. *American Folk Art: The Art of the Common Man in America, 1750–1900*. New York: Museum of Modern Art, 1932.

Interesting as one of the first folk art documents.

Chotner, Deborah, et al. *American Naïve Paintings: The Collections of the National Gallery of Art Systematic Catalogue*. Washington, D.C.: National Gallery of Art/Cambridge University Press, 1993.

Comprehensive catalogue of the National Gallery's collection with detailed histories, biographies, and recent findings about folk artists.

Christensen, Erwin O. *The Index of American Design*. New York: Macmillan, 1950.

Illustrates the original plates from The Index of American Design.

D'Ambrosio, Paul S., and Charlotte M. Emans. *Folk Art's Many Faces: Portraits in the New York State Historical Association*. Cooperstown: New York State Historical Association, 1987.

Catalogue of the outstanding portrait collection at the New York State Historical Association. Excellent aesthetic interpretation and comprehensive biographical information about artists.

Eaton, Allen. *Immigrant Gifts to American Life: Some Experiments in Appreciation of Our Foreign-Born Citizens to American Culture*. New York: Russell Sage Foundation, 1932.

One of the first books to document immigrant folk art in America. Classic study emphasizing social context of folk art.

Glassie, Henry. *Pattern in the Material Folk Culture of the Eastern United States*. Philadelphia: University of Pennsylvania Press, 1968.

Classic study of regionalism in material culture and how folk art relates to other artifacts.

Hall, Michael D. *Stereoscopic Perspective: Reflections on American Fine and Folk Art*. Ann Arbor: UMI Research Press, 1988.

Thought-provoking essays on a variety of folk art topics.

Hartigan, Lynda Roscoe, et al. *Made with Passion: The Hemphill Folk Art Collection*. Washington, D.C.: Smithsonian Institution Press, 1990.

Catalogue that accompanies the exhibition of twentieth-century folk art of Herbert W. Hemphill, Jr. Excellent essay on twentieth-century collecting and explanation of individual catalogue pieces.

Hemphill, Herbert W., Jr., and Julia Weissman. *Twentieth-Century American Folk Art and Artists*. New York: E. P. Dutton, 1974.

One of the first books on the subject; information is dated, but still a good introduction to twentieth-century folk art.

Jaffee, David. " 'One of the Primitive Sort': The Portrait Makers of the Rural North, 1760–1860." In *Rural America, 1780–1900: Essays in Social History*, edited by Jonathan Prude and Stephen Hahn. Chapel Hill: University of North Carolina Press, 1985. Pp. 103–38.

Uses case studies of several well-documented folk painters to illustrate cultural meanings and nineteenth-century consumerism.

Janis, Sidney. *They Taught Themselves: American Primitive Painters of the Twentieth Century*. New York: Dial Press, 1942.

Some information is outdated, but interesting anecdotes; one of the first books on the subject.

Jones, Louis C. *Outward Signs of Inner Beliefs: Symbols of American Patriotism.* Cooperstown: New York State Historical Association, 1975.

> Small but excellent catalogue that uses the NYSHA collection to illustrate symbolism in folk art.

———. *Three Eyes on the Past.* Syracuse, N.Y.: Syracuse University Press, 1982.

> Director emeritus of the New York State Historical Association reviews the disciplines of folk art and folklore as they developed throughout the twentieth century. Engaging personal insights by one of American museums' most distinguished scholars.

Lipman, Jean, and Thomas N. Armstrong III, eds. *American Folk Painters of Three Centuries.* New York: Hudson Hills Press, in association with the Whitney Museum of American Art, 1980.

> A useful reference with good biographies of artists based on previously published material; accompanied exhibition of the same name.

Lipman, Jean, with Elizabeth V. Warren and Robert Bishop. *Young America: A Folk-Art History.* New York: Hudson Hills Press, in association with the Museum of American Folk Art, 1986.

> Publication that accompanied exhibition of the same name. Basic information, although critics disagree with some interpretations.

Lipman, Jean, and Alice Winchester. *The Flowering of American Folk Art (1776–1876).* New York: Viking Press, 1974.

> Publication that accompanied exhibition of the same name. Still useful, although much information is outdated and critics disagree with some interpretations.

Lipman, Jean, et al. *Five-Star Folk Art: One Hundred Folk Art Masterpieces.* New York: Harry N. Abrams, Inc., in association with the Museum of American Folk Art, 1990.

> Accompanied the exhibition of the same name. A publication by art historians in response to folk art criticism by folklorists and social historians. A "Michelin" guide stressing aesthetic quality in folk art; includes a "letter symposium" that attempts to define "quality" in folk art.

Little, Nina Fletcher. *The Abby Aldrich Rockefeller Folk Art Collection.* Boston: Little, Brown, for Colonial Williamsburg, 1957.

> First catalogue of the collection; a rare book.

———. *Country Arts in Early American Homes.* New York: E. P. Dutton, 1975.

> Explores several different varieties of folk art forms—landscapes, carvings, schoolgirl art, ceramics, fireboards—mainly from author's collection.

Metcalf, Eugene W., Jr. "Black Art, Folk Art and Social Control." In *Winterthur Portfolio,* 18, 1983. Pp. 271–89.

> Argues that black folk art has been misunderstood and misinterpreted by early writers and collectors.

Muller, Nancy C. *Paintings and Drawings at the Shelburne Museum.* Shelburne, Vt.: Shelburne Museum, 1976.

Catalogue of the notable painting collection, including both folk and academic works of art.

National Gallery of Art. *An American Sampler: Folk Art from the Shelburne Museum*. Washington, D.C.: National Gallery of Art, 1987.

Catalogue that accompanied the exhibition. Insightful essays by Benjamin L. Mason, David Park Curry, and Jane C. Nylander, with excellent catalogue entries by Celia Oliver and Robert Shaw.

Old Sturbridge Village. *Meet Your Neighbors: New England Portraits, Painters, and Society*, 1790–1850. Sturbridge, Mass.: Old Sturbridge Village, 1992.

Explores social and cultural meanings of folk artists and portraits. Insightful essays by Jack Larkin, Elizabeth Mankin Kornhauser, and David Jaffee.

Polese, Richard, ed. *Celebrate: The Story of the Museum of International Folk Art*. Santa Fe: The Museum of New Mexico Press, 1979.

History of the museum, published on its twenty-fifth anniversary. Illustrates some of the collection.

Quimby, Ian M. G., and Scott T. Swank, eds. *Perspectives on American Folk Art*. New York: W. W. Norton for the H. F. du Pont Winterthur Museum, 1980.

Essays from the 1977 conference on American folk art at Winterthur Museum. Seminal work that includes many interpretations of American folk art by leading scholars.

Rumford, Beatrix T., ed. *American Folk Paintings: Paintings and Drawings Other Than Portraits from the Abby Aldrich Rockefeller Folk Art Center*. Boston: Little, Brown, in association with the Colonial Williamsburg Foundation, 1988.

Encyclopedic catalogue of the permanent collection. Outstanding aesthetic interpretation and historical background.

———. *American Folk Portraits: Paintings and Drawings from the Abby Aldrich Rockefeller Folk Art Center*. Boston: Little, Brown, 1981.

Catalogue of the superlative collection of the Abby Aldrich Rockefeller Folk Art Center. Excellent introductory essay by Donald R. Walters and Carolyn J. Weekley with interesting individual catalogue entries.

Rumford, Beatrix T., and Carolyn J. Weekley. *Treasures of American Folk Art from the Abby Aldrich Rockefeller Folk Art Center*. Boston: Little, Brown, in association with the Colonial Williamsburg Foundation, 1989.

Publication that accompanied the exhibition of folk art from the Abby Aldrich Rockefeller Folk Art Center in 1989–90. Excellent overview that illustrates many folk art forms and gives brief histories and interpretation.

Sears, Clara Endicott. *Some American Primitives: A Study of New England Faces and Folk Portraits*. Boston: Houghton Mifflin, 1941.

One of the first books on folk painting. Catalogue of Miss Sears's personal collection, now at Fruitlands Museums, Harvard, Massachusetts. Most information is outdated, but contains wonderful anecdotes about early collecting.

Vlach, John Michael. *Plain Painters: Making Sense of American Folk Art*. Washington, D.C.: Smithsonian Institution Press, 1988.

Insightful, controversial essay on folk portraiture; a folklorist refutes traditional art history methods of evaluating folk painting.

Vlach, John Michael, and Simon J. Bronner, eds. *Folk Art and Art Worlds*. Ann Arbor: UMI Research Press, 1986.

Essays from the Washington Meeting on Folk Art, organized by the American Folklife Center at the Library of Congress. A seminal work that continues to expand the dialogue between the academic community and folk art collectors that began at the 1977 Winterthur conference. One of the most insightful and far-reaching books of folk art criticism.

\mathcal{J}NDEX

Note: Italicized page numbers refer to picture captions.

ABOUT THE AUTHOR

Jacquelyn Oak began her professional career as a member of the research department of the Shelburne Museum in Vermont. As research associate and later registrar at the Museum of Our National Heritage in Lexington, Massachusetts, she curated numerous folk art exhibitions, including "Face to Face: M. W. Hopkins and Noah North," an art and social history of two New York State folk portraitists. The author of many folk art articles, she currently is a museum and fine arts consultant preparing an exhibition and catalogue entitled "The Art of Reform: Folk Painters and Social Concerns."